DRAWING
MADE EASY

DRAWING
MADE EASY

HOW TO DRAW FROM OBSERVATION AND IMAGINATION

ROBBIE LEE

CONTENTS

WHAT YOU NEED

BLENDING STUMPS PENCILS
ERASERS SHARPENERS
PAPER STRAIGHTEDGES

I ALWAYS KNEW I WAS GOOD AT DRAWING, JUST NOT *GREAT* AT IT. PEOPLE WHO WERE *GREAT* WERE THOSE COMIC ARTISTS AND ANIMATORS WHO COULD DRAW HORSES IN ANY POSE FROM THEIR IMAGINATION.

MY HORSES LOOKED LIKE COWS. OCCASIONALLY I COULD GET A DECENT HORSE HEAD, BUT THEN I'D MANGLE THE LEGS AND END UP COVERING MOST OF THE BODY WITH A BUSH OR SOMETHING. EVERY FAILED ATTEMPT WAS A REMINDER THAT I *SIMPLY WASN'T A GREAT DRAWER* AND SO IT WENT.

THEN I HEARD ABOUT FIXED VS. GROWTH MINDSET.

IT'S A RESEARCH-BASED CONCEPT DEVELOPED BY STANFORD PROFESSOR CAROL DWECK. AS A TEACHER, I CAN SAY THAT IT'S A UBIQUITOUS TOPIC AT EDUCATION CONFERENCES THESE DAYS. SIMPLY PUT, PEOPLE WITH A FIXED MINDSET BELIEVE SUCCESS IS BUILT PRIMARILY ON NATURAL TALENT. PEOPLE WITH A GROWTH MINDSET BELIEVE SUCCESS IS BUILT PRIMARILY ON EFFORT AND LEARNING.

AT THE TIME, I FIRMLY IDENTIFIED WITH THE FIXED MINDSET. THIS WAS A *BAD THING*.

IF THINGS DON'T COME EASILY TO A PERSON WITH A *FIXED MINDSET*, THEY FEEL LESS TALENTED. THEY SHY AWAY FROM CHALLENGES WHERE THEY MIGHT FAIL. BUT A PERSON WITH A *GROWTH MINDSET* LOVES A CHALLENGE, EVEN IF THEY FAIL ALONG THE WAY. THEY KNOW THAT WORKING THROUGH A PROBLEM MEANS THEY'LL BE GETTING SMARTER IN THE PROCESS.

SO, IN MY LATE THIRTIES, I STARTED TRYING TO LOOK AT THE WORLD THROUGH A GROWTH MINDSET. LIKE DOING A U-TURN WITH A STAR DESTROYER, IT TOOK A LONG, LONG TIME, BUT GRADUALLY I UNDERSTOOD THAT THOSE HORSE DRAWERS WEREN'T JUST RELYING ON RAW TALENT. INSTEAD, THEY HAD STUDIED HORSE ANATOMY AND LEARNED ABOUT HOW HORSE LEGS PIVOT AND BEND; THEY HAD FILLED SKETCHBOOKS WITH COUNTLESS HORSES FROM OBSERVATION AND LIKELY MESSED UP A LOT ALONG THE WAY.

LAST SUMMER, MOSTLY FREE FROM MY FIXED MINDSET, I SAT DOWN WITH A COUPLE OF BOOKS ON DRAWING HORSES AND ALSO A TUBE OF THOSE TINY, REALISTIC HORSE FIGURINES. AND NOW . . . I CAN DRAW RESPECTABLY REALISTIC HORSES FROM MY IMAGINATION. ARE THEY EXQUISITE? NO, NOT YET. BUT IS IT THRILLING? YES! I LOVE DRAWING HORSES!

IT'S IN THE SPIRIT OF THE GROWTH MINDSET THAT I OFFER YOU THIS BOOK. IT'S THE KIND OF BOOK I WOULD HAVE ESCHEWED WHEN I WAS STARTING OUT, THINKING TALENT AND PRACTICE WERE ALL ANYONE REALLY NEEDED. BUT THERE IS ALL KINDS OF STUFF HERE THAT WOULD HAVE BEEN HUGELY HELPFUL TO ME WHEN I WAS STARTING OUT, AND SEVERAL THINGS THAT WOULD HAVE BEEN HELPFUL JUST A FEW YEARS AGO.

WHETHER YOU'RE A PRECOCIOUS YOUNG PERSON EAGER TO GET BETTER AT DRAWING OR AN ADULT WHO'S DUSTING OFF YOUR PENCIL CASE, EMBRACE THE CHALLENGING PARTS AND HAVE FUN WITH THE EASIER ONES. AND IF YOU TIME TRAVEL, PLEASE SLIP ME A COPY WHEN I WAS YOUNGER AND MAKE ME READ IT.

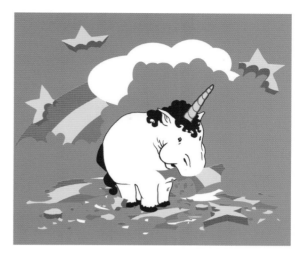

MY T-SHIRT DESIGN, "FAT UNICORN," WAS BORN FROM A SINCERE BUT FAILED EFFORT TO DRAW A REALISTIC HORSE.

(COPYRIGHT 2008 SHIRT. WOOT)

WITH A FIXED MINDSET, SEEING SOMEONE PERFORM BETTER FEELS BAD.

THROUGH A GROWTH MINDSET, SEEING SOMEONE PERFORM BETTER IS INSPIRING.

INTRODUCTION

BY THE TIME YOU'RE DONE WITH THIS BOOK, YOU SHOULD BE BETTER AT DRAWING. MAYBE A *LOT* BETTER.

BUT WHAT EXACTLY DOES "BETTER AT DRAWING" MEAN?

MAKING COOLER DOODLES? COPYING PICTURES MORE ACCURATELY? DRAWING MORE REALISTIC PORTRAITS? RENDERING DESIGN PLANS WITH MORE PRECISION?

TO HELP US CLARIFY WHAT EXACTLY YOU'LL BE GETTING *BETTER AT*, LET'S BREAK DRAWING DOWN INTO THREE METHODS.

METHOD 1: JUST DRAW

YOU COULD ALSO CALL THIS EXPRESSIVE OR SYMBOL DRAWING. THIS IS WHAT LITTLE KIDS AND GREAT ARTISTS DO. IT'S PURELY INTUITIVE. YOU DON'T REALLY THINK ABOUT HOW YOUR SUBJECT IS PUT TOGETHER.

YOU *JUST DRAW*.

METHOD 2: DRAW FROM OBSERVATION

THIS METHOD INVOLVES COPYING PICTURES OR TRYING TO DRAW A STILL LIFE. YOU DON'T THINK ABOUT HOW YOUR SUBJECT IS PUT TOGETHER. YOU JUST DRAW WHAT YOU SEE.

FOR BEGINNING ARTISTS, IT'S EASIER TO DRAW A SUBJECT FROM A SIDE VIEW . . .

. . . AND HARDER IF IT'S POINTING TOWARD YOU.

(WE'LL ADDRESS THIS IN CHAPTER 3.)

METHOD 3: DRAW FROM YOUR IMAGINATION (CONSTRUCTION)

HERE YOU THINK ABOUT HOW YOUR SUBJECT IS PUT TOGETHER, CONSTRUCTING IT FROM YOUR IMAGINATION AND COMBINING WHATEVER YOU KNOW ABOUT IT FROM PHOTOS, OBSERVATION, PROPORTIONS, ETC.

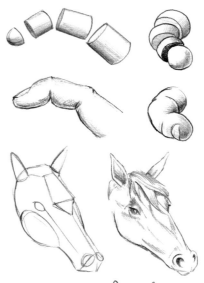

A THOROUGH UNDERSTANDING OF YOUR SUBJECT GIVES YOU GREATER CONTROL IF YOU WANT TO ABSTRACT THE OBJECT OR DRAW IT IN A CARTOONY STYLE.

THE GOAL OF THIS BOOK IS TWOFOLD: 1) TO DEVELOP A SOLID FOUNDATION FOR THE SECOND AND THIRD METHODS OF DRAWING, AND 2) TO BUILD YOUR CONFIDENCE WITH STEP-BY-STEP EXAMPLES ALONG THE WAY.

AND HERE'S THE PLAN TO DO IT:

CHAPTERS 1 AND 2 COVER THE FUNDAMENTALS OF DRAWING. WE'RE TALKING TOOLS AND MATERIALS, THE MECHANICS OF DRAWING, BEGINNING WITH SKETCHES AND FINISHING WITH SHADING AND CONTRAST.

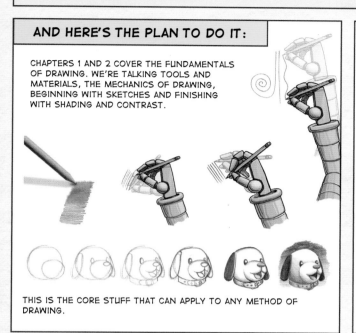

THIS IS THE CORE STUFF THAT CAN APPLY TO ANY METHOD OF DRAWING.

CHAPTER 3 COVERS HOW TO DRAW WHAT YOU'RE LOOKING AT, BOTH FROM A PICTURE AND FROM LIFE.

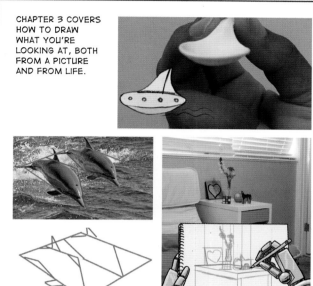

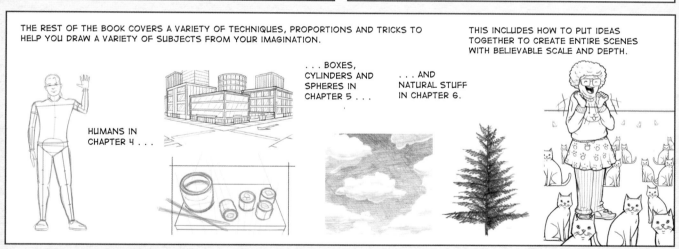

THE REST OF THE BOOK COVERS A VARIETY OF TECHNIQUES, PROPORTIONS AND TRICKS TO HELP YOU DRAW A VARIETY OF SUBJECTS FROM YOUR IMAGINATION.

HUMANS IN CHAPTER 4 . . .

. . . BOXES, CYLINDERS AND SPHERES IN CHAPTER 5 . . .

. . . AND NATURAL STUFF IN CHAPTER 6.

THIS INCLUDES HOW TO PUT IDEAS TOGETHER TO CREATE ENTIRE SCENES WITH BELIEVABLE SCALE AND DEPTH.

LET'S GET STARTED. . . .

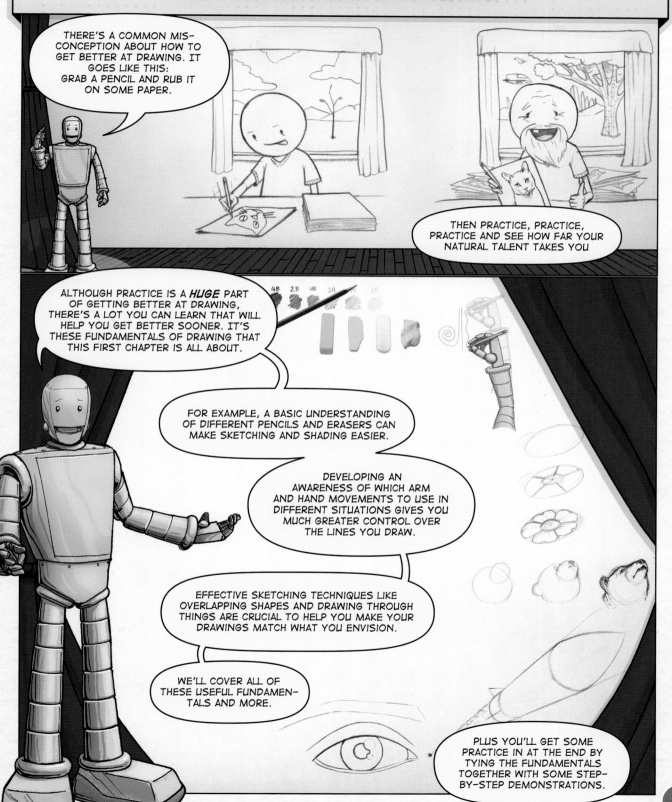

| PENCILS | IN THIS SECTION I'LL COVER THE BASICS OF ART SUPPLIES, AND THEN I'LL TELL YOU WHAT TO BUY BASED ON YOUR BUDGET. |

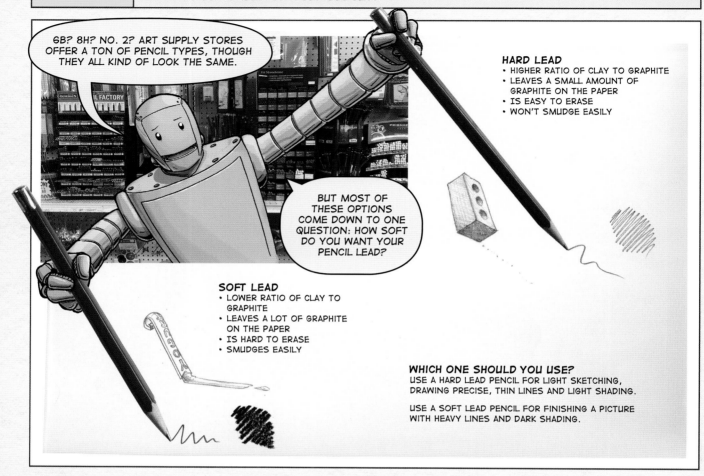

6B? 8H? NO. 2? ART SUPPLY STORES OFFER A TON OF PENCIL TYPES, THOUGH THEY ALL KIND OF LOOK THE SAME.

BUT MOST OF THESE OPTIONS COME DOWN TO ONE QUESTION: HOW SOFT DO YOU WANT YOUR PENCIL LEAD?

HARD LEAD
- HIGHER RATIO OF CLAY TO GRAPHITE
- LEAVES A SMALL AMOUNT OF GRAPHITE ON THE PAPER
- IS EASY TO ERASE
- WON'T SMUDGE EASILY

SOFT LEAD
- LOWER RATIO OF CLAY TO GRAPHITE
- LEAVES A LOT OF GRAPHITE ON THE PAPER
- IS HARD TO ERASE
- SMUDGES EASILY

WHICH ONE SHOULD YOU USE?
USE A HARD LEAD PENCIL FOR LIGHT SKETCHING, DRAWING PRECISE, THIN LINES AND LIGHT SHADING.

USE A SOFT LEAD PENCIL FOR FINISHING A PICTURE WITH HEAVY LINES AND DARK SHADING.

BUT THE PENCILS DON'T SAY "HARD" OR "SOFT." THEY'RE GRADED WITH A CODE USING B AND H.

LIKE PANT SIZES, THIS STUFF ISN'T INTERNATIONALLY REGULATED. THE DARKNESS OR HARDNESS OF TWO PENCILS WITH THE SAME RATING CAN VARY A BIT BETWEEN BRANDS.

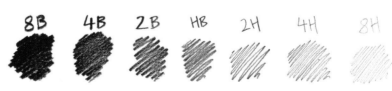

8B 4B 2B HB 2H 4H 8H

<<<< SOFT HB IS THE MIDDLE VALUE, EQUIVALENT TO A NO. 2 PENCIL. HARD >>>>>

YOU CAN FIND VARIOUS HARDNESSES FOR MECHANICAL PENCIL LEAD, TOO, THOUGH MOST COME STANDARD WITH HB LEAD.

MECHANICAL PENCILS CREATE UNIFORMLY THIN LINES (SOMETIMES GOOD, SOMETIMES BAD), BUT THEY ARE REALLY CONVENIENT, AND SOME COME WITH PRECISE, TINY ERASERS.

A STANDARD 7MM LEAD IS FINE, BUT 5MM IS OKAY, TOO. ANYTHING SMALLER BREAKS EASILY.

AVOID CHEAP STUFF!
YOU DON'T NEED TO SPEND A LOT OF MONEY ON PENCILS—A DECENT HB (NO. 2) FROM THE GENERAL STORE WILL WORK. BUT AVOID THE REALLY CHEAP ONES; THEIR HB RATING IS OFTEN WRONG, AND THEY CAN HAVE AWFUL ERASERS AND UNCENTERED LEAD.

GOOD ENOUGH!

AVOID!

ERASERS

ANY ARTIST ERASER WORKS PRETTY WELL, BUT THEY HAVE THEIR PROS AND CONS. HERE ARE THE FOUR MAIN CATEGORIES:

PLASTIC/VINYL
THE STANDARD ERASER FOR ARTISTS BECAUSE IT REMOVES THE MOST GRAPHITE. IT'S ALSO THE LEAST GENTLE, BUT IT'S USUALLY FINE ON MOST PAPERS. IF YOU GET ONLY ONE ERASER, GET THIS ONE.

RUBBER
A LITTLE GENTLER THAN PLASTIC, BUT ALSO A LITTLE LESS EFFECTIVE. AVOID CHEAP, STUDENT-GRADE ERASERS AS THEY CAN BE VERY HARD.

KNEADED
LIKE PUTTY, A KNEADED ERASER CAN BE MOLDED INTO WHATEVER SHAPE YOU NEED. TO USE IT, PRESS IT AGAINST THE PAPER TO LIFT AWAY THE GRAPHITE. IT DOESN'T ERASE VERY THOROUGHLY, AND YOU'LL NEED TO CONSTANTLY RESHAPE IT TO EXPOSE A CLEAN SURFACE, BUT IT'S GOT A LOT OF USES.

ARTGUM
ERASES THOROUGHLY AND GENTLY BECAUSE IT CRUMBLES SO EASILY, BUT THE CRUMBS CAN BE ANNOYING. IT'S ALSO A BIT IMPRECISE BECAUSE THE HARD CORNERS DISSOLVE SO EASILY.

A PLASTIC ERASER INITIALLY SMEARS THE GRAPHITE AND EVEN PUSHES IT INTO THE PAPER.

BUT IF YOU USE A KNEADED ERASER FIRST TO REMOVE MOST OF THE GRAPHITE, THE WHOLE THING WILL ERASE MORE CLEANLY.

OFTEN, YOU'LL WANT TO GET INTO A TIGHT CORNER OR ERASE BETWEEN TWO FINISHED AREAS.

TINY MECHANICAL PENCIL ERASERS WORK WELL, BUT THEY DON'T LAST LONG, SO USE THEM SPARINGLY AND BUY REFILLS.

YOU CAN SLICE OFF THE ENDS OF A PLASTIC ERASER TO CREATE FRESH CORNERS.

THERE'S ALSO A COOL TOOL KNOWN AS AN ERASER PENCIL (SOMETIMES CALLED AN "ERASIL"). YOU CAN SHARPEN IT LIKE A PENCIL TO ERASE IN REALLY TIGHT SPACES.

ERASER PENCIL

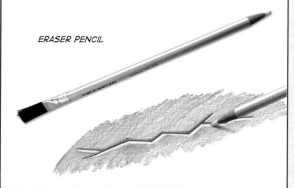

IF YOU REALLY NEED PRECISION, USE AN ERASER SHIELD. YOU CAN PRESS HARD WITH THE ERASER AND REMOVE ALMOST ALL THE GRAPHITE IN THE TINY REVEALED AREA. IT'S GREAT FOR CREATING A STARRY SKY OR HIGHLIGHTS IN AN EYE.

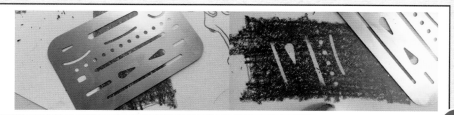

PAPER	WHEN IT COMES TO PAPER, THE TWO MAIN QUALITIES ARE TEXTURE AND THICKNESS.

TEXTURE

TEXTURE IS OFTEN REFERRED TO AS TOOTH.

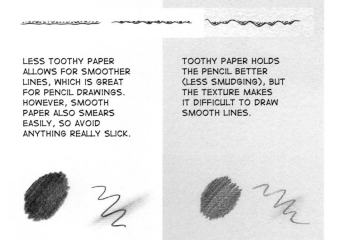

LESS TOOTHY PAPER ALLOWS FOR SMOOTHER LINES, WHICH IS GREAT FOR PENCIL DRAWINGS. HOWEVER, SMOOTH PAPER ALSO SMEARS EASILY, SO AVOID ANYTHING REALLY SLICK.

TOOTHY PAPER HOLDS THE PENCIL BETTER (LESS SMUDGING), BUT THE TEXTURE MAKES IT DIFFICULT TO DRAW SMOOTH LINES.

THICKNESS

THE THICKNESS OF THE PAPER IS KNOWN AS WEIGHT, AND IT'S SHOWN TWO WAYS—POUNDS OR GSM.

FOR EXAMPLE, CHEAP PRINTER PAPER IS USUALLY 20-LB (42GSM).

HEAVY CARD STOCK IS AROUND 150-LB (300GSM).

THICKER PAPER IS STURDIER AND WON'T GET DAMAGED AS EASILY, BUT IT'S ALSO MORE EXPENSIVE.

THINNER PAPER IS USUALLY FINE, BUT ANYTHING LESS THAN 24-LB (50GSM) CAN BUCKLE EASILY WHEN ERASING. PLUS IT CAN LOOK CHEAP, WHICH YOU MIGHT NOT WANT IF YOU DO A DETAILED DRAWING.

IF YOU DRAW ON TOOTHIER PAPER, LIKE WATERCOLOR OR CANVAS PAPER, YOU'LL LIKELY HAVE TROUBLE WITH PRECISE DETAIL LINES, BUT THE TOOTH IS NECESSARY WHEN IT'S TIME TO PAINT.

IF YOU'RE DRAWING WITH PENCIL, ANY SMOOTH PAPER THAT'S AT LEAST 24-LB. (50GSM) IS FINE. THIS INCLUDES DECENT PRINTER PAPER (BUT NOT THE SLICK OR GLOSSY TYPE) AND OFFICIAL DRAWING OR SKETCH PAPER FROM THE ART STORE, WHICH IS USUALLY AROUND 60-90-LBS. (130-190GSM).

BLENDING STUMPS

THOUGH IT'S JUST SOME TIGHTLY ROLLED PAPER, A BLENDING STUMP'S POINTED ENDS GIVE YOU MORE CONTROL FOR SMUDGING THAN WHEN YOU USE YOUR FINGER. ALSO, FINGER OILS CAN DAMAGE YOUR DRAWING.

ONE MEDIUM-SIZED STUMP IS ALL YOU'LL LIKELY NEED, BUT IF YOU END UP LOVING THESE THINGS, GET A RANGE OF SIZES.

YOU CAN USE SANDPAPER TO SHARPEN STUMPS AND GET A FRESH POINT, BUT I DON'T. IT'S A LOT OF WORK, AND I THINK THEY'RE BEST WHEN THEY'RE SEASONED, LIKE A CAST-IRON SKILLET.

SHARPENERS

HANDHELD SHARPENERS WORK FINE, BUT A SHARPENER IS ONLY AS GOOD AS ITS BLADE, SO CONSIDER THESE THINGS DISPOSABLE AND REPLACE THEM (OR THEIR BLADES) AS SOON AS THEY STOP WORKING WELL.

THE SAME RULE APPLIES TO ELECTRIC SHARPENERS. BUY ONE WITH REPLACEABLE OR SELF-SHARPENING BLADES, AND KEEP YOUR COLORED PENCILS AWAY FROM IT AS THE LEAD CAN GUM IT UP.

OF COURSE, DOING THE BULK OF YOUR DRAWING WITH A MECHANICAL PENCIL CERTAINLY HELPS.

FOR MOST DRAWINGS, A STANDARD 12" (30CM) RULER IS FINE, THOUGH FOR SOME PERSPECTIVE WORK YOU COULD USE A LONGER 18" (46CM) ONE. TRY TO GET A CLEAR ONE WITH GRID LINES ON IT, WHICH WILL HELP YOU WHEN DRAWING PERPENDICULAR LINES.

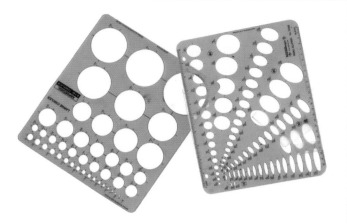

BE CAREFUL IF YOU INK YOUR ARTWORK. INK DOESN'T REALLY DRY ON PLASTIC OR METAL, SO IT WILL BUILD UP ON THE EDGES OF YOUR RULER AND SMEAR ONTO YOUR PAPER. MAKE SURE TO KEEP YOUR RULER CLEAN.

ALSO, DON'T SLIDE YOUR RULER OVER FRESHLY INKED AREAS. SLIDE IT *AWAY* FROM FRESHLY INKED AREAS.

CIRCLE AND ELLIPSE TEMPLATES CAN SAVE A LOT OF TIME, ESPECIALLY WHEN DRAWING PEOPLE OR CYLINDERS. I CERTAINLY USE THEM A LOT.

SO WHAT DO YOU BUY?

$:
YOU CAN TOTALLY GET BY WITH

- 24-LB. (50GSM) PRINTER PAPER (AVOID THE *REALLY* SMOOTH STUFF)
- A QUALITY HB/NO. 2 PENCIL
- A PLASTIC ERASER
- A HANDHELD SHARPENER
- AN 18" (46CM) STRAIGHTEDGE

DURING OUR STEP-BY-STEPS, IF I SUGGEST A HARD LEAD PENCIL, JUST PRESS MORE LIGHTLY WITH YOUR HB. IF I USE A BLENDING STUMP, JUST ROLL UP SOME PAPER TO MAKE YOUR OWN OR USE YOUR FINGER.

$$:
UPGRADE! GET

- A SKETCHBOOK OR DRAWING PAD
- A HARD LEAD PENCIL (4H)
- A SOFT LEAD PENCIL (4B)
- A KNEADED ERASER
- A MEDIUM-SIZED BLENDING STUMP
- A MECHANICAL PENCIL FOR CONVENIENCE (LOOK FOR ONE WITH A TINY ERASER)

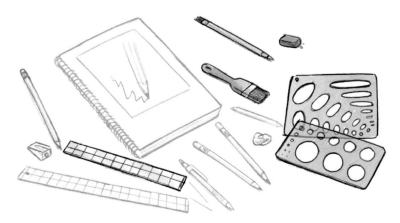

$$$:
WELL, ALL RIGHT! THROW IN

- AN ERASER PENCIL FOR HIGHLIGHTS AND PRECISION ERASING
- A CIRCLE TEMPLATE
- AN ELLIPSE TEMPLATE
- AN ERASER SHIELD
- A BRUSH (TO REMOVE YOUR ERASER BITS WITHOUT SMUDGING YOUR DRAWING)
- AN ARTGUM ERASER
- A SHORTER STRAIGHTEDGE

NOW THAT WE HAVE OUR SUPPLIES, LET'S BREAK DOWN THE PHYSICAL ACT OF DRAWING. IT MIGHT SEEM SIMPLISTIC, BUT DEVELOPING AN AWARENESS OF HOW YOU HOLD YOUR PENCIL AND PAPER, AND WHICH ARM MUSCLES YOU USE, IS AN IMMEDIATE WAY TO SEE MEANINGFUL IMPROVEMENT WITH YOUR DRAWING.

FOR EXAMPLE:

THESE TWO MOTIONS ARE NATURAL AND GIVE YOU EXCELLENT CONTROL WITH SHORT LINES. YOU PROBABLY DO THEM AUTOMATICALLY.

BUT THEY DON'T WORK VERY WELL FOR MEDIUM OR LONG LINES.

FOR **MEDIUM OR LONG** LINES, FREEZE YOUR WRIST AND FINGERS AND MOVE ONLY WITH YOUR **ELBOW AND SHOULDER**.

GIVE IT A TRY. DRAW TWO SPIRALS, ONE THE SIZE OF A CHERRY, AND ONE THE SIZE OF YOUR FIST. TRY EACH ONE WITH YOUR WHOLE ARM AND THEN AGAIN WITH YOUR WRIST/ FINGERS. YOU MIGHT BE SURPRISED AT HOW DIFFERENT IT FEELS.

SO, IF YOU NEED TO DRAW SHORT LINES, MOVE AT THE WRIST AND FINGERS.

AND FOR LONGER ONES, USE YOUR WHOLE ARM.

THE CUTOFF BETWEEN THE TWO FOR ME IS ABOUT 2" (5CM). EXPERIMENT AND SEE WHERE IT IS FOR YOU.

AT FIRST, YOU MIGHT NEED TO CONSIDER EACH LINE'S LENGTH. IS IT A WHOLE-ARM LINE (BLUE) OR A WRIST/FINGER LINE (RED)?

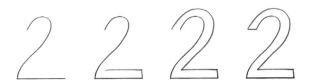

IT'S A BIT OF WORK, BUT AFTER A WHILE IT BECOMES AUTOMATIC.

REGARDLESS OF LINE LENGTH, YOU'LL GENERALLY WANT TO AVOID PUSHING YOUR PENCIL. MOTIONS THAT INVOLVE **PULLING OR PIVOTING** USE DIFFERENT MUSCLES AND GENERALLY OFFER YOU MORE CONTROL. FOR EXAMPLE:

OUR FIRST MOVE IS USUALLY A PULL. GREAT!

BUT TO GET BACK TO THE TOP, WE OFTEN PUSH. THERE'S LESS CONTROL THAT WAY.

INSTEAD, GO BACK TO THE TOP, THEN PULL AGAIN . . .

. . . OR ROTATE THE PAPER SO YOU'RE BACK TO A MORE NATURAL MOVEMENT.

THE MOST IMPORTANT THING IS TO FEEL COMFORTABLE WHEN YOU DRAW. FIGURE OUT WHAT MOVEMENTS FEEL MOST COMFORTABLE, AND THEN TRY TO MAKE THEM HABITUAL.

KEEP THE PAPER STRAIGHT

BECAUSE OF THE WAY THE ARM ENTERS THE WORK AREA, MOVING AT THE WRIST AND FINGERS NATURALLY PRODUCES ANGLED LINES.

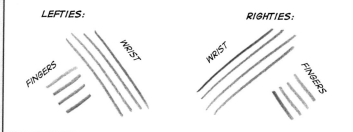

LEFTIES:

RIGHTIES:

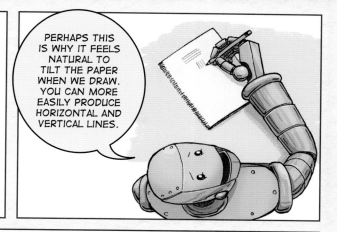

PERHAPS THIS IS WHY IT FEELS NATURAL TO TILT THE PAPER WHEN WE DRAW. YOU CAN MORE EASILY PRODUCE HORIZONTAL AND VERTICAL LINES.

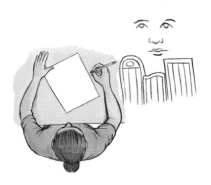

BUT TURNING YOUR PAPER CAN *SKEW* EVERYTHING. SOMETIMES IT'S OBVIOUS WHEN YOU DO IT; SOMETIMES IT RESULTS IN MISTAKES YOU CAN'T QUITE PINPOINT.

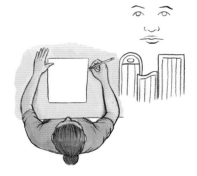

GET IN THE HABIT OF DRAWING WITH THE PAPER PERPENDICULAR TO YOUR SHOULDERS. IT MIGHT FEEL UNNATURAL AT FIRST, BUT THE STUFF WE TALKED ABOUT ON THE LAST PAGE WILL HELP IT FEEL LESS AWKWARD OVER TIME.

NO? IT FEELS TOO AWKWARD?

OKAY, AT LEAST DO IT WHEN IT REALLY MATTERS, LIKE WHEN YOU'RE LINING THINGS UP OR DRAWING VERTICAL STRUCTURES. THEN YOU CAN GO BACK TO THE MORE COMFORTABLE ANGLE FOR DETAILS. (I DO THIS SOMETIMES.)

CORRECT PENCIL GRIP

PENCIL GRIP PROBABLY WON'T MAKE YOUR DRAWINGS ANY BETTER, BUT IT WILL ENABLE YOU TO DRAW FOR LONGER PERIODS.

IT MATTERS!

SOME GRIPS CAN HURT YOUR HANDS OVER EXTENDED PERIODS OF DRAWING.

BUT THE CORRECT GRIP ALLOWS YOU TO DRAW FOR MILES.

YOU PROBABLY THINK YOU'RE TOO OLD TO SWITCH PENCIL GRIPS, BUT I DID IT WHEN I WAS FORTY, SO IT'S NEVER TOO LATE.

IT TOOK ME TWO YEARS AND TONS OF SHAKY LINES TO FINALLY FEEL COMFORTABLE WITH CORRECT PENCIL GRIP, BUT IT WAS TOTALLY WORTH IT. IF YOU HAVE TROUBLE, BUY SOME OF THOSE CUSHIONS MADE TO HELP LITTLE KIDS LEARN CORRECT PENCIL GRIP AND PUT THEM ON EVERYTHING.

OKAY, WE'VE GOT OUR SUPPLIES, WE KNOW WHICH ARM MUSCLES TO MOVE, HOW TO POSITION OUR PAPER AND SO FORTH. NOW LET'S GET INTO THE FUNDAMENTALS OF SKETCHING, LIKE SKETCHING THE OVERALL SHAPES FIRST, DRAWING THROUGH YOUR OBJECTS AND HOW TO SKETCH DECENT CIRCLES AND OVALS.

WHEN BEGINNERS START A DRAWING, THEY OFTEN GO RIGHT IN WITH HARD LINES, HOPING IT ALL TURNS OUT OKAY.

SOMETIMES IT WORKS, BUT WITHOUT EXPLORING OPTIONS, WHO KNOWS IF IT'S AS GOOD AS IT COULD BE. PLUS, ANY ADJUSTMENTS REQUIRE HEAVY ERASING AND REDRAWING.

IT'S MUCH EASIER TO GET THE BASIC IDEA DOWN WITH REALLY LIGHT LINES AND THEN REVISE IT USING DARKER ONES. YOU KNOW, *SKETCHING*.

SKETCHING ALLOWS YOU TO PEER INTO THE FUTURE AND DECIDE IF YOU LIKE IT OR NOT.

IN THE NEXT FOUR PAGES, WE'LL COVER A FEW OTHER WAYS YOU CAN USE SKETCHING TO IMPROVE ALMOST ANY DRAWING.

SKETCH OVERALL SHAPES FIRST

THOUGH THE INDIVIDUAL COMPONENTS MIGHT LOOK OKAY, THE SIZE AND POSITION WILL LIKELY BE OFF.

JUST TO BE CLEAR, DON'T DRAW LIKE THIS!

FOR EXAMPLE, IT'S TEMPTING TO DRAW SUNGLASSES BY DRAWING ONE COMPLETE HALF . . .

. . . AND THEN REPLICATING ALL THOSE CURVES, EXCEPT IN REVERSE.

INSTEAD, *START WITH THE OVERALL SHAPE.*

THEN, CARVE OUT THE MAJOR CONTOURS AND LARGEST INTERIOR SHAPES . . .

. . . AND SAVE THE FUN PART, THE DETAILS, FOR LAST (LIKE DESSERT).

STARTING WITH OVERALL SHAPES MEANS YOU IGNORE THE SMALLER CONTOURS, BUMPS, DIVOTS AND SO ON. GET THE OVERALL ANGLE AND LENGTH OF THE SHAPE FIRST, THEN GO BACK AND ADD THE DETAILS.

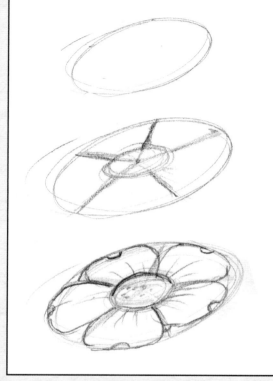

SOMETIMES, CONSIDERING YOUR SUBJECT A COMBINATION OF TWO OR MORE OVERLAPPING SHAPES CAN HELP YOU ESTABLISH THE STRUCTURE OF AN OBJECT, MAKING IT FEEL MORE THREE-DIMENSIONAL.

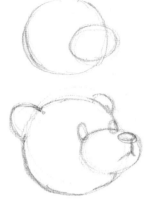

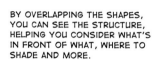

BY OVERLAPPING THE SHAPES, YOU CAN SEE THE STRUCTURE, HELPING YOU CONSIDER WHAT'S IN FRONT OF WHAT, WHERE TO SHADE AND MORE.

BUT EVEN IF THE FINAL SHAPES AREN'T VISIBLE IN THE FINAL PRODUCT, THE THREE-DIMENSIONALITY YOU GET FROM OVERLAPPING SHAPES REMAINS.

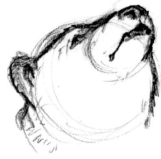

FOR PROTRUSIONS LIKE ARMS AND LEGS, YOU MIGHT FIRST USE LINES TO GET THE RIGHT POSITION, LENGTH AND ANGLE, AND THEN COME BACK WITH THE OVERALL SHAPE.

KEEP YOUR LINES LIGHT. YOU'LL END UP ERASING A LOT OF THEM.

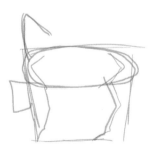

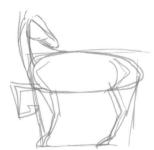

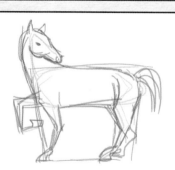

LIGHTLY SKETCHING THE GENERAL SHAPES FIRST IS POSSIBLY THE MOST IMPORTANT CONCEPT IN DRAWING. WE'LL SEE VARIATIONS ON THE CONCEPT IN EVERY CHAPTER OF THIS BOOK.

AFTER SKETCHING THE OVERALL SHAPE, YOU GET TO THE SECONDARY SHAPES AND INTERIOR DETAILS. FOR THESE, IT'S OFTEN USEFUL TO DRAW THROUGH OBJECTS AND START GROUPS OF DETAILS WITH THEIR GESTALT.

SKETCH THE GESTALT

GROUPS OF OBJECTS CAN IMPLY AN OVERALL SHAPE, KIND OF LIKE THE WAY A GROUP OF BEES MIGHT FORM A FIST IN A CARTOON, OR THE WAY THIS TEXT FORMS A CIRCLE. THE SHAPE OF SUCH AN ARRANGEMENT IS OFTEN REFERRED TO AS THE *GESTALT*.

LIGHTLY SKETCHING OUT THE GESTALT CAN OFTEN HELP LINE THINGS UP IN A DRAWING, AND IT'S USUALLY EASIER AND FASTER, TOO.

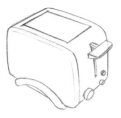
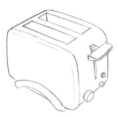

THE GESTALT OF THE TOASTER SLOTS IS A QUADRILATERAL.

SO, DRAW THAT SHAPE FIRST . . .

. . . THEN THE DETAILS.

THE GESTALT OF THE LEFT PIPS IS A QUADRILATERAL; THE TOP AND RIGHT ONES FORM CIGAR SHAPES.

SO DRAW THOSE SHAPES FIRST.

THE GESTALT OF THESE WINDOWS IS A GIANT RECTANGLE.

SO, DRAW THAT SHAPE FIRST . . .

. . . THEN THE GESTALT OF EACH ROW . . .

. . . AND THEN THE INDIVIDUAL WINDOWS.

DRAW THROUGH THE OBJECT

SKETCHING THROUGH SOMETHING YOU'VE ALREADY DRAWN CAN HELP ELEMENTS OF YOUR PICTURE LINE UP. ALTHOUGH YOU'LL HAVE MORE TO ERASE, GETTING THINGS RIGHT THE FIRST TIME WILL SAVE TIME IN THE END.

SKETCHING CIRCLES

THEY SAY IT'S IMPOSSIBLE TO DRAW A PERFECT CIRCLE, BUT THEY DON'T SAY IT'S IMPOSSIBLE TO *SKETCH* ONE.

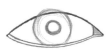 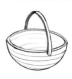

CIRCLES AND ELLIPSES ARE CRITICAL ELEMENTS IN A LOT OF DRAWINGS. LEARNING TO SKETCH THEM WELL CAN BE A BIG HELP.

CIRCLES AND ELLIPSES DON'T HAVE TO BE PERFECT TO BE USEFUL, BUT THEY DO NEED TO BE PRETTY GOOD. HERE'S HOW TO DO IT:

START BY SKETCHING THE WHOLE CIRCLE. IT'S OKAY IF IT'S LOPSIDED AT FIRST. YOU'LL FIX IT LATER. *DRAW REALLY, REALLY LIGHTLY!*

FOR LARGER CIRCLES, USE YOUR WHOLE ARM.

FOR CIRCLES SMALLER THAN 1" (2.5CM), USE YOUR FINGERS AND WRIST.

NOW USE YOUR FINGERS AND WRIST TO SKETCH LOTS AND LOTS OF SHORT ARCS TO ADD HERE, SUBTRACT HERE, ETC., UNTIL IT'S ALL EVEN.

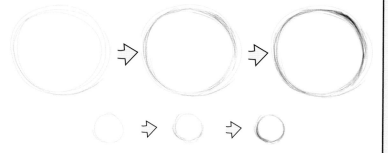

WHEN YOU FIX THE IMPERFECTIONS FOR CIRCLES (AND ELLIPSES), YOU'LL LIKELY CREATE NEW IMPERFECTIONS. IT MIGHT TAKE SEVERAL LINES TO FINALLY GET IT RIGHT, SO KEEP EVERYTHING LIGHT UNTIL THE VERY END.

UNLESS YOU'RE ENTERING A FREEHAND CIRCLE AND ELLIPSE DRAWING CONTEST, THERE'S NOTHING DISHONEST ABOUT USING A TEMPLATE.

WHEN DRAWING ELLIPSES, YOU FIRST NEED TO CONSIDER WHETHER IT'S TILTING. IF SO, START WITH THE *AXIS* TO GET THE CORRECT AMOUNT OF TILT.

NEXT, SKETCH THE WHOLE SHAPE REALLY, REALLY LIGHTLY.

TRY TO MAKE IT SYMMETRICAL IN BOTH DIRECTIONS.

WHOLE ARM

WRIST/ FINGERS

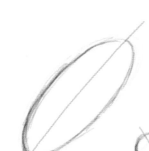

THEN, USE SMALLER ARCS TO REVISE THE SHAPE UNTIL IT'S EVEN AND SMOOTH.

KEEP IN MIND, ELLIPSES CURVE THE ENTIRE TIME. THIS MEANS NO PILL SHAPES AND NO POINTY FOOTBALLS.

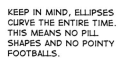

IF THEY LOOK ROUGH OR IT TAKES YOU A LONG TIME, THAT'S OKAY. CIRCLES AND ELLIPSES GET BETTER WITH PRACTICE!

STEP-BY-STEP: ROCKET

ELLIPSES, CIRCLES, GESTALT, OVERALL SHAPE, DRAWING THROUGH THE OBJECT, LIGHT LINES . . . LET'S PUT IT ALL INTO PRACTICE WITH A COUPLE OF STEP-BY-STEPS. REMEMBER TO PAY ATTENTION TO WHICH PART OF YOUR ARM YOU'RE USING, AND TRY TO AVOID PUSHING YOUR PENCIL. NOTE: I MADE MY LINES DARKER SO THEY WOULD SHOW UP IN THE DEMONSTRATION, BUT YOURS SHOULD BE LIGHT SINCE YOU'RE SKETCHING. USE A HARD LEAD PENCIL IF YOU HAVE ONE.

1 LIGHTLY SKETCH TWO LINES RADIATING OUT FROM A POINT. MAKE THEM PRETTY CLOSE TO EACH OTHER.

NEXT, ADD A THIRD LINE. MAKE SURE ALL THREE LINES ARE EVENLY SPACED.

THESE LINES ARE LONG, SO USE YOUR WHOLE ARM.

YOUR MIDDLE LINE SHOULD BE CENTERED. IF IT'S NOT, ADJUST IT.

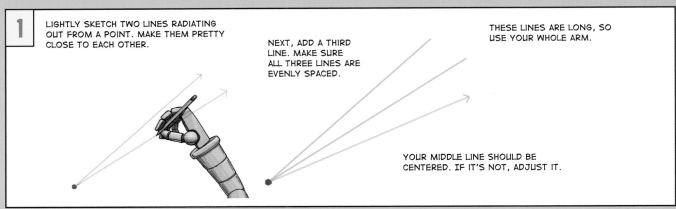

2 ADD TWO LIGHT LINES THAT ARE *PERPENDICULAR* TO THE MIDDLE LINE.

KEEP THESE LINES PERPENDICULAR TO THE MIDDLE LINE; OTHERWISE, YOUR ROCKET WILL LOOK LIKE A PENNE PASTA ROCKET.

3 USE THE PERPENDICULARS FROM STEP 2 TO SKETCH FAT ELLIPSES. THEY SHOULD ALMOST BE CIRCLES. IF THEY'RE NOT FAT ENOUGH, YOUR ROCKET WILL LOOK LIKE A DEODORANT STICK.

NEXT, ERASE THE INTERIOR LINES. YOU SHOULD BE LEFT WITH A CYLINDER.

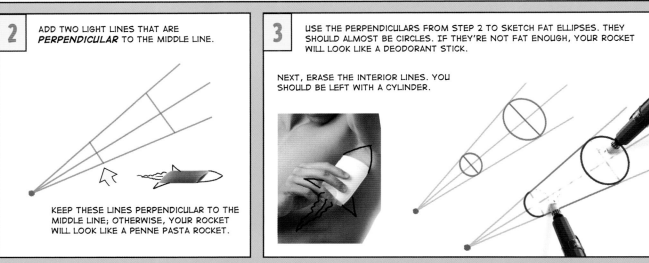

4 FOR THE NOSE CONE, PLACE A DOT IN FRONT OF THE ROCKET ALONG THE MIDDLE LINE. CONNECT THE DOT TO THE EDGES OF THE ELLIPSE WITH SOFTLY CURVING LINES.

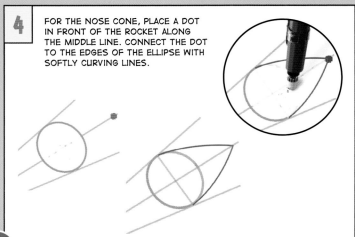

5 FOR THE FINS, DRAW HALF OF AN ELLIPSE. USE IT AS A GUIDELINE FOR TWO TRIANGLES. THE MIDDLE FIN CAN JUST BE A HEAVY LINE.

GO, ROCKET, GO!

THE EXHAUST SHOULD CONVERGE TO THE VANISHING POINT.

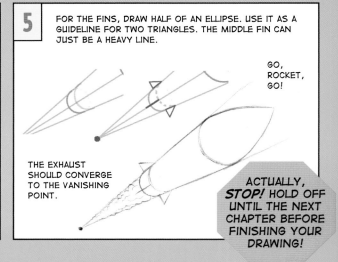

ACTUALLY, *STOP!* HOLD OFF UNTIL THE NEXT CHAPTER BEFORE FINISHING YOUR DRAWING!

STEP-BY-STEP: EYES

1 LIGHTLY SKETCH THE TOP OF THE EYE. IT'S NOT SYMMETRICAL, AND THE HIGHEST POINT IS USUALLY CLOSER TO THE NOSE.

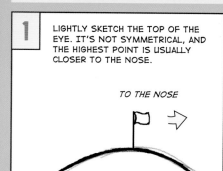

TO THE NOSE

2 DIVIDE THE BOTTOM INTO TWO LINES.

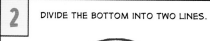

HORIZONTAL *CURVED*

OVERALL, THE BOTTOM SHOULD BE FLATTER THAN THE TOP.

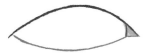

AT THIS POINT, IT KIND OF LOOKS LIKE A PENGUIN.

ADD A THIN LINE TO SHOW THE THICKNESS OF THE SKIN AT THE BOTTOM.

3 THE IRIS SHOULD OVERLAP THE EYE AT THE TOP . . .

BE SURE TO *SKETCH THROUGH* THE TOP OF THE EYE TO GET THE CIRCLE AS PERFECT AS YOU CAN!

. . . AND ALSO A TINY BIT BELOW.

THE IRIS SHOULD BE A *LITTLE* WIDER THAN EACH WHITE PART.

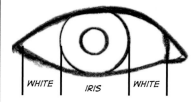

WHITE IRIS WHITE

THREE THINGS: THE IRIS OVERLAPS THE EYE SHAPE, IS A PERFECT CIRCLE, AND IS A LITTLE WIDER THAN EACH WHITE PART. IF YOU FIND IT IMPOSSIBLE TO MEET ALL THREE CONDITIONS, THE BOTTOM OF YOUR EYE SHAPE IS PROBABLY TOO *CURVED*.

DOESN'T OVERLAP

TOO WIDE

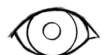
NOT A CIRCLE

4 THE PUPIL SHOULD BE ABOUT ONE-THIRD OF THE IRIS.

ONCE YOU HAVE THE PUPIL, ERASE THE LEFTOVER IRIS.

DRAW A REFLECTION OR TWO.

5 SOME FOLKS HAVE A CREASE ALONG THEIR EYELID, AND SOME DON'T. TO DRAW ONE, SIMPLY REDRAW THE TOP OF THE EYE, JUST A LITTLE HIGHER UP AND A LITTLE LARGER.

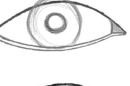

6 THE EYEBROW IS WIDER THAN THE EYE, LIKE AN UMBRELLA.

TO THE EAR

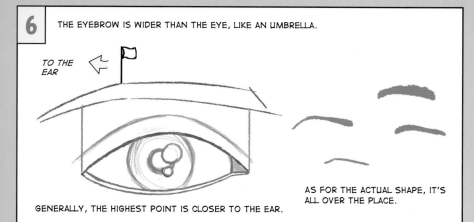

AS FOR THE ACTUAL SHAPE, IT'S ALL OVER THE PLACE.

GENERALLY, THE HIGHEST POINT IS CLOSER TO THE EAR.

IN THE NEXT CHAPTER, WE'LL GET TO THE TEXTURE AND SHADING.

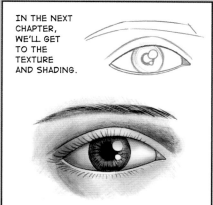

FINISHING A DRAWING

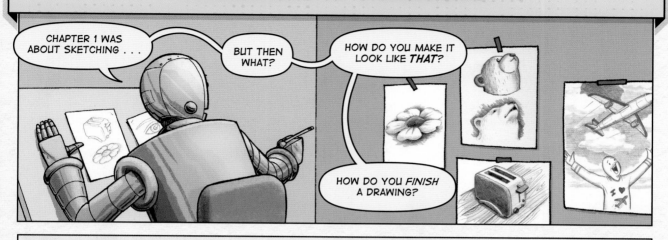

THAT'S WHAT THIS CHAPTER IS ABOUT. WE'LL BREAK THE PROCESS OF TURNING A SKETCH INTO A FINISHED DRAWING INTO THREE STEPS: CLEANING UP LINES, ADDING TEXTURE AND SHADING.

STEP 1: CLEANING UP LINES STEP 2: ADDING TEXTURE STEP 3: SHADING

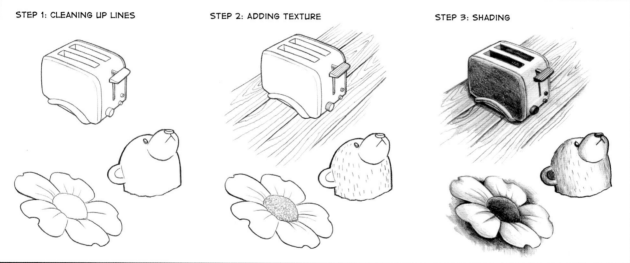

AS PROMISED, WE'LL ALSO COVER HOW TO APPLY LINE, TEXTURE AND SHADING TO YOUR SKETCHES FROM CHAPTER 1.

TO GO FROM SKETCH TO FINISHED DRAWING, YOUR FIRST MOVE IS TO DARKEN LINES YOU WANT TO KEEP AND ERASE THE EXTRA ONES.

IT'S AN ITERATIVE PROCESS; YOU'LL LIKELY END UP ERASING AND REDRAWING A FEW TIMES UNTIL YOU'RE SATISFIED.

DARKEN GOOD LINES.

ERASE BAD LINES (AND GOOD ONES ACCIDENTALLY).

FIX THE GOOD LINES YOU ACCIDENTALLY ERASED.

THEN KEEP ERASING AND FIXING UNTIL YOU'RE SATISFIED.

HOW HEAVY YOU DRAW THESE FINAL LINES IS UP TO YOU. PENCIL ARTISTS OFTEN LIKE TO LEAVE THE LINES LIGHT SO THEY DISAPPEAR AFTER THE IMAGE IS SHADED.

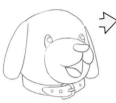
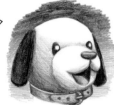

BUT IF YOU WANT TO KEEP YOUR LINES (I USUALLY DO), YOU'LL WANT TO MAKE THE LINES RELATIVELY *HEAVY*.

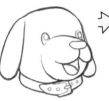
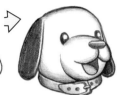

VARY THE LINE WEIGHT

THOUGH YOU GENERALLY WANT LINES THAT ARE DARK AND EASY TO READ, A DRAWING USUALLY LOOKS BEST IF YOU MIX UP THE LINE WEIGHTS.

A VARIETY OF LINE WEIGHTS IS MORE DYNAMIC AND FEELS MORE NATURAL THAN LINES THAT ARE ALL THE SAME DARKNESS AND THICKNESS.

JUST PRESSING HARDER OR LIGHTER WITH AN HB OR 4B PENCIL WILL CREATE MOST OF THE VARIETY YOU NEED.

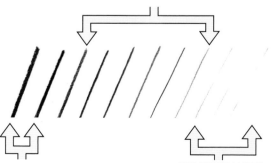

BUT YOU CAN EXTEND THE *HEAVY* END OF THE SPECTRUM BY GOING OVER THE LINES A COUPLE OF TIMES AND/OR USING A DULL PENCIL.

USE BROKEN LINES OR A SHARPENED HARD LEAD PENCIL FOR *EXTRA-LIGHT* LINES.

OF COURSE, YOU CAN'T JUST RANDOMLY MAKE SOME LINES THICK AND SOME LINES THIN AND EXPECT IT TO LOOK BETTER. THERE'S GENERALLY A LOGIC TO IT.

VARIED LINE WEIGHT CREATES EMPHASIS, AND WHEN USED CAREFULLY CAN CREATE CLARITY IN YOUR DRAWING.

THE OPPOSITE IS TRUE, TOO. EMPHASIZE THE WRONG LINES, AND YOUR IMAGE CAN LOOK WEIRD AND CONFUSING.

LINES DON'T ACTUALLY EXIST AROUND THINGS, OF COURSE. THEY ARE JUST SYMBOLS, TELLING THE VIEWER WHERE ONE THING ENDS AND ANOTHER BEGINS. IN OTHER WORDS, THEY'RE EDGES.

HEAVIER ———————————————————————→ LIGHTER

THE MORE IMPORTANT OR PRONOUNCED THE EDGE IS, THE HEAVIER THE LINE SHOULD BE.

OUTLINES = HEAVY

THE *MOST* IMPORTANT EDGE IS USUALLY THE OUTLINE SINCE IT *DEFINES THE ACTUAL OBJECT.* MAKE THIS LINE THE HEAVIEST.

I USUALLY GO BACK AND BEEF UP OUTLINES WITH A FEW EXTRA PASSES.

SOFT EDGES = LIGHT LINES

FOR SOFT EDGES, USE BROKEN LINES AND LIGHT PRESSURE TO GENTLY WHISPER "THERE'S AN EDGE SOMEWHERE AROUND HERE."

OTHERWISE YOU'LL END UP WITH UNCOMFORTABLE BEDS, CARS FROM THE 1970S AND ROBOT BREAD.

DISTANCE = HEAVY TO LIGHT

USE HEAVY LINES FOR CLOSE-UP OBJECTS AND LIGHTER LINES FOR DISTANT ONES.

LIGHTER LINES IN THE DISTANCE

OH—EXCEPT TEXTURE LINES. KEEP THEM THIN! BUT THERE'S LOTS MORE ABOUT THAT ON THE NEXT PAGE!

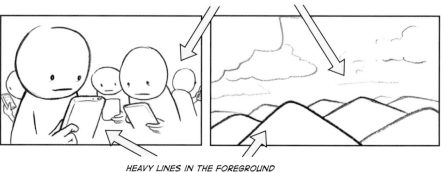

HEAVY LINES IN THE FOREGROUND

EVERYTHING ELSE

AS FOR ALL THE LINES IN BETWEEN, THEY'RE A JUDGEMENT CALL. JUST ASK YOURSELF "HOW WELL DEFINED SHOULD THE EDGE BE?"

OR, MORE SIMPLY, *"WHAT LOOKS BEST TO ME?"*

TEXTURE CAN GO A LONG WAY TOWARD MAKING A PICTURE MORE INTERESTING AND COMPELLING.

BUT THERE'S A THIN LINE BETWEEN TEXTURE TO ADD *INTEREST* . . .

. . . AND MAKING YOUR PICTURE MESSY. HERE ARE SOME TIPS:

EXTEND TEXTURE PAST THE EDGES

IN MOST CASES, EXTENDING TEXTURE OFF THE EDGES OF YOUR OBJECT MAKES IT LOOK MORE NATURAL.

SPEAKING OF EDGES, IT'S TEMPTING TO TRY TO CRAM TEXTURE LINES IN AT THE BORDER OF THE IMAGE, WHICH OFTEN LEADS TO DISTORTION.

INSTEAD, DRAW YOUR TEXTURE NATURALLY EVEN IF THAT MEANS EXTENDING IT OFF THE BORDER . . .

. . . AND ERASING THE EXTRA LINES LATER.

TEXTURE = LIGHT LINES

USE THIN LINES FOR TEXTURE; OTHERWISE, THE IMAGE CAN GET CONFUSING OR DISTRACTING.

THIN LINES ADD INTEREST AND DETAIL WITHOUT TAKING OVER.

THICK TEXTURE LINES OVERPOWER THE IMAGE.

IF YOU'RE JUST A THICK LINE KIND OF PERSON, THAT'S OKAY. DRAW YOUR TEXTURE LINES THICK, BUT KEEP YOUR OTHER LINES EVEN *THICKER*.

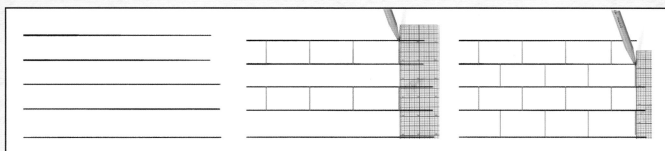

A LOT OF ARCHITECTURAL TEXTURES, LIKE BLOCK WALLS, SHINGLED ROOFS, TILES, ETC., HAVE STAGGERED LINES. IT'S EASIEST TO DRAW THE HORIZONTAL LINES FIRST, THEN SKIP EVERY OTHER ROW AS YOU DRAW THE VERTICAL LINES.

STEP-BY-STEP: WOOD GRAIN

1 DRAW A RECTANGLE AND A SLOPPY OVAL. THEY SHOULD LINE UP IN THE SAME DIRECTION

2 PLACE FIVE EVENLY AND CLOSELY SPACED DOTS ABOVE THE OVAL.

THEN PLACE ANOTHER FIVE DOTS IN A ROW IN FRONT OF THE OVAL. SPACE THESE DOTS FARTHER AND FARTHER APART. IT'S OKAY IF YOUR LAST DOT ENDS UP OFF THE BOARD.

3 CONNECT THE DOTS. CONTINUE THE PATTERN OFF THE BOARD AND ERASE IT LATER, OR JUST DRAW IN THE AIR.

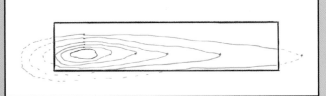

4 CONTINUE THE PATTERN TO FILL THE REST OF THE BOARD.

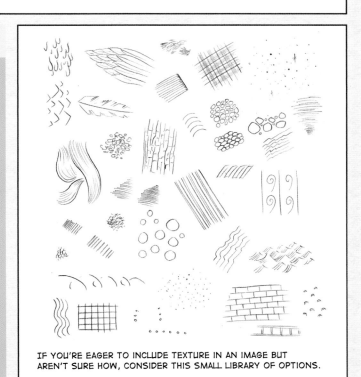

IF YOU'RE EAGER TO INCLUDE TEXTURE IN AN IMAGE BUT AREN'T SURE HOW, CONSIDER THIS SMALL LIBRARY OF OPTIONS.

5 REPEAT THE PROCESS WITH OTHER BOARDS, BUT SWITCH UP THE LOCATION OF THE OVAL IN STEP 1.

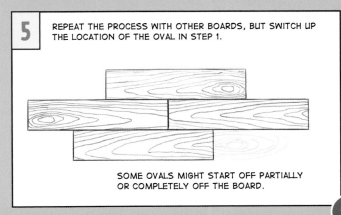

SOME OVALS MIGHT START OFF PARTIALLY OR COMPLETELY OFF THE BOARD.

LET'S CLEAN UP OUR LINES AND ADD TEXTURE TO OUR SKETCHES FROM CHAPTER 1.

1 FIRST, CLEAN UP YOUR SKETCH.

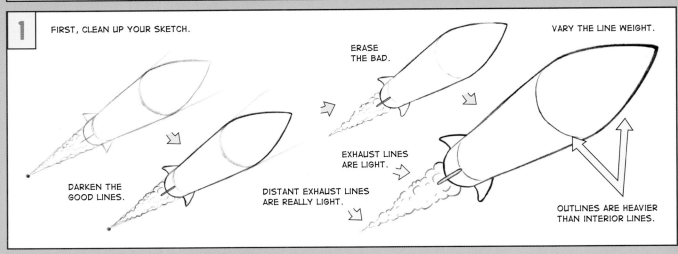

ERASE THE BAD.

VARY THE LINE WEIGHT.

DARKEN THE GOOD LINES.

EXHAUST LINES ARE LIGHT.

DISTANT EXHAUST LINES ARE REALLY LIGHT.

OUTLINES ARE HEAVIER THAN INTERIOR LINES.

2 TO ADD TEXTURE, DRAW A LIGHT GRID OF THE FOLLOWING LINES:

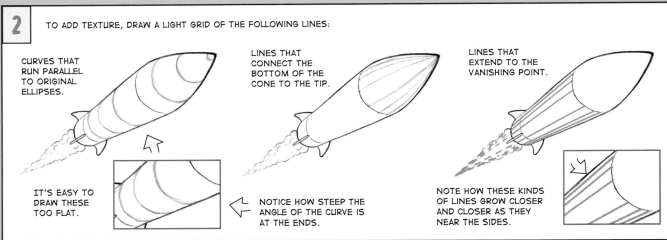

CURVES THAT RUN PARALLEL TO ORIGINAL ELLIPSES.

LINES THAT CONNECT THE BOTTOM OF THE CONE TO THE TIP.

LINES THAT EXTEND TO THE VANISHING POINT.

IT'S EASY TO DRAW THESE TOO FLAT.

NOTICE HOW STEEP THE ANGLE OF THE CURVE IS AT THE ENDS.

NOTE HOW THESE KINDS OF LINES GROW CLOSER AND CLOSER AS THEY NEAR THE SIDES.

FOR SMALLER PANELS, DRAW THE WHOLE CURVE AND THEN ERASE THE EXTRA.

OTHERWISE, IT MIGHT BE TOO CURVY AND LOOK LIKE A POCKET.

3 USE THE GRID YOU JUST MADE AS THE BASIS FOR YOUR TEXTURE AND DETAILS.

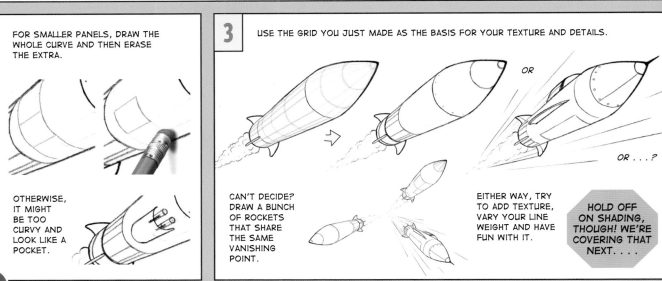

OR

OR . . . ?

CAN'T DECIDE? DRAW A BUNCH OF ROCKETS THAT SHARE THE SAME VANISHING POINT.

EITHER WAY, TRY TO ADD TEXTURE, VARY YOUR LINE WEIGHT AND HAVE FUN WITH IT.

HOLD OFF ON SHADING, THOUGH! WE'RE COVERING THAT NEXT. . . .

STEP-BY-STEP: EYE TEXTURE

1 FIRST, ERASE THE EXTRA SKETCH LINES AND DARKEN THE GOOD LINES.

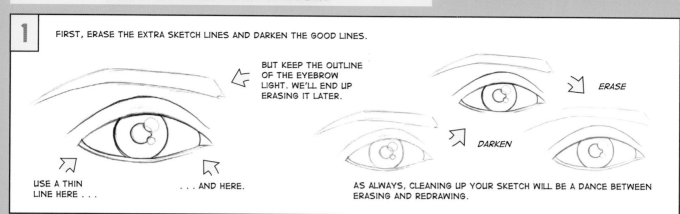

BUT KEEP THE OUTLINE OF THE EYEBROW LIGHT. WE'LL END UP ERASING IT LATER.

ERASE

DARKEN

USE A THIN LINE HERE . . .

. . . AND HERE.

AS ALWAYS, CLEANING UP YOUR SKETCH WILL BE A DANCE BETWEEN ERASING AND REDRAWING.

BECAUSE EYELASHES ARE A BUNCH OF FORESHORTENED CURLS THAT CONSTANTLY CHANGE DIRECTION, THEY CAN BE REALLY CHALLENGING! HERE'S WHAT TO DO.

2 LIGHTLY RADIATE LINES FROM THE MIDDLE OF THE EYE. THEY'RE JUST GUIDELINES. YOU'LL ERASE THEM LATER, SO KEEP THEM LIGHT.

3

MOST TOP EYELASHES CURVE UP, LIKE A SAUCER . . .

MOST BOTTOM EYELASHES CURVE DOWN, LIKE AN EYEBROW . . .

. . . EXCEPT UP TOP, WHERE THEY'RE SHORT AND STRAIGHT.

. . . EXCEPT HERE, WHERE THEY'RE SHORTER AND STRAIGHT.

4 FOLLOW THE PATTERN FOR THE OTHER EYELASHES.

THERE ARE FEWER EYELASHES NEAR THE INSIDE CORNER.

START EACH LINE AT THE EYELID AND FEATHER IT OUT AT THE END.

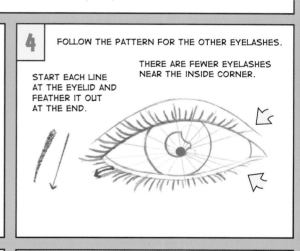

5 EYEBROW TEXTURE LINES SEEM TO CONVERGE AT A VANISHING POINT BETWEEN THE EYES . . .

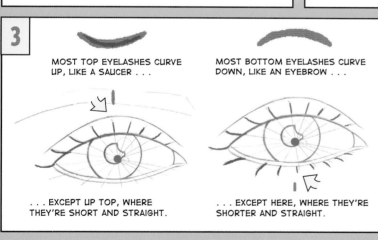

. . . BUT KEEP YOUR LINES LOOSE AND FEEL FREE TO VARY THE ANGLE AND CURVATURE A LITTLE.

WHEN YOU'RE DONE, YOU'LL NEED TO DO ANOTHER COUPLE OF ROUNDS OF REDRAWING AND ERASING, BUT DON'T WORRY ABOUT REALLY LIGHT MARKS. THEY'LL JUST BLEND IN WITH THE SHADING WE'LL DO IN A FEW PAGES.

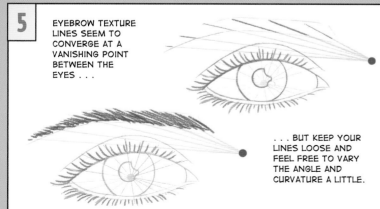

STEP 3: SHADING

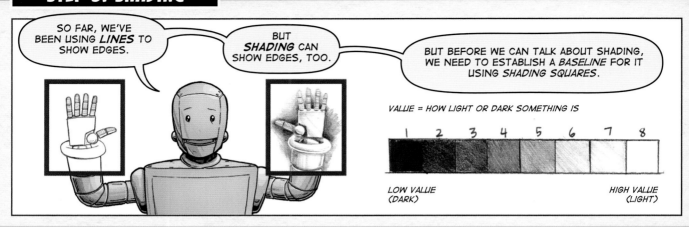

SO FAR, WE'VE BEEN USING *LINES* TO SHOW EDGES.

BUT *SHADING* CAN SHOW EDGES, TOO.

BUT BEFORE WE CAN TALK ABOUT SHADING, WE NEED TO ESTABLISH A *BASELINE* FOR IT USING *SHADING SQUARES*.

VALUE = HOW LIGHT OR DARK SOMETHING IS

1 2 3 4 5 6 7 8

LOW VALUE (DARK)

HIGH VALUE (LIGHT)

STEP-BY-STEP: SHADING SQUARES

MAKING A SET OF SHADING SQUARES CAN BE HELPFUL WHEN YOU'RE LEARNING THIS STUFF. GIVE IT A TRY.

1 DRAW AND NUMBER A ROW OF EIGHT SQUARES. SHADE THE FIRST ONE AS DARK AS YOU CAN. USE A SOFT LEAD PENCIL IF YOU HAVE ONE.

2 SHADE 4 AND 5 NEXT. SHOOT FOR MIDDLE VALUES, BUT IT'S OKAY IF YOU'RE OFF A LITTLE. YOU CAN ADJUST THEM LATER.

3 WORK YOUR WAY OUT FROM THE MIDDLE, GOING A LITTLE LIGHTER OR A LITTLE DARKER.

4 USING YOUR PENCIL AND ERASER, ADJUST THE VALUES UNTIL EACH ONE IS DISTINCT FROM ITS NEIGHBORS.

| USING THE FULL RANGE | NOW THAT WE'VE ESTABLISHED THE FULL RANGE OF VALUES, USE IT, AND USE ALL OF IT! |

SOME BEGINNING ARTISTS AVOID DARKER VALUES. AS A RESULT, THE DRAWING FEELS WASHED OUT.

VALUE RANGE = 6-8

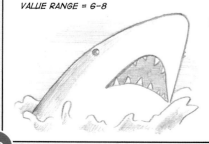

OTHERS MIGHT GO OVERBOARD AND SHADE *EVERYTHING*, LEAVING NO AREAS WITH 7S OR 8S. THIS CAN ALSO HAPPEN THROUGH ACCIDENTAL SMUDGING. EITHER WAY, THE FINAL IMAGE FEELS MUDDY.

VALUE RANGE = 1-6

SHADING WITH THE *FULL* RANGE OF VALUES, AND GOING BACK WITH YOUR ERASER TO BRING BACK THE 7S AND 8S, MAKES YOUR PICTURE CLEAR AND MORE DYNAMIC.

VALUE RANGE = 1-8

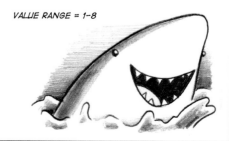

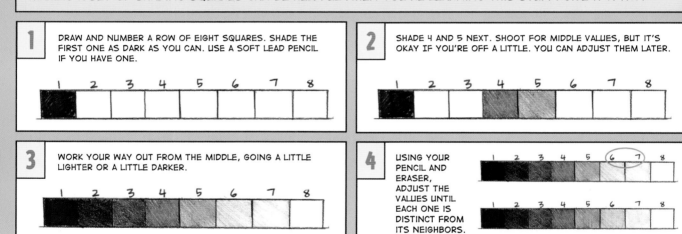

SHADE IN ONE DIRECTION AT A TIME

WHEN APPLYING ALL THESE VALUES, TRY TO MOVE YOUR PENCIL IN A PURPOSEFUL DIRECTION.

USUALLY THIS MEANS STICKING WITH ONE UNIFORM DIRECTION.

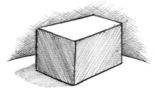

BUT NOT ALWAYS.

EITHER WAY, TRY TO AVOID RANDOM CHANGES IN DIRECTION, OR YOUR SHADING WILL LOOK MESSY—AND USUALLY NOT IN A COOL WAY.

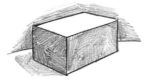

FOR SMALLER AREAS, YOU CAN AVOID THIS ISSUE AND USE LITTLE CIRCLES.

BLENDERS

YOU MAY WANT TO USE A BLENDING STUMP (OR PAPER TOWEL, FINGER, ETC.) TO SMOOTH OUT YOUR SHADING.

BUT IT'S NOT MAGIC. IF THE PENCIL LINES ARE TOO LOOSE, THEY SIMPLY WON'T BLEND.

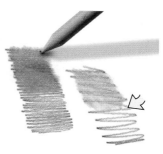

ALSO, BE WARNED: SMUDGING MAKES HIGHER VALUES A *LOT* DARKER!

FOR VALUES OF 6 OR 7, PUT AWAY YOUR PENCIL. A DIRTY BLENDING STICK OR A FINGER IS ALL YOU NEED.

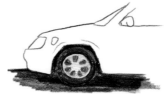

SAVE REALLY DARK VALUES FOR LAST

EVEN THOUGH YOU SHOULD DEFINITELY *INCLUDE* 1S AND 2S IN YOUR PICTURE, YOU MIGHT NOT WANT TO *START* WITH THEM. FOR EXAMPLE:

UH-OH, THE TIRE! IT'S SUPPOSED TO BE DARKER THAN THE ROAD!

ROADS ARE BLACK, RIGHT? SO YOU SHADE THE ROAD WITH A 1.

WAIT! WHAT ABOUT *SHADING* THE TIRE? AND WHAT ABOUT THE *WHEEL WELL*?

OKAY, ERASE THE ROAD SO IT'S A 2 AND MAKE THE TIRES A 1.

ARGH! OKAY, ERASE THE ROAD AGAIN, AND THE TIRE. MAKE THE ROAD A 3, THE TIRE A 2, AND THE WHEEL WELL AND SHADOW A 1.

IN THIS SCENARIO, IT WOULD HAVE BEEN MUCH EASIER TO SHADE EVERYTHING INITIALLY WITH A 3, SO THAT WHEN YOU NEED TO GO DARKER, YOU CAN.

OKAY, WE KNOW TO USE THE FULL RANGE OF VALUES, BUT THAT STILL DOESN'T TELL US *WHICH* VALUE TO USE FOR A GIVEN SURFACE.

THE COLOR OF THE OBJECT IS DEFINITELY A FACTOR, OF COURSE.

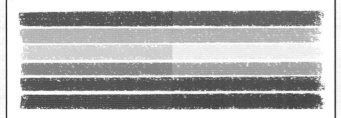

SOME HUES SIMPLY TRANSLATE TO LOWER VALUES, SOME TO HIGHER VALUES.

SO, WHEN SHADING A SURFACE, THINK ABOUT ITS COLOR AND WHAT VALUE THAT WOULD TRANSLATE TO ON OUR SHADING SQUARES.

BUT AN EVEN BIGGER FACTOR IS *HOW MUCH A SURFACE IS FACING THE LIGHT SOURCE.*

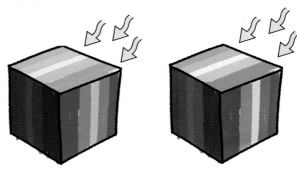

IN FACT, DARKER HUES *FACING* THE LIGHT SOURCE OFTEN HAVE HIGHER VALUES THAN LIGHTER COLORS *FACING AWAY* FROM THE LIGHT SOURCE.

ASK YOURSELF, "HOW MUCH IS THIS SURFACE FACING THE LIGHT?" (IF THERE IS NO LIGHT SOURCE, MAKE ONE UP! I USUALLY PUT MINE HIGH UP AND BEHIND THE VIEWER'S RIGHT SHOULDER.)

FOR DISTANT LIGHT SOURCES OR LIGHT SOURCES BEHIND THE VIEWER, ALL OBJECTS GENERALLY FOLLOW THE SAME PATTERN.

FOR EXAMPLE, IN THIS SCENARIO EACH OBJECT'S RIGHT SIDE WILL BE LIGHTER THAN ITS LEFT SIDE.

BUT FOR LOCAL LIGHT SOURCES, EACH OBJECT MUST BE EVALUATED SEPARATELY.

BOTH SIDES SHADED EQUALLY.

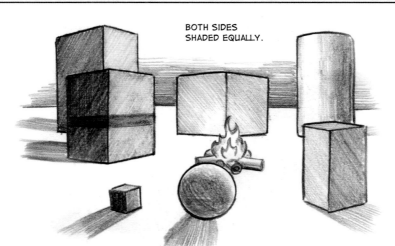

LEFT SIDE DARKER THAN RIGHT SIDE.

RIGHT SIDE DARKER THAN THE LEFT.

(WE'LL COVER SHADOWS ON THE GROUND IN CHAPTER 6.)

OBJECTS WITH FLAT SURFACES, LIKE BOXES AND PYRAMIDS, SHOULD BE SHADED WITH UNIFORM, EVEN VALUES, SEPARATED BY A CLEAN EDGE.

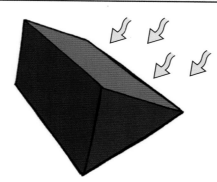

BUT THE SURFACES OF ROUNDED FORMS, LIKE CYLINDERS AND SPHERES, SHOULD BE SHADED WITH A GRADUAL CHANGE IN VALUE.

IN CHAPTER 5, WE'LL GET INTO THE SPECIFICS OF SHADING ROUNDED FORMS BASED ON THEIR RELATIVE POSITIONS TO LIGHT SOURCES.

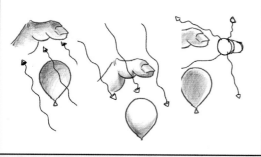

BUT FOR NOW, SIMPLY MAKING ALL THE OUTSIDE EDGES DARKER AND FADING THEM IN GRADUALLY CAN DO THE TRICK. IT MIGHT NOT BE TECHNICALLY CORRECT, BUT IT'S ENOUGH TO SAY:

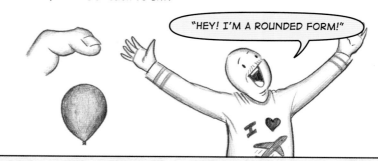

"HEY! I'M A ROUNDED FORM!"

RECOGNIZING THIS CONCEPT HELPS YOU DETERMINE WHICH FORM YOU'RE COMMUNICATING. FOR EXAMPLE, LET'S SAY YOU DREW THESE TWO SHAPES:

 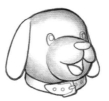

IF YOU WANT THEM TO APPEAR ROUNDED . . .

IF YOU WANT THEM TO APPEAR FLAT . . .

. . . SHADE WITH A GRADUAL CHANGE IN VALUE.

. . . SHADE THEM WITH NO CHANGE IN VALUE.

FOR OUR PUPPY, WE CAN SHADE THE EDGES OF THE HEAD WITH A GRADUAL CHANGE IN VALUE TO SUGGEST ROUNDNESS.

BUT LEAVE THE EARS WITH AN EVEN VALUE TO SUGGEST A FLAT SURFACE.

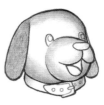

BUT SOMETIMES . . .

IN RARE SITUATIONS WITH REALLY CLOSE LIGHT SOURCES, BOTH FLAT AND CURVED SURFACES WILL PRESENT A GRADUAL CHANGE IN VALUE.

THIS IS THE EXCEPTION TO THE RULE. GENERALLY, OBJECTS ARE FAR ENOUGH FROM THE LIGHT SOURCE THAT YOU STICK WITH ALL THAT STUFF WE JUST COVERED.

WE KNOW THAT COLORS TRANSLATE TO DARK OR LIGHT VALUES. SO IF WE ARE SHADING THIS DOG, WE KNOW TO MAKE ITS PINK TONGUE A MEDIUM VALUE, AND ITS EYES AND NOSE A DARK VALUE.

AND YOU MIGHT WANT TO SHADE THE EDGES A LITTLE TO IMPLY A ROUNDED FORM.

BUT HOW DO YOU DECIDE WHAT VALUES TO USE FOR THE REST?

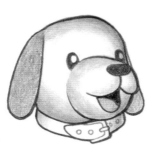

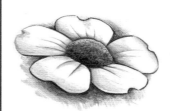

IN GENERAL, YOU SHOULD CHOOSE VALUES THAT CREATE CLARITY . . .

. . . OTHERWISE, THE DRAWING CAN BE DIFFICULT TO READ.

WITH LINE IT'S EASY. WANT MORE CLARITY? JUST MAKE YOUR OUTLINES DARKER.

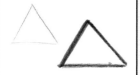

BUT WITH SHADING, MAKING AN OBJECT DARKER IS ONLY HALF OF IT. YOU'VE ALSO GOT TO MAKE THE AREA *NEXT* TO IT *LIGHTER*.

HIGH CONTRAST

LOW CONTRAST

SO, YEAH, *SOME* OF YOUR VALUE DECISIONS ARE MADE FOR YOU, BUT THE OTHER VALUES ARE COMPLETELY YOUR DECISION. YOUR GUIDING LIGHT AS YOU DECIDE SHOULD BE *CONTRAST*.

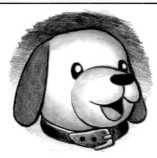

BY PLACING DARK NEXT TO LIGHT, YOU CAN BRING A PICTURE TO LIFE.

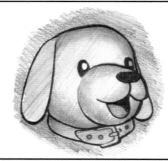

BUT DARK NEXT TO DARK AND LIGHT NEXT TO LIGHT LEAVES A DRAWING FLAT, UNDERWHELMING AND DIFFICULT TO READ.

THOUGH CREATING CONTRAST IS GENERALLY JUST PUTTING DARK VALUES NEXT TO LIGHT ONES, IT MIGHT NOT BE OBVIOUS HOW TO MAKE THAT HAPPEN. SOMETIMES, YOU'LL NEED TO FUDGE IT WITH A GRADIENT.

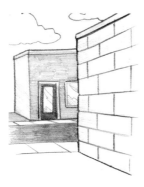

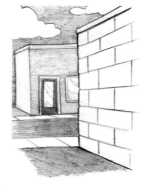

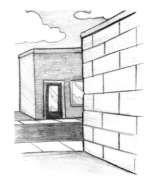

IF I KEEP THE SKY AND THE GROUND LIGHT, THERE'S NO CONTRAST WITH THE CLOUDS OR THE SIDEWALK.

BUT IF I SHADE THEM DARK, IT KIND OF LOOKS LIKE IT'S NIGHT AND THE GROUND IS ASPHALT. BUT I DON'T WANT THAT!

SOUNDS LIKE A JOB FOR A GRADIENT. THOUGH IT SUGGESTS A ROUNDED FORM, THE CLARITY OF THE IMAGE IS WORTH IT.

BOTH CONTRAST AND LINE CAN DEFINE AN EDGE, BUT MAKE SURE THEY'RE DEFINING IT THE SAME WAY!

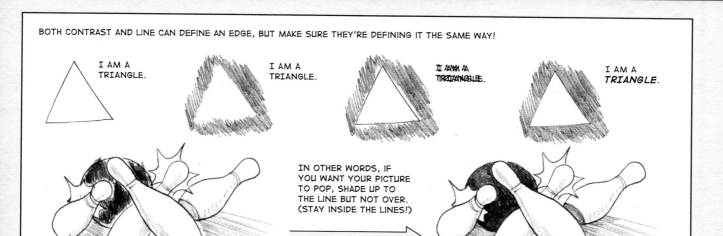

I AM A TRIANGLE.

I AM A TRIANGLE.

I AM A TRIANGLE.

I AM A *TRIANGLE.*

IN OTHER WORDS, IF YOU WANT YOUR PICTURE TO POP, SHADE UP TO THE LINE BUT NOT OVER. (STAY INSIDE THE LINES!)

TEXTURE CAN CREATE CONTRAST . . . AND IT CAN TAKE IT AWAY.

DEPENDING ON THE THICKNESS AND NUMBER OF LINES, TEXTURE CAN HAVE VALUE, JUST LIKE SHADING.

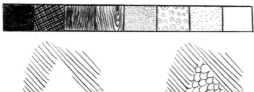

IN FACT, TEXTURE CAN CREATE ENOUGH CONTRAST TO DEFINE EDGES ON ITS OWN.

BUT TWO SIMILAR VALUES OFFER LITTLE CONTRAST.

GENERALLY, AVOID PUTTING TEXTURE NEXT TO AN AREA THAT HAS A SIMILAR VALUE.

LIGHT OR MEDIUM VALUE TEXTURE NEXT TO WHITE = OKAY

DARK TEXTURE NEXT TO LIGHT VALUE = OKAY

MEDIUM TEXTURE NEXT TO MEDIUM VALUE = POOR SEPARATION OF EDGES

THERE ARE ALSO SITUATIONS WHEN YOU DON'T WANT CLARITY. IN THESE INSTANCES, TRY THINNER LINES AND/OR LOW CONTRAST.

REFLECTIONS

STEAM, SMOKE, HAZE, FOG, ETC.

LOW-CONTRAST BACKGROUND VS. HIGH-CONTRAST FOREGROUND

AND MORE!

SHADOWS AND HIGHLIGHTS

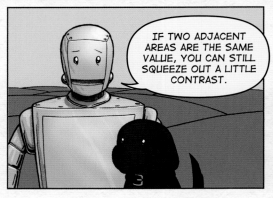

IF TWO ADJACENT AREAS ARE THE SAME VALUE, YOU CAN STILL SQUEEZE OUT A LITTLE CONTRAST.

JUST SHADE WHAT'S IN THE BACK.

AND HIGHLIGHT WHAT'S IN FRONT.

IN OTHER WORDS, MAKE ONE SIDE OF THE EDGE A LITTLE DARKER AND THE OTHER SIDE A LITTLE LIGHTER.

THE EFFECT IS SUPPOSED TO BE SUBTLE, SO FADE YOUR SHADOWS AND HIGHLIGHTS OUT AS YOU GET AWAY FROM THE EDGE.

FOR LIGHTER VALUES, USE SUBTLE SHADING AND FADE IT OUT. BE CAREFUL NOT TO OVERDO IT, OR YOU MIGHT CHANGE THE MEANING OF THE PICTURE.

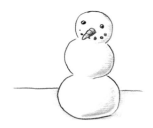

LIGHT SHADING = SNOWMAN ON SNOW *TOO MUCH = SNOWMAN ON DIRT*

FOR DARKER VALUES YOU CAN BE A BIT MORE HEAVY-HANDED.

STEP-BY-STEP: CRACK BEVEL

YOU CAN ALSO PLACE A SHADOW NEXT TO A HIGHLIGHT TO CREATE A BEVELED EDGE ALONG ANY CRACK OR SEAM. JUST SHADE ON ONE SIDE OF THE LINE AND ERASE ON THE OTHER.

1 DRAW A CRACK WITH A HEAVY LINE. SHADE THE ENTIRE AREA WITH A MEDIUM VALUE.

2 SHADE ABOVE THE LINE.

3 USING THE SMALLEST ERASER YOU HAVE, ERASE BELOW THE LINE.

4 AND MAYBE ADD A LITTLE BIT OF EXTRA SHADING BELOW THE HIGHLIGHT TO MAKE IT POP.

STEP-BY-STEP: BRICK BEVEL

A SIMILAR TECHNIQUE CAN BE USED FOR BRICKS, TILES, PANELS, ETC.

1 DRAW A ROW OF BLOCKS WITH EVEN HORIZONTAL LINES AND TWO SETS OF VERTICAL LINES. SHADE THE WHOLE THING A MEDIUM VALUE, ANYWHERE BETWEEN 3 AND 6.

HOLD YOUR PENCIL FLAT TO COVER GROUND MORE QUICKLY.

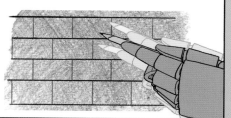

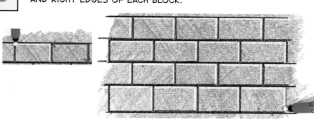

2 SHADE THE LEFT AND BOTTOM EDGES OF EACH BLOCK.

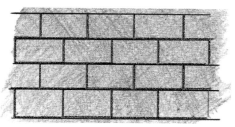

3 USE THE SMALLEST ERASER YOU HAVE TO LIGHTEN THE TOP AND RIGHT EDGES OF EACH BLOCK.

AS YOU MIGHT IMAGINE, THE EDGES YOU SHADE AND THE ONES YOU HIGHLIGHT DEPEND ON THE DIRECTION OF THE LIGHT SOURCE.

IF I SHADED THE TOP AND RIGHT AND HIGHLIGHTED THE BOTTOM AND LEFT, THE LIGHT WOULD APPEAR TO BE COMING FROM THE OPPOSITE DIRECTION.

LOOK FOR OPPORTUNITIES TO CREATE BEVELS IN YOUR DRAWINGS, ESPECIALLY WHEN TWO ADJACENT SURFACES ARE SEPARATED BY A CRACK OR SMALL GAP.

NOW LET'S PRACTICE ALL THAT SHADING STUFF WITH OUR EYE AND ROCKET. I'LL PLOP DOWN OUR SHADING SQUARES TO MAKE SURE WE'RE ON THE SAME PAGE.

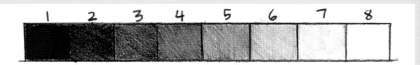

1

THE REFLECTION OF LIGHT IS WHAT BRINGS THE EYE TO LIFE. MAKE SURE YOURS ARE AT LEAST AS BIG AS MINE!

 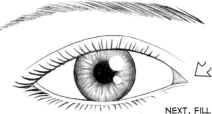

USE THE FULL RANGE OF VALUES AND SHADE IN TIGHT SWIRLS SINCE IT'S A SMALL AREA.

NEXT, FILL IN THIS AREA WITH A 6.

2

WHETHER YOU GO WITH LIGHT OR DARK SKIN, YOU'LL NEED TO SHADE THE SKIN AT LEAST A LITTLE.

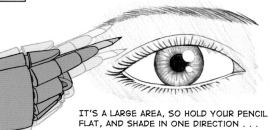 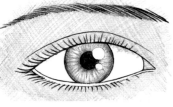 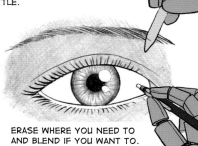

IT'S A LARGE AREA, SO HOLD YOUR PENCIL FLAT, AND SHADE IN ONE DIRECTION . . .

. . . AND THEN IN ANOTHER DIRECTION.

ERASE WHERE YOU NEED TO AND BLEND IF YOU WANT TO.

3

TO CREATE DEPTH, FIRST IDENTIFY WHICH SURFACES FACE TOWARDS THE LIGHT AND WHICH FACE AWAY.

BASED ON OUR REFLECTIONS IN STEP 1, THE LIGHT IS COMING FROM ABOVE AND TO THE RIGHT. SO OUR SHADING WILL LOOK LIKE THIS (BUT SMOOTHER):

LET'S BREAK IT DOWN INTO ZONES. SHADE WITH A PENCIL FOR LOW VALUES, AND USE YOUR ERASER FOR HIGH VALUES.

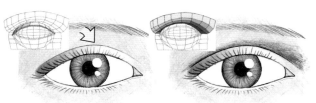

WHEN HIGHLIGHTING WITH YOUR ERASER, YOU'LL INEVITABLY ERASE UNINTENDED STUFF. FIX IT LATER AND REMEMBER THAT'S JUST PART OF THE PROCESS.

THE THICKNESS OF THE BOTTOM EYELID FACES UP, SO ERASE TO KEEP IT LIGHT.

THE TOP EYELID AND EYELASHES WILL CAST A SHADOW OVER THE TOP OF THE EYEBALL; EXTEND THIS SHADOW OVER THE WHITE AREAS LIGHTLY AND DARKER OVER THE IRIS.

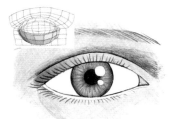 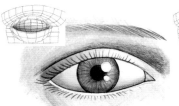 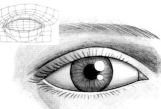

TO TAKE YOUR EYE DRAWING TO THE NEXT LEVEL, FIND BLACK-AND-WHITE PHOTOS OF EYES AND STUDY THEM CLOSELY.

STEP-BY-STEP: SHADING AT ONE ANGLE

1 AGAIN, SHADE LARGE AREAS WITH YOUR PENCIL HELD FLAT. MOVE IN ONE DIRECTION, THEN ANOTHER. ERASE YOUR ENCROACHMENTS AND BLEND IF YOU WANT.

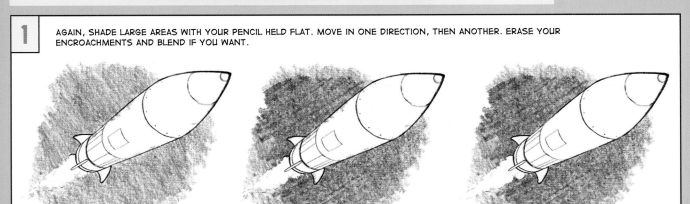

2

I'M CHOOSING THESE VALUES TO MAKE THE NOSE CONE AND FINS CONTRAST THE FUSELAGE.

IT DOESN'T CONTRAST THE SPACE AROUND IT WELL IN ALL PLACES, BUT I'LL FIX THAT SOON.

SHADE THE ROUNDED EDGES WITH A GRADUAL CHANGE.

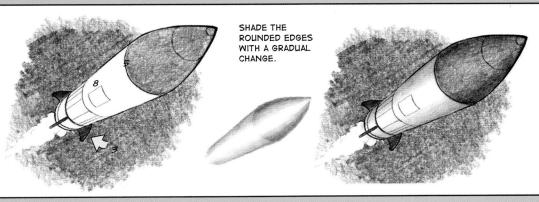

3 HIGHLIGHT THE EDGE OF THE ROCKET.

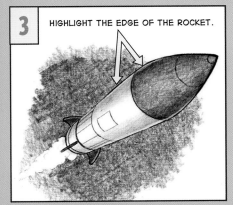

4 DARKEN THE OUTER SPACE RIGHT NEXT TO THE ROCKET.

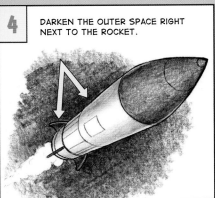

5 GO BACK AND FORTH, SHADING AND HIGHLIGHTING UNTIL EVERYTHING POPS.

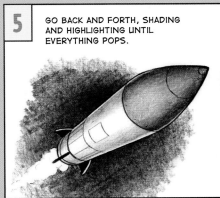

6

FIND ANY PANELS OR INTERIOR EDGES THAT COULD USE A SHADOW/HIGHLIGHT COMBO TO CREATE A BEVEL.

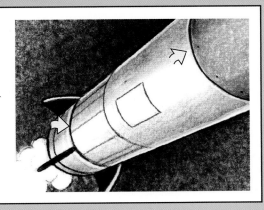

7 FOR THE EXHAUST, IMAGINE A BUNCH OF SPHERES. SHADE THEIR OUTER EDGES.

LET THE CONTRAST FADE OFF AS THE EXHAUST RECEDES INTO THE DISTANCE.

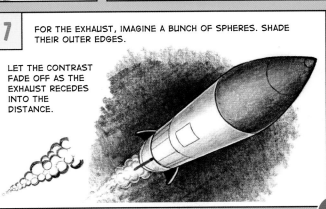

DRAWING FROM OBSERVATION

IN THIS CHAPTER, YOU'LL FOLLOW STEP-BY-STEPS FOR ALL KINDS OF EVERYDAY SUBJECTS.

PLUS, IN THE SECOND HALF OF THIS BOOK, YOU'LL LEARN THE BASIC PRINCIPLES OF DRAWING PEOPLE, BOXES, CYLINDERS, SPHERES AND CONES. ADD ALL THAT UP AND YOU CAN DRAW ALMOST ANYTHING FROM YOUR IMAGINATION.

DINOSAURS HUMMINGBIRDS HAPPY LUCKY CATS CORAL HAIRBRUSHES BLIMPS DARTH VADER FORKS, KNIVES AND SPOONS EYEPATCHES PALM FRONDS CORVETTES BANANAS FINGERNAILS LAMPS HORSES OWLS CREAM LOGOS HANDS WHEN THE FINGER POINTE TOWARDS YOU BROCCOLI FR WRISTWATCHES AIRPLANES CUPCAKE FR POODLES STAR FRUIT TACOS LIKE, REAL HEARTS BA FROM SEINFELD ON FOOTBALL HELMETS T PINEAPPLES H THE SPHYNX NICORNS SHAVING COUNTRIES SHIRT ORCHIDS BEARS

WELL, EXCEPT THIS STUFF.

UNLESS YOU KNOW THE ANATOMY OF EVERY ANIMAL, THE SCHEMATICS OF EVERY AUTOMOBILE, THE CUT OF EVERY JIB, ETC., YOU'LL NEED TO SUPPLEMENT YOUR CORE SKILLS BY DRAWING FROM *OBSERVATION*, EITHER FROM LIFE OR FROM PICTURES. THAT'S WHAT *THIS* CHAPTER IS ALL ABOUT.

FIRST, WE'LL LEARN HOW TO UNSEE COMPLEX FORMS . . .

. . . AND SEE FLAT SHAPES INSTEAD.

THEN WE'LL LOOK AT A NUMBER OF TECHNIQUES LIKE USING NEGATIVE SPACE, PLUMB LINES AND DRAWING ANGLES TO HELP YOU DRAW THOSE SHAPES.

THEN WE'LL USE STEP-BY-STEPS TO PRACTICE TWO SPECIFIC PROCESSES YOU CAN USE TO FAITHFULLY COPY AN EXISTING IMAGE.

METHOD 1: STRAIGHT LINES FIRST

METHOD 2: GRID DRAWING

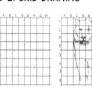

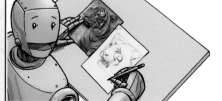

FINALLY, WE'LL END WITH PRACTICAL TIPS FOR DRAWING FROM DIRECT OBSERVATION, SUCH AS WITH STILL LIFES.

FORESHORTENING	TO DRAW WHAT YOU SEE, ONE MUST FIRST UNDERSTAND THE CONCEPT OF *FORESHORTENING*.

WHEN A 3-D FORM IS POINTED TOWARD OR AWAY FROM YOU, IT APPEARS SQUISHED. THIS IS CALLED *FORESHORTENING*, AND IT'S WHY WORDS AND SYMBOLS ON THE ROAD ARE PAINTED ALL STRETCHED OUT LIKE THIS:

SO THAT, FROM YOUR CAR, IT'S EASY TO READ, LIKE THIS:

IN THIS CASE, THE FORESHORTENED VERSION LOOKS NORMAL, BUT THAT'S USUALLY NOT THE CASE.

MOST OF THE TIME, FORESHORTENING MAKES THINGS LOOK *DISTORTED*.

FORESHORTENED SQUARES AND CIRCLES LOOK LIKE TRAPEZOIDS AND ELLIPSES.

FORESHORTENED FINGERS AND SHOES TAKE ON THE SHAPES OF BEANS AND GUM-DROPS.

NOW LET'S SAY YOU WANT TO DRAW A SPOON.

NO PROBLEM. JUST USE SPOON SHAPES: A LOPSIDED OVAL AND A LONG TEARDROP.

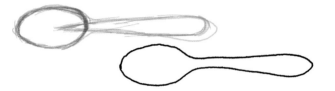

EASY RIGHT? THE SHAPES YOU USE TO DRAW A SPOON ARE PRETTY INTUITIVE. THEY MATCH WHAT WE WOULD USE AS A SYMBOL FOR A SPOON.

BUT . . . IF YOU TRY TO DRAW A SPOON THAT'S POINTING TOWARD YOU, IT'S ENTIRELY DIFFERENT. THE FORESHORTENING MAKES IT VERY UNSPOON-LIKE, AND *THAT* MAKES IT DIFFICULT TO DRAW.

BUT IT'S ALL IN YOUR HEAD. FOR EXAMPLE, YOU PROBABLY WOULDN'T SAY THIS DOLPHIN FIN OR CARTOONY SAILBOAT ARE HARD TO DRAW, *EVEN THOUGH THEY'RE THE SAME SHAPE AS THE SPOON.*

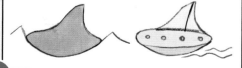

TO DRAW THIS SPOON, THEN, YOU MUST *UN-SEE* THE SPOON. DRAW THE *ACTUAL SHAPE* PRESENTED TO YOU INSTEAD.

IF IT HELPS, SQUINT YOUR EYES AND PICTURE THE SAILBOAT.

THEN DRAW A PAIR OF MONSTERS EATING THE BOAT.

ADD A PAIR OF 1970S JEAN SHORTS AND A THIRD MONSTER . . .

. . . AND AN UPSIDE-DOWN SNOWBOARD.

THERE IS NO SPOON.

FORM VS. SHAPE

TO PUT IT MORE INTELLECTUALLY, IT COMES DOWN TO FORM VS. SHAPE. *FORM* IS THREE-DIMENSIONAL, LIKE A SPHERE OR A BOX. *SHAPE* IS A 2-D CONCEPT, LIKE A CIRCLE OR A RECTANGLE. THE FORM IS WHAT THE OBJECT *IS*, BUT THE SHAPE IS WHAT WE USE TO *DRAW* IT.

SOMETIMES, THE FORM OF THE OBJECT AND THE SHAPES WE USE TO DRAW IT KIND OF MATCH UP.

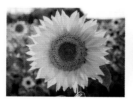

OTHER TIMES, ESPECIALLY WHEN AN OBJECT IS FORESHORTENED, THE FORM OF THE OBJECT AND THE SHAPE WE SHOULD USE TO DRAW IT DEFY INTUITION.

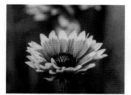

THE CHALLENGE, THEN, IS TO DISREGARD DIFFICULT-TO-DRAW FORESHORTENED THREE-DIMENSIONAL FORMS, AND INSTEAD, SEE EASY-TO-DRAW TWO-DIMENSIONAL *SHAPES*. *DON'T SEE THE FORM, SEE THE SHAPE.*

DON'T SEE A TRAFFIC CONE.

DON'T SEE A BENCH.

DON'T SEE A LEAF.

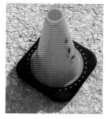

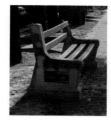

SEE A GRAVY BOAT . . .

SEE A TILTED TRIANGLE AND ITS REFLECTION . . .

SEE A CARTOON YORKIE . . .

. . . AND AN EMOJI WITH A DUNCE HAT.

. . . AND SOME TRIANGLES.

. . . AND A UNISLUG.

TRY IT OUT!

SKETCH EACH OF THESE MYSTERY SHAPES AS BEST AS YOU CAN. *DON'T TURN THE PAGE UNTIL YOU DO.*

AS ALWAYS, LIGHTLY SKETCH THE OVERALL SHAPE FIRST. . .

. . . AND THEN ADD THE CONTOURS, BUMPS AND DENTS.

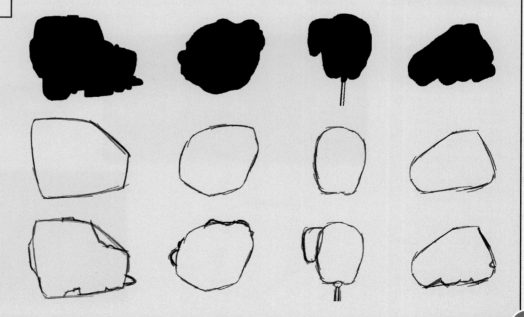

OKAY, HERE ARE THE MYSTERY OBJECTS WHOSE SHAPES YOU JUST DREW:

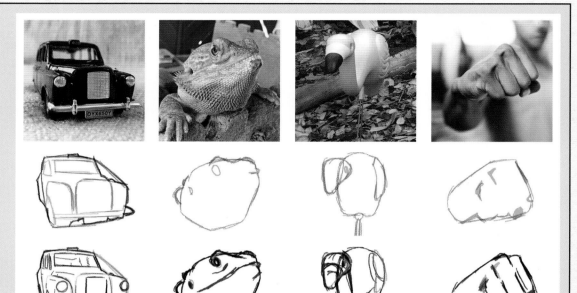

NOW, ADD YOUR DETAILS, TRYING TO FOCUS ON *THEIR* SHAPES, TOO.

WHAT DO YOU THINK? WAS IT EASIER THIS WAY?

AS HELPFUL AS IT IS TO START WITH A SILHOUETTE, IT'S ONLY REALLY PRACTICAL IF YOU HAVE MULTIPLE COPIES OF YOUR IMAGE OR A DRAWING APP WHERE YOU CAN ADD A SILHOUETTE ON A SEPARATE LAYER.

THE NEXT BEST THING, THEN, IS TO CLOSE ONE EYE AND *SQUINT*. CLOSING ONE EYE DIMINISHES YOUR DEPTH PERCEPTION, AND LOOKING AT A BLURRED VERSION OF AN IMAGE CAN CAUSE THE DETAILS TO DROP OUT, HELPING YOU FOCUS ON THE SHAPES.

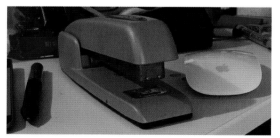

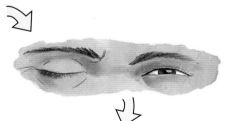

IT TAKES PRACTICE TO RETRAIN HOW YOU SEE THINGS, BUT ONCE YOU'RE ABLE TO SEE SHAPE INSTEAD OF FORM, DRAWING FROM OBSERVATION WILL BE MUCH EASIER. STILL, THERE ARE A FEW OTHER USEFUL TIPS THAT CAN HELP. LET'S COVER THEM NEXT, AND THEN WE'LL PRACTICE WITH STEP-BY-STEP EXAMPLES.

MOST DRAWINGS FEATURE AT LEAST A *FEW* LINES THAT ARE *HORIZONTAL* OR *VERTICAL* . . .

THESE ARE THE LOW-HANGING FRUIT. DRAW THEM RIGHT AFTER YOU LAY IN THE BASIC SHAPES. KEEP THEM PARALLEL TO THE EDGES OF THE PAPER.

THEN LOOK FOR THOSE OTHER ANGLES. COMPARE THEM TO THE EDGES OF THE PHOTO TO GET A SENSE OF THEIR ANGLE. USE THE EDGES OF YOUR PAPER TO REPLICATE THE ANGLE.

. . . AND A WHOLE LOT OF ANGLED LINES.

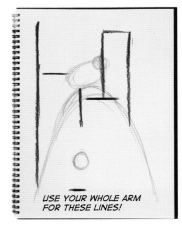

USE YOUR WHOLE ARM FOR THESE LINES!

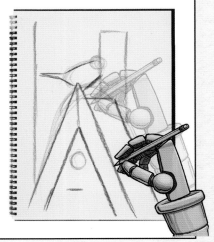

FOR EXAMPLE, PART OF THE LIZARD'S MOUTH IS A HORIZONTAL LINE. START THERE AND USE THE TOP OF THE PAPER AS A GUIDE TO DRAW IT.

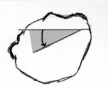

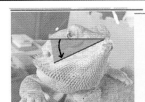

FOR THE REST, COMPARE THE ANGLE TO A HORIZONTAL LINE. LIGHTLY SKETCH THE OVERALL ANGLE FIRST, AND THEN YOU CAN ADD THE CONTOURS.

PLUMB LINES

A BUILDER CAN USE A PLUMB LINE (A HEAVY WEIGHT AT THE BOTTOM OF A STRING) TO MAKE SURE THINGS ARE LINED UP VERTICALLY.

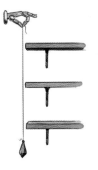

PLUMB LINES CAN BE SIMILARLY HELPFUL IN DRAWING. TO CHECK HOW THINGS ARE LINED UP, DRAW A LIGHT, VERTICAL LINE FROM ANY DISCRETE POINT ON YOUR DRAWING. THEN, DO THE SAME THING WITH YOUR SOURCE IMAGE.

FOR EXAMPLE, THE DRAWING LOOKS OFF, BUT WHY?

IF I DROP LINES DOWN FROM THE MIDDLE OF EACH EYE . . .

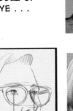

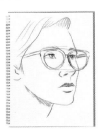

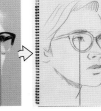

. . . I SEE THAT HER LEFT EYE IS TOO FAR IN.

THERE WE GO.

MAKE SURE YOUR SKETCHBOOK IS SQUARE TO YOUR SHOULDERS WHEN USING PLUMB LINES OR ANY OTHER KIND OF VERTICAL LINES.

POSITIVE SPACE REFERS TO THE OBJECT OR ELEMENT IN AN IMAGE. **NEGATIVE SPACE** IS THE AREA AROUND IT.

POSITIVE AND NEGATIVE SPACE ARE LINKED, OF COURSE. YOU CAN'T DRAW ONE WITHOUT ALSO DRAWING THE OTHER.

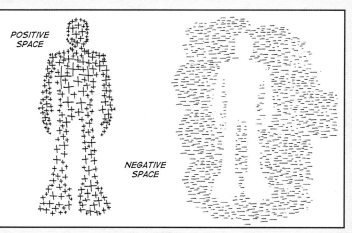

POSITIVE SPACE

NEGATIVE SPACE

WHICH WORKS OUT, BECAUSE SOMETIMES IT'S *EASIER* TO DRAW THE NEGATIVE SPACE! FOR EXAMPLE . . .

. . . LET'S SAY YOU WANT TO DRAW THESE BIRDS. YOUR FIRST MOVE WOULD BE TO START WITH THE OVERALL SHAPES, OF COURSE.

NEXT, ANALYZE THE NEGATIVE SPACE. DO YOUR BEST TO IGNORE THE BIRDS THEMSELVES. JUST SEE THE SHAPE OF THE SPACE BETWEEN THEM.

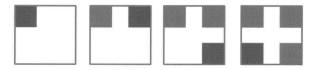

IF THE NEGATIVE SPACE SHAPES ARE EASIER TO DRAW THAN THE POSITIVE SPACE ONES, THEN DRAW THEM. AS IF BY MAGIC, THE POSITIVE SPACE SHAPES WILL APPEAR.

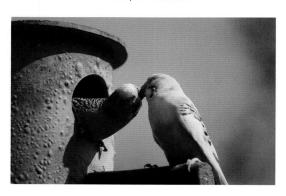

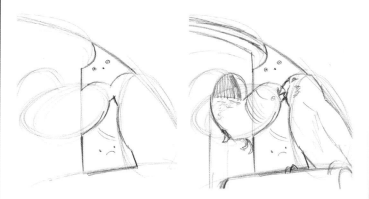

IT CAN BE HELPFUL TO PRETEND THEY'RE SOMETHING ELSE, LIKE STATES OR BATS OR MONSTERS.

EVEN IF THE NEGATIVE SPACE SHAPES AREN'T EASIER TO DRAW THAN THE ACTUAL OBJECTS, COMPARING THE ONES IN THE PHOTO TO THE ONES IN YOUR DRAWING IS A GREAT WAY TO CHECK THAT YOU DREW THE POSITIVE SPACE ACCURATELY.

KEEP YOUR EYES PEELED FOR TIMES WHEN DRAWING THE NEGATIVE SPACE WOULD MEAN DRAWING A SIMPLER SHAPE! IT DOESN'T HAPPEN IN EVERY PICTURE, BUT IT'S A POWERFUL TECHNIQUE WHEN IT DOES.

EVEN IF YOU START WITH THE POSITIVE SPACE, YOU CAN USE THE NEGATIVE SPACE SHAPES TO MAKE SURE YOU DREW THEM RIGHT.

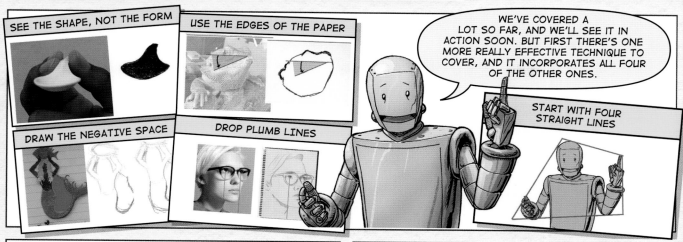

SEE THE SHAPE, NOT THE FORM

USE THE EDGES OF THE PAPER

DRAW THE NEGATIVE SPACE

DROP PLUMB LINES

WE'VE COVERED A LOT SO FAR, AND WE'LL SEE IT IN ACTION SOON. BUT FIRST THERE'S ONE MORE REALLY EFFECTIVE TECHNIQUE TO COVER, AND IT INCORPORATES ALL FOUR OF THE OTHER ONES.

START WITH FOUR STRAIGHT LINES

IT'S A TECHNIQUE BASED ON THE FACT THAT A **STRAIGHT** LINE IS **MUCH** EASIER TO COPY THAN A CURVED LINE.

A CURVED LINE IS CONSTANTLY CHANGING DIRECTION, AND EACH DIRECTION USUALLY HAS A DIFFERENT LENGTH.

BUT A STRAIGHT LINE HAS ONLY TWO COMPONENTS— **ANGLE** AND **LENGTH**.

SO THEN, IF WE FIRST REDRAW OUR CURVED LINES AS STRAIGHT ONES . . .

. . . CAPTURING THE OVERALL SHAPE BECOMES A MATTER OF DRAWING ONE SIMPLE, STRAIGHT LINE AT A TIME.

FROM THERE WE HAVE GUIDES WE CAN USE FOR THE CURVED LINES, AND OFTEN A PLETHORA OF EASY-TO-DRAW NEGATIVE SPACE CHUNKS.

YOU CAN THEN CONTINUE THE PROCESS FOR DETAILS.

IT CAN BE TEDIOUS AT FIRST, BUT IT'S REALLY SATISFYING TO KNOW EXACTLY WHERE YOUR DETAILS GO AT THE END.

LET'S TRY ONE TOGETHER.

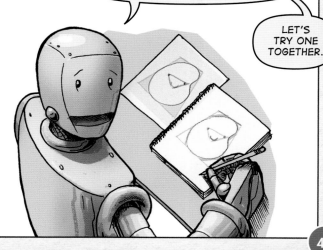

1 FIRST, DRAW THE ENTIRE CAT WITH **FOUR STRAIGHT LINES.** NORMALLY, YOU'D DRAW THE LINES ON THE SOURCE IMAGE YOURSELF, TOO, BUT FOR THIS DEMONSTRATION I'LL DO IT.

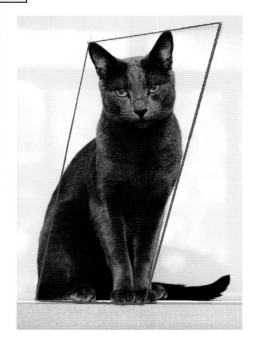

CHECK EACH ANGLE: COMPARE THE ANGLES OF EACH LINE TO THE EDGES OF THE PAPER.

CHECK THE LENGTH: USE YOUR FINGERS LIKE CALIPERS OR GRAB SOME SCRAP PAPER, A PENCIL, ETC. (OR ACTUAL CALIPERS).

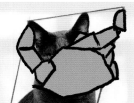

THE SUCCESS OF THE ENTIRE IMAGE DEPENDS ON THIS FIRST STEP. DRAW YOUR FIRST SHAPE TOO WIDE OR THIN, AND THE CAT WILL BE TOO WIDE OR TOO THIN.

2

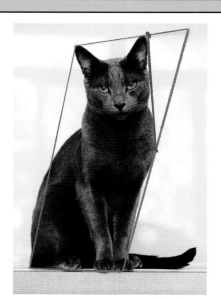

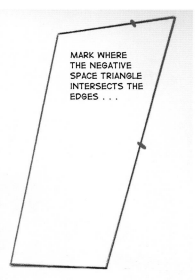

MARK WHERE THE NEGATIVE SPACE TRIANGLE INTERSECTS THE EDGES . . .

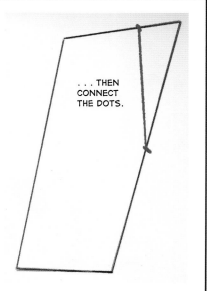

. . . THEN CONNECT THE DOTS.

3 | THE HEAD AND FRONT LEGS COMBINE TO FORM A SHAPE. DRAW IT USING A SINGLE LINE.

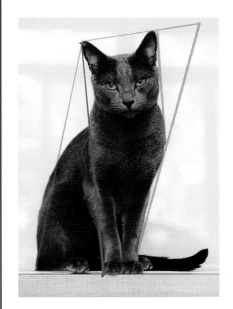

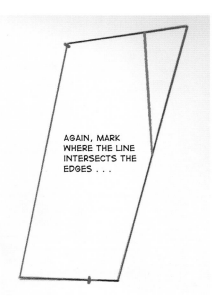

AGAIN, MARK WHERE THE LINE INTERSECTS THE EDGES . . .

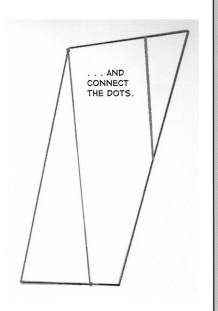

. . . AND CONNECT THE DOTS.

4

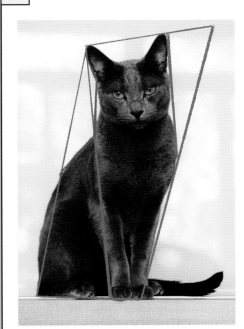

SOMETIMES SHAPES CAN BE TOUGH TO COPY, LIKE THIS NEGATIVE SPACE TRAPEZOID-LOOKING SHAPE ON THE CAT'S SIDE.

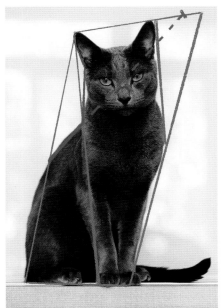

IN THESE CASES, *LIGHTLY* EXTEND THE LINES UNTIL THEY HIT A LINE YOU'VE ALREADY DRAWN.

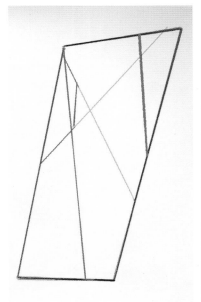

AND, AGAIN, MARK THE INTERSECTIONS AND CONNECT THE DOTS.

5 CONTINUE TO CARVE OUT NEGATIVE SPACE. USE FOUR STRAIGHT LINES TO DRAW THE GESTALT OF THE FACE AS A TRAPEZOID, THEN DRAW THE DETAILS ONE STRAIGHT LINE AT A TIME.

AT FIRST, IGNORE THE CAT'S FACE. DRAW *ONLY* FOUR STRAIGHT LINES.

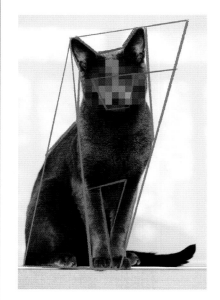

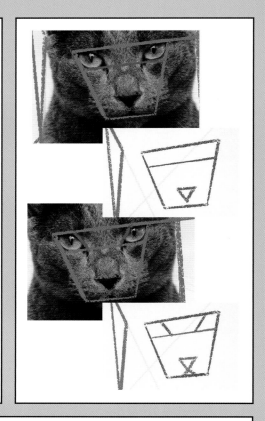

6 KEEP CARVING OUT SHAPES USING STRAIGHT LINES. AT SOME POINT, YOU CAN'T STAND IT ANYMORE—YOU'VE JUST GOTTA DRAW THE CAT! IN FACT, YOU CAN GET OFF THE STRAIGHT-LINE TRAIN WHENEVER YOU WANT. BUT THE LONGER YOU STAY ON, THE MORE FAITHFUL YOUR DRAWING WILL BE TO THE ORIGINAL.

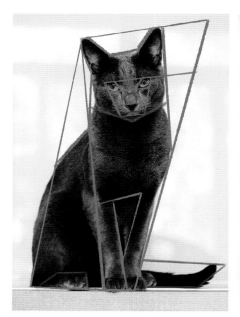

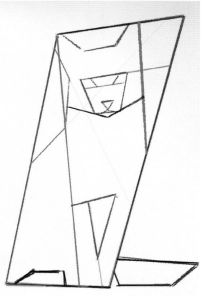

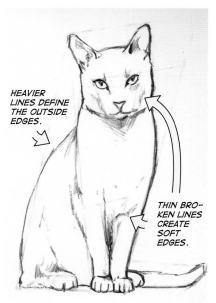

HEAVIER LINES DEFINE THE OUTSIDE EDGES.

THIN BRO-KEN LINES CREATE SOFT EDGES.

FOR OUR STEP-BY-STEP EXAMPLE, I PROVIDED THE STRAIGHT LINES FOR YOU. ON THE NEXT PAGE I'LL GIVE YOU SOME TIPS FOR WHEN YOU'RE ON YOUR OWN.

LARGEST SHAPES FIRST

YOU SHOULD END UP WITH THE SAME RESULT NO MATTER WHAT SHAPE YOU START WITH SO LONG AS YOU CAPTURE THE WHOLE SHAPE WITH YOUR FIRST FOUR LINES.

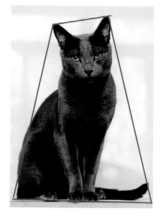

EITHER OF THESE TWO SHAPES WOULD BE OKAY. THEY WORK JUST AS WELL AS THE SHAPE I GAVE YOU.

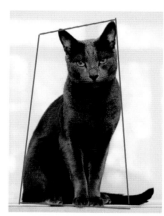

BUT THIS ONE WOULD BE PROBLEMATIC. THE HEAD WOULD LOOK GOOD, BUT IT MIGHT NOT BE UNIFIED WITH THE BODY THE SAME WAY AS IN THE SOURCE PHOTO.

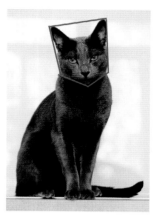

FOR A GROUP OF OBJECTS, CAPTURE THE ENTIRE GROUP (THE GESTALT) WITH YOUR FIRST SHAPE.

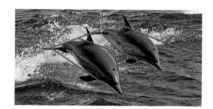

ONE SHAPE AT A TIME

IT CAN BE TEMPTING TO DRAW YOUR FIRST OVERALL SHAPE, AND THEN JUST KEEP GOING ON THE PHOTO WITHOUT TRANSFERRING ANYTHING TO YOUR PAPER. BUT A DRAWING CRISSCROSSED WITH STRAIGHT LINES ISN'T MUCH HELP.

INSTEAD, JUST DO ONE SHAPE ON THE PHOTO, THEN COPY THE SHAPE TO YOUR DRAWING. THEN ANOTHER SHAPE ON YOUR PHOTO, AND COPY *THAT* SHAPE, AND SO ON.

KEEP YOUR LINES TIGHT

AVOID *LOOSE* LINES. THEY USUALLY GIVE YOU LARGE, COMPLICATED NEGATIVE SPACE SHAPES.

TOO LOOSE = COMPLEX SHAPE :(

LINES DRAWN MORE *TIGHTLY* AROUND THE SUBJECT CREATE SIMPLER NEGATIVE SPACE SHAPES.

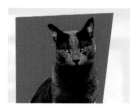
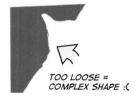

TIGHT LINES = SIMPLE SHAPES :)

GRID DRAWING

ANOTHER USEFUL STRATEGY FOR COPYING AN IMAGE IS TO USE A GRID.

YOU MAY HAVE SEEN GRID DRAWING IN KIDS' ACTIVITY BOOKS, BUT DON'T LET THAT FOOL YOU. GRIDS ARE POWERFUL TOOLS THAT HAVE BEEN USED BY THE MASTERS. WHEN DONE CORRECTLY, A GRID CAN TURN THE PROCESS OF DRAWING EVEN THE MOST COMPLEX OBJECTS INTO A SIMPLE GAME OF CONNECT THE DOTS.

STEP-BY-STEP: GRID DRAWING

1 YOU'LL BE USING A GRID TO DRAW THIS BUTTERFLY AND FLOWER IMAGE. FIRST, THOUGH, YOU NEED TO MAKE A GRID TO DRAW ON.

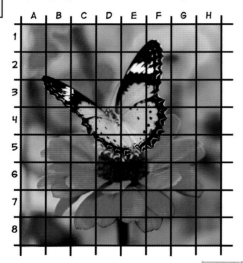

DRAW A RECTANGLE THAT'S THE SAME *SHAPE* AS THE SOURCE PHOTO, IN THIS CASE, A LITTLE TALLER THAN IT IS WIDE. NOTE THAT THE SIZE DOESN'T MATTER, ONLY THE SHAPE.

FOR EXAMPLE, THIS RECTANGLE COULD BE 3" X 3.5" (8CM X 9CM), 6" X 7" (15CM X 18CM) OR 30' X 34' (9M X 10M).

NEXT, DIVIDE THE RECTANGLE IN HALF BOTH WAYS TO QUARTER IT. THEN DIVIDE EACH QUARTER IN HALF BOTH WAYS, ETC., UNTIL YOU HAVE EIGHT ROWS AND EIGHT COLUMNS. LABEL YOUR GRID LIKE THE SOURCE PHOTO.

USE A STRAIGHT-EDGE, AND KEEP THESE LINES LIGHT AND THIN!

2 *START WITH A SIMPLE TILE,* LIKE E-2. NOTE WHERE THE EDGES INTERSECT THE GRID AND MAKE CORRESPONDING DOTS, THEN CONNECT THEM.

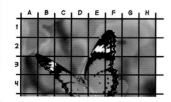

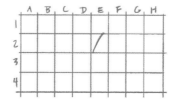

BEFORE YOU MOVE ON, DOUBLE-CHECK THAT YOU DREW IN THE CORRECT SPACE!

CONTINUE TO TRANSFER DOTS ONE AT A TIME. USE LIGHT SKETCH LINES TO CONNECT THEM. AS ALWAYS, DRAW THE OVERALL SHAPE FIRST, THEN GO BACK AND ADD DENTS AND BUMPS AND CONTOURS.

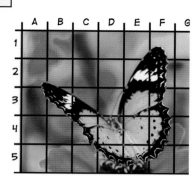 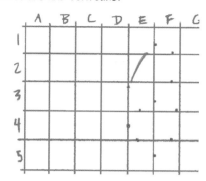

4

SMALLER DETAILS OFTEN DON'T INTERSECT THE GRID LINES. IN THESE CASES, USE A GRID INSIDE YOUR GRID. IF NECESSARY, YOU CAN SUBDIVIDE EVEN FURTHER!

5

CONTINUE TO WORK, MARKING INTERSECTIONS AND CONNECTING DOTS. TAKE IT ONE SQUARE AT A TIME. IF TWO SQUARES DON'T LINE UP, DON'T ASSUME THE MORE RECENT ONE IS CORRECT. STEP BACK AND TRY TO FIGURE OUT WHERE THE MISTAKE WAS.

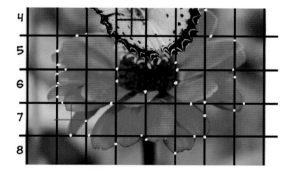

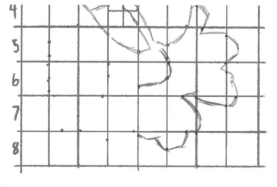

6

BEFORE YOU GET TOO FAR WITH DETAIL LINES, ERASE THE GRID! MOVE YOUR ERASER OVER THE ENTIRE PAPER. IF YOUR GRID LINES WERE LIGHT, THEY SHOULD DROP OUT WHILE YOUR DRAWING REMAINS.

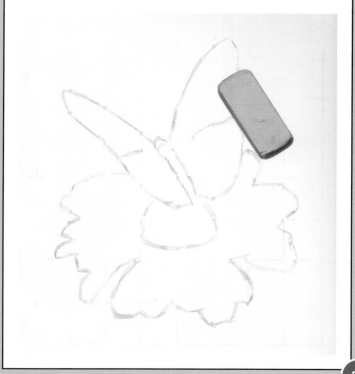

GRID DRAWING IS A HASSLE, BUT THE FINAL PRODUCT IS USUALLY WORTH IT. GRIDS ESPECIALLY SHINE FOR LARGE DRAWINGS LIKE BANNERS, SIDEWALK ART OR MURALS.

BIG OR JUST KIND OF BIG, HERE ARE A FEW PRACTICAL CONSIDERATIONS WHEN YOU'RE WORKING WITH A GRID.

INVEST IN A T-SQUARE IF YOU PLAN ON DRAWING A LOT OF GRIDS ON POSTER-SIZED PAPER.

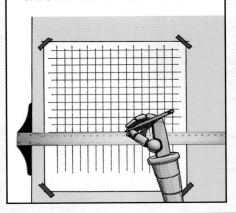

OR GET A CHALK LINE IF YOU'RE WORKING EVEN BIGGER.

AT THE END OF THE DAY, YOU MAY NEED TO GET CREATIVE, BUT EVEN A SLOPPY GRID CAN BE A HUGE HELP FOR WORKING ON OVERSIZED PROJECTS.

GRID DRAWING IS USUALLY PRESENTED WITH A GRID FULL OF **SQUARES**. IT'S UNNECESSARY, THOUGH, AND REQUIRES A BIT OF MATH. BUT, IF YOU WANT SQUARES, HERE'S HOW TO DO IT:

1 DIVIDE THE LENGTH OF THE SHORTER SIDE OF THE SOURCE PHOTO BY THE NUMBER OF SQUARES YOU WANT. THIS GIVES YOU THE WIDTH OF THE SOURCE GRID SQUARES. CALL IT W.

2 DIVIDE ANY LENGTH OF THE TARGET RECTANGLE (THE ONE YOU'LL BE DRAWING ON) BY THE CORRESPONDING LENGTH OF THE PHOTO. LET'S CALL THIS R FOR RATIO.

3 MULTIPLY W BY R. THIS GIVES YOU THE WIDTH OF THE SQUARES FOR YOUR TARGET RECTANGLE.

OF COURSE, THAT JUST GIVES YOU THE *SIZE* OF THE SQUARES. YOU STILL NEED TO MEASURE THEM OUT AND THEN DRAW THE GRID.

BUT ALL THAT MATH IS ONLY NECESSARY IF YOU WANT *SQUARES*. AS LONG AS YOUR SOURCE IMAGE AND DRAWING SURFACE ARE PROPORTIONAL, SIMPLY DIVIDING IN HALF, DIVIDING THE HALVES IN HALF, ETC., A FEW TIMES (WHAT WE DID BACK IN STEP 1) WORKS JUST AS WELL!

THERE ARE SOME IMAGES YOU JUST DON'T WANT TO COVER WITH A GRID. PRINT A COPY INSTEAD OR OVERLAY A CLEAR SHEET OF PLASTIC OR GLASS (BE CAREFUL!) AND DRAW A GRID ON IT WITH A THIN MARKER.

DRAWING FROM LIFE: BASICS

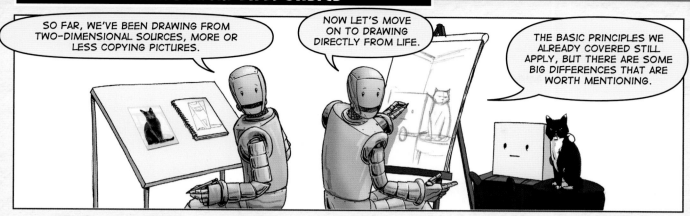

SO FAR, WE'VE BEEN DRAWING FROM TWO-DIMENSIONAL SOURCES, MORE OR LESS COPYING PICTURES.

NOW LET'S MOVE ON TO DRAWING DIRECTLY FROM LIFE.

THE BASIC PRINCIPLES WE ALREADY COVERED STILL APPLY, BUT THERE ARE SOME BIG DIFFERENCES THAT ARE WORTH MENTIONING.

FIRST, WHEN DRAWING FROM LIFE, YOUR POSITION RELATIVE TO YOUR SKETCHBOOK IS IMPORTANT.

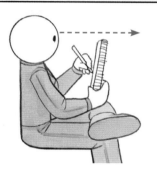

HOLD YOUR SKETCHBOOK ALMOST VERTICAL AND JUST BELOW YOUR LINE OF SIGHT. IT MAKES YOUR SUBJECT "CLOSER" TO YOUR ACTUAL DRAWING.

HOLDING YOUR SKETCHBOOK CLOSE TO VERTICAL ALSO FORCES YOU TO LOOK AT THE IMAGE DIRECTLY, NOT AT AN ANGLE.

WHILE YOU'RE AT IT, KEEP YOUR SKETCHBOOK PARALLEL TO YOUR SHOULDERS (PERPENDICULAR TO YOUR LINE OF SIGHT). THIS MAKES IT EASIER TO DROP PLUMB LINES AND MEASURE ANGLES.

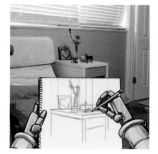

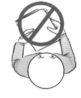

HOLD STILL! YOUR POSITION RELATIVE TO YOUR SUBJECT CHANGES THE ANGLES YOU DRAW!

OTHERWISE, YOU MAY END UP WITH A CUBIST VERSION, WHERE YOU CAN SEE MULTIPLE VIEWPOINTS AT THE SAME TIME.

FINALLY, KEEP ONE EYE CLOSED. THIS ELIMINATES DEPTH PERCEPTION, MAKING IT EASIER TO SEE SHAPE INSTEAD OF FORM.

BOTH EYES = DEPTH = HARDER TO SEE SHAPE

ONE EYE = NO DEPTH = EASIER TO SEE SHAPE

(WELL, NOT LIKE THIS *EXACTLY*. BUT HOPEFULLY YOU GET THE IDEA.)

ONCE YOU'VE GOT YOUR SKETCHBOOK HELD CORRECTLY, ONE EYE CLOSED AND YOUR BODY FROZEN INTO POSITION, IT'S TIME TO DO ALL THAT STUFF FROM EARLIER IN THE CHAPTER: DROP PLUMB LINES, MEASURE ANGLES AND SEE SHAPE INSTEAD OF FORM. HERE'S AN EXAMPLE OF HOW ALL THOSE CONCEPTS APPLY TO A TYPICAL STILL LIFE:

DROP DOWN PLUMB LINES TO MEASURE THE WIDTH OF THE SUBJECT.

THEN LAY IN *LOOSE, LIGHT SKETCH BLOBS* TO MAKE SURE YOU HAVE ROOM FOR EVERYTHING.

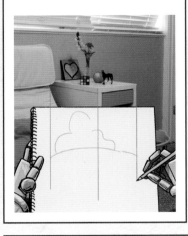

COPY ANGLES: FOR ANY STRAIGHT EDGES, USE THE TOP OF THE SKETCHBOOK AS A GUIDE TO GET THE ANGLE RIGHT.

HOLD YOUR PENCIL OVER THE LINES TO HELP IDENTIFY THE ANGLE YOU NEED TO DRAW. LONGER LINES ARE EASIER TO COMPARE, ESPECIALLY IF YOU'RE TRYING TO MATCH THE ANGLE OF A LINE RECEDING AWAY FROM YOU.

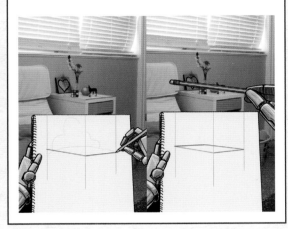

RAIN DOWN MORE PLUMB LINES TO SEE WHERE DETAILS GO AND HOW WIDE THEY ARE.

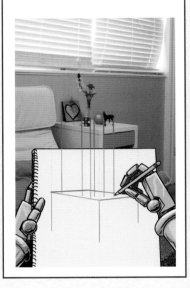

AT THIS POINT, YOU WOULD HAVE A CLEAR IDEA OF THE OVERALL STRUCTURE AND WHERE THE DETAILS GO, SO YOU'D REPEAT THE PROCESS FOR THE DETAILS THEMSELVES.

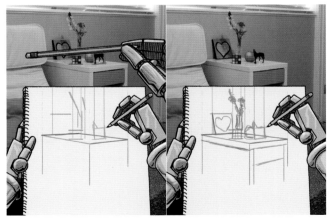

AS ALWAYS, KEEP YOUR EYES OPEN FOR NEGATIVE SPACE SHAPES THAT MIGHT BE EASIER TO DRAW THAN THE POSITIVE SPACE SHAPES.

HERE'S ANOTHER EXAMPLE:

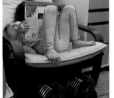

DROP DOWN PLUMB LINES, SKETCH THE OVERALL SHAPES.

MEASURE AND REPLICATE ANGLES.

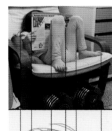

SKETCH SHAPES.

ANALYZING THE ANGLES OF LINES WHEN DRAWING FROM LIFE TAKES A BIT OF PRACTICE. START WITH SUBJECTS THAT HAVE OBVIOUS LINES, AND THEN MOVE ON FROM THERE.

A GOOD WAY TO PRACTICE MEASURING ANGLES WHEN DRAWING FROM LIFE IS TO USE A *DRAWING FRAME*.

CUT A RECTANGLE OUT OF A PIECE OF CARDSTOCK, LIKE A FOLDER, A CEREAL BOX OR EVEN THE COVER OF THIS BOOK IF YOU'RE DESPERATE.

THE RECTANGLE DOESN'T HAVE TO BE PERFECT. REALLY, ANY SHAPE WORKS.

TRACE THE RECTANGLE (OR WHATEVER) INTO YOUR SKETCHBOOK NEAR THE TOP.

NOW, PLACE THE FRAME INTO YOUR SKETCHBOOK NEAR THE TOP.

NO SKETCHBOOK? PLACE IT IN A HARDCOVER BOOK.

SANDWICH IT DEEP IN THE MIDDLE SO THAT IT DOESN'T FLOP OVER.

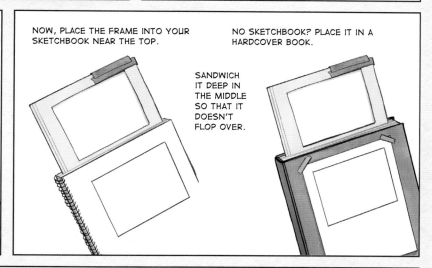

LET'S LEARN HOW TO USE A DRAWING FRAME BY DRAWING A STILL LIFE TOGETHER. TRACE THE BOTTOM OF A COFFEE MUG ON A SHEET OF PAPER, AND ARRANGE THE MUG, PENCIL AND PAPER SOMETHING LIKE THIS . . .

NOW SIT LIKE THIS . . .

. . . SO THAT YOU SEE SOMETHING LIKE THIS:

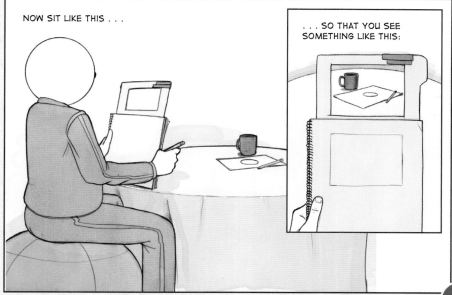

STEP-BY-STEP: STILL LIFE

TRY TO ARRANGE YOUR STILL LIFE SIMILAR TO THE ONE BELOW. UNLESS WE LIVE IN THE SAME HOUSE (HEY, MELISSA!), THE OBJECTS THEMSELVES WON'T BE IDENTICAL, BUT THE FOLLOWING STEPS WILL ROUGHLY HOLD TRUE.

THE PAPER

1 FIRST, DROP LINES DOWN FROM THE CORNERS OF THE PAPER.

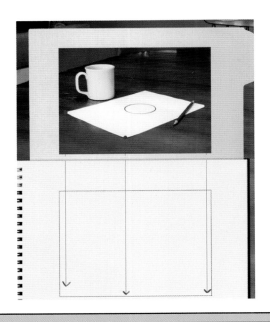

2 DRAW THE BOTTOM EDGES OF THE SHEET OF THE PAPER, COMPARING ITS ANGLES TO THE BOTTOM OF THE FRAME.

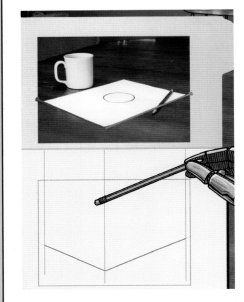

HOLD YOUR PENCIL BETWEEN TWO LINES TO MAKE SURE THEY'RE THE SAME ANGLE.

3 REPEAT THE PROCESS FOR THE BACK CORNER. DROP A PLUMB LINE DOWN . . .

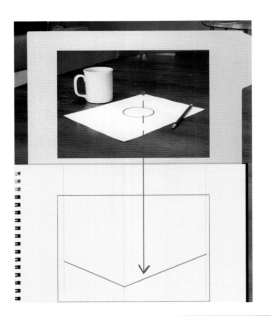

4 . . . AND COPY THE ANGLES.

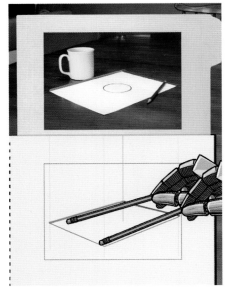

THE ANGLES OF THE BACK EDGES SHOULD APPEAR A LITTLE FLATTER THAN THE FRONT ONES.*

*MORE ON THAT IN CHAPTER 5.

5 RAIN DOWN PLUMB LINES TO GET THE WIDTH OF THE COFFEE MUG AND THE CIRCLE.

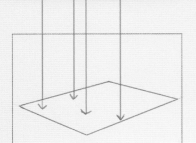

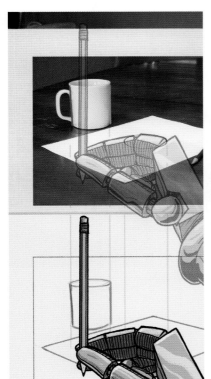

6 THE TOP OF THE MUG IS A CIRCLE, BUT IT PRESENTS ITSELF AS AN ELLIPSE. TRACE OVER IT IN THE AIR WITH YOUR PENCIL, THEN DRAW IT BELOW. DO THE SAME THING WITH THE CIRCLE ON THE PAPER. (SEE CHAPTER 1 FOR SKETCHING ELLIPSES.)

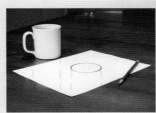

HOLD YOUR PENCIL SIDEWAYS TO SEE WHERE YOUR ELLIPSE LINES UP WITH THE PAPER.

NOTICE THAT THE CIRCLE ON THE PAPER SHOULD APPEAR FATTER THAN THE TOP OF THE MUG.

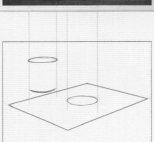

MAKE SURE IT LINES UP THE SAME WAY IN YOUR DRAWING.

7 COMPARE THE SIDES OF THE MUG TO A PENCIL HELD STRAIGHT UP AND DOWN. NOTICE THAT THEY DON'T APPEAR TO BE PERFECTLY VERTICAL.

THE ACTUAL EDGES OF THE MUG *ARE* VERTICAL (I'M ASSUMING YOURS ARE, TOO). IT'S JUST THAT THE EDGES DON'T *APPEAR* VERTICAL SINCE WE'RE ABOVE THE SCENE AND *LOOKING DOWN*.

MORE ON THIS IN CHAPTER 5.

8 FOR THE HANDLE, FIRST SKETCH ANY FLAT EDGES . . .

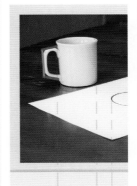
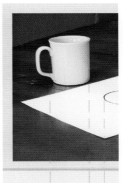

. . . THEN ADD THE CURVES AND DRAW THE NEGATIVE SPACE.

9 USE THE NON-FORESHORTENED PENCIL IN YOUR HAND TO MEASURE THE ANGLES OF THE FORESHORTENED PENCIL. KIND OF SURREAL, HUH?

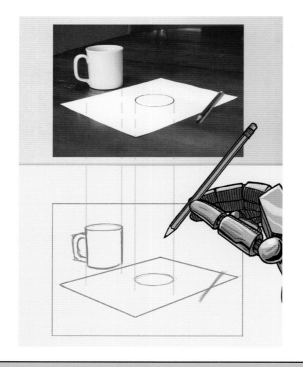

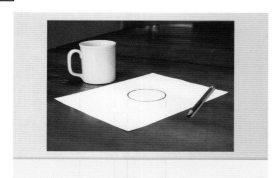

10 TO FINISH THE PENCIL, TRY TO CAREFULLY OBSERVE THE LINES AND CURVES.

ALTERNATIVELY, YOU CAN USE THE SAME PROCESS YOU USED FOR THE ROCKET IN CHAPTER 1.

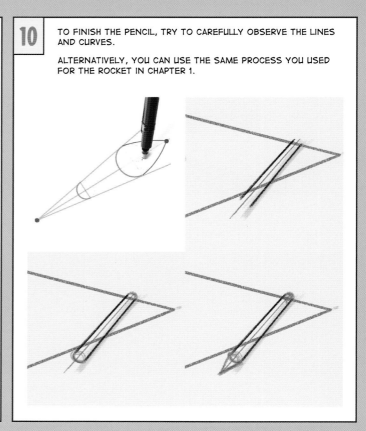

11 FROM THERE, YOU CAN CLEAN UP THE LINES AND SHADE.

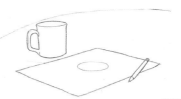

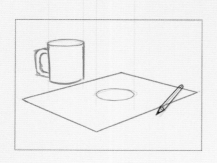

12 TRY TO USE WHAT WE LEARNED IN CHAPTER 2 TO FINISH THE DRAWING.

USE HEAVIER LINES ON THE OUTSIDE AND THINNER LINES INSIDE AND FOR TEXTURE.

SNAP A BLACK-AND-WHITE PHOTO AND ADJUST THE CONTRAST UNTIL YOU GET A FULL RANGE OF VALUES. USE THAT IMAGE TO HELP YOU SEE HOW DARK AND LIGHT TO SHADE, OR DEVIATE FROM IT TO CREATE MORE CONTRAST AND CLARITY IF YOU'D LIKE.

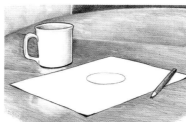

REMEMBER TO:

AVOID SHADING IN DIFFERENT DIRECTIONS.

CREATE CONTRAST.

USE THE FULL RANGE OF VALUES.

KEEPING ALL OF THOSE TECHNIQUES AND CONCEPTS IN YOUR HEAD WHILE YOU'RE DRAWING TAKES PRACTICE, SO HERE IS THE ESSENTIAL INFO IN CASE YOU NEED A QUICK REFERENCE.

THE NUMBER ONE MOST HELPFUL CONCEPT IS TO VISUALIZE FORESHORTENED THREE-DIMENSIONAL FORMS AS FLAT, TWO-DIMENSIONAL SHAPES.

THE SECOND MOST USEFUL CONCEPT IS REPLICATING THE ANGLES OF ANY STRAIGHT (OR ALMOST STRAIGHT) LINES IN YOUR IMAGE.

USE YOUR WHOLE ARM FOR THIS.

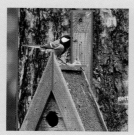
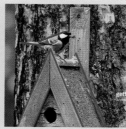

BUT THIS STUFF IS IMPORTANT, TOO:

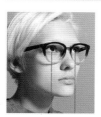
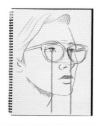
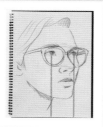

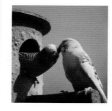

DROP DOWN PLUMB LINES TO MAKE SURE THINGS ARE LINED UP CORRECTLY.

SEE THE SHAPES OF THE NEGATIVE SPACE. SOMETIMES THEY'RE EASIER TO DRAW THAN THE POSITIVE SPACE SHAPES.

WHEN DRAWING FROM LIFE, AS OPPOSED TO COPYING A PICTURE, DO THIS:

THEN, DROP PLUMB LINES TO GET THE WIDTH OF EVERYTHING RIGHT AND REPLICATE THE ANGLES OF AS MANY EDGES AS YOU CAN.

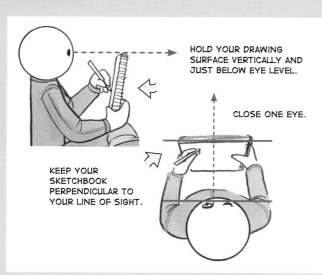

HOLD YOUR DRAWING SURFACE VERTICALLY AND JUST BELOW EYE LEVEL.

CLOSE ONE EYE.

KEEP YOUR SKETCHBOOK PERPENDICULAR TO YOUR LINE OF SIGHT.

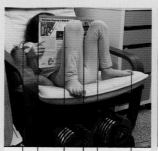
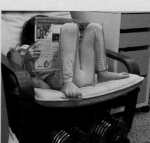

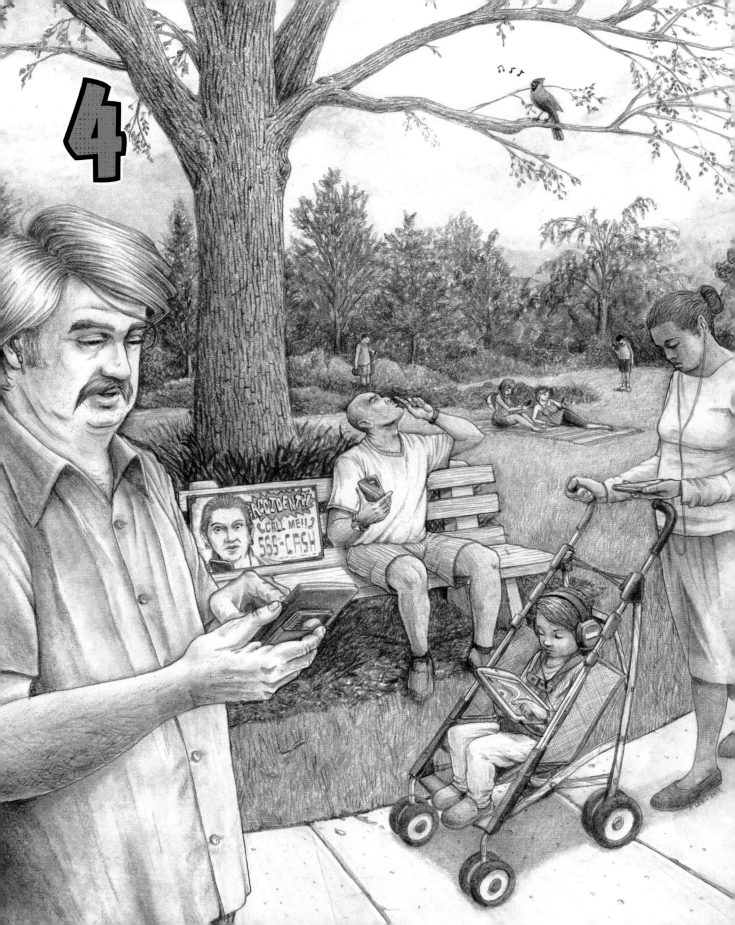

Drawing People

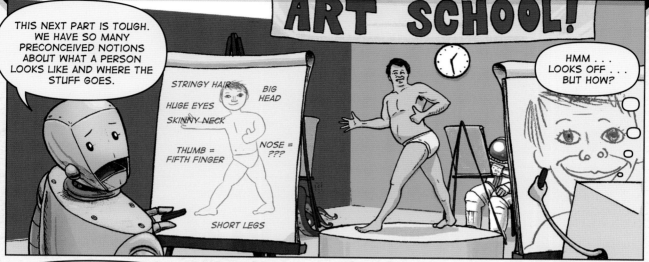

ART SCHOOL!

THIS NEXT PART IS TOUGH. WE HAVE SO MANY PRECONCEIVED NOTIONS ABOUT WHAT A PERSON LOOKS LIKE AND WHERE THE STUFF GOES.

STRINGY HAIR

BIG HEAD

HUGE EYES

SKINNY NECK

THUMB = FIFTH FINGER

NOSE = ???

SHORT LEGS

HMM . . . LOOKS OFF . . . BUT HOW?

TO DRAW A REALISTIC PERSON, YOU'LL NEED TO FORGET THE *SYMBOLS* WE USUALLY USE TO DRAW THEM . . .

. . . AND LEARN HOW TO DRAW HUMANS THE WAY THEY ARE, NOT THE WAY THEY SEEM.

PLEASE, HURRY.

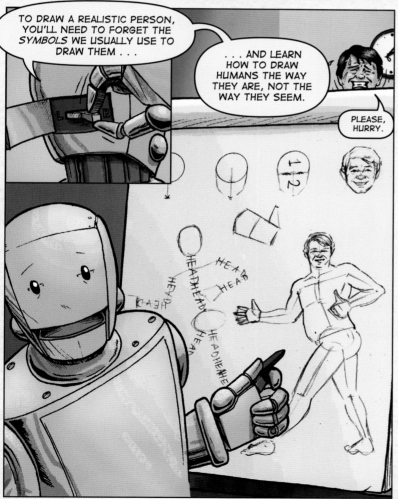

OF COURSE, THAT'S A BIG TASK! WE'LL BREAK IT INTO MORE MANAGEABLE CHUNKS.

FIRST, WE'LL START WITH THE HEAD AND EYES . . .

. . . AND THE OTHER PARTS OF THE FACE (AND WHERE THEY GO) . . .

. . . AND THEN HAIR AND EXPRESSIONS.

THEN WE'LL LEARN ABOUT BODY PARTS: ARMS, LEGS, HANDS AND FEET . . .

. . . AND THEN THE BASIC PROPORTIONS AND STEPS FOR PUTTING IT ALL TOGETHER.

THE HEAD SHAPE IS BASICALLY A CIRCLE AND A HALF TALL AND ONE CIRCLE WIDE. YOU NEED TO START WITH A DECENT CIRCLE, SO SKETCH LIGHTLY UNTIL YOU GET IT RIGHT. YOU CAN ALSO USE A CIRCLE TEMPLATE OR TRACE A COFFEE MUG OR SOMETHING.

1.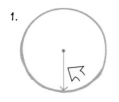

MARK THE RADIUS . . .

. . . AND THEN DUPLICATE IT BELOW.

2.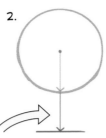

3.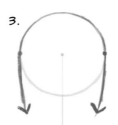

4.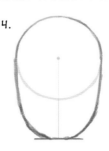

5.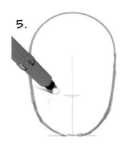

IT CAN TAKE A LOT OF SKETCHING TO GET BOTH SIDES EVEN FOR THE JAW.

SLIGHT TWEAKS TO THESE CURVES CAN PRODUCE REALLY DIFFERENT JAWLINES.

LANTERN JAW: DROP LONG LINES DOWN ALMOST VERTICALLY AND START CURVING THEM BELOW THE LIPS.

OVAL JAW: START CURVING TOWARDS THE CHIN ALMOST FROM THE BEGINNING.

FOR MIDDLE-AGED FOLKS, USE A HARD LINE FOR THE CHIN, AND A BROKEN AND SLIGHTLY LOWER LINE FOR THE REST OF THE JAW.

FOR HEAVIER FACES, THE JAW CAN BE COMPLETELY COVERED.

STEP-BY-STEP: COMPLETE HEAD

FOLLOW THESE STEPS TO DRAW A COMPLETE HEAD.

KEEP YOUR SKETCHBOOK LINED UP WITH YOUR SHOULDERS FOR THESE VERTICAL LINES!

FOR PRACTICE, TRY DRAWING YOUR HEADS KIND OF SMALL.

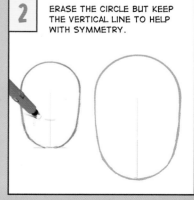

1 PICK A HEAD SHAPE FROM ABOVE.

2 ERASE THE CIRCLE BUT KEEP THE VERTICAL LINE TO HELP WITH SYMMETRY.

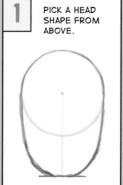

A PAIR OF EYES

IT'S REALLY HARD TO DRAW A COMPLETE EYE AND THEN DRAW THE EXACT SAME EYE IN *REVERSE*.

INSTEAD, FOLLOW THE STEPS BELOW TO DRAW THE EYES IN CHUNKS, A LITTLE AT A TIME.

PRACTICE A FEW EYES AND CHECK THE BOTTOM OF THE PAGE TO CONTINUE DRAWING YOUR HEAD.

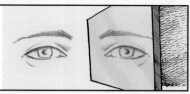

1 DRAW THE TOP OF THE LEFT EYE . . .

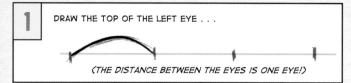

(THE DISTANCE BETWEEN THE EYES IS ONE EYE!)

2 . . . THEN THE TOP OF THE RIGHT.

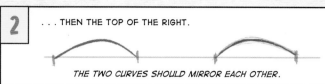

THE TWO CURVES SHOULD MIRROR EACH OTHER.

CONTINUE TO WORK IN CHUNKS. DRAW A LITTLE PART ON THE LEFT, AND THEN THE SAME THING ON THE RIGHT.

3

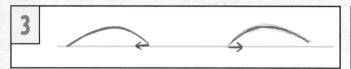

4 REMEMBER: THE BOTTOM IS FLATTER THAN THE TOP!

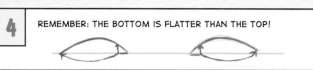

5

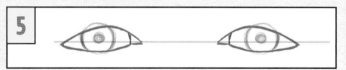

6

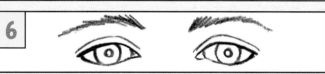

THOUGH THE EYES *ARE* AT THE TOP OF THE *FACE*, THEY'RE *NOT* AT THE TOP OF THE *HEAD*.

IN FACT, THEY'RE *HALFWAY** FROM THE TOP TO THE BOTTOM . . .

. . . AND ONE EYE FROM EACH SIDE**

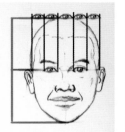

*UNLESS YOU'RE LOOKING UP OR DOWN.

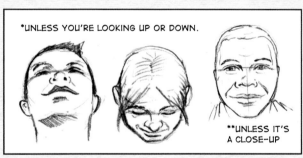

**UNLESS IT'S A CLOSE-UP

NO NEED TO DRAW EYELASHES FOR SMALLER PAIRS OF EYES. JUST USE A SINGLE HEAVY LINE FOR THE TOP EYELASHES, AND A THIN LINE (OR NO LINE AT ALL) FOR THE BOTTOM.

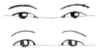

NOTE: THE OPPOSITE APPROACH DOESN'T WORK!

3 DIVIDE THE HEAD IN HALF.

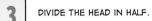

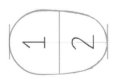

DOUBLE CHECK THE EVENNESS BY TURNING YOUR PAPER SIDEWAYS.

4 *LIGHTLY* SKETCH FIVE BASIC EYE SHAPES ACROSS THAT HALFWAY LINE TO GET THE SIZE AND POSITION RIGHT. IT WILL PROBABLY TAKE A FEW TRIES UNTIL YOU GET THE HANG OF IT.

EYES ARE SMALLER THAN WHAT MOST PEOPLE THINK THEY SHOULD BE.

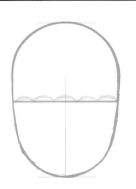

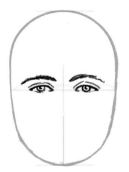

THE NOSE

NOSES COME IN A VARIETY OF SHAPES AND SIZES, BUT GENERALLY, THEY CAN BE DRAWN WITH TWO PARENTHESES, A NOSEBALL AND TWO RAINBOWS.

FOLLOW THE STEPS AND PRACTICE A FEW NOSES BEFORE ADDING ONE TO YOUR HEAD.

1 START WITH A LIGHT GUIDELINE.

2 VISUALIZE THE SIDES OF THE NOSE AS A PAIR OF PARENTHESES AROUND A FOUR-LETTER WORD.

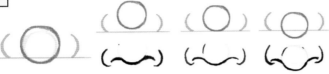

3 DRAW THIS LIGHTLY. YOU'LL END UP ERASING MUCH OF IT LATER.

THE NOSEBALL CAN BE ON, ABOVE OR BELOW THE GUIDELINE.

4 THE RAINBOWS SHOULD HOVER SLIGHTLY ABOVE THE PARENTHESES.

5 KEEP A TINY BIT OF THE NOSEBALL FOR A BUTTON NOSE.

CURL UP YOUR PARENTHESES AT THE BOTTOM.

VISUALIZING THE NOSEBALL CAN COME IN HANDY LATER WHEN DRAWING THE NOSE AT DIFFERENT ANGLES OR SHADING IT.

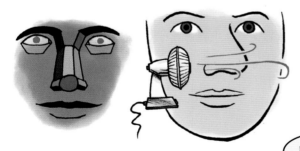

THE BRIDGE OF THE NOSE IS TRICKY BECAUSE IT ENDS GRADUALLY, LIKE A HILL. AVOID USING HARD LINES TO DRAW IT, OR IT WILL LOOK LIKE THE NOSE HAS HARD EDGES OR IS BEING SEEN FROM THE SIDE.

INSTEAD, USE A LIGHT, BROKEN LINE OR SOME SHADING TO MERELY *SUGGEST* THE SIDES OF THE NOSE.

THE GENERAL SHAPE FOR SUCH LINES IS SOMETHING LIKE HANDLEBARS STARTING BETWEEN THE EYES AND THE EYEBROWS, AND EXTENDING DOWN INTO THE NOSEBALL.

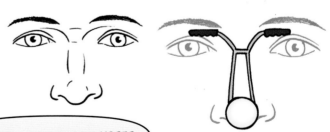

PRACTICE A FEW DIFFERENT *NOSES*, THEN ADD ONE TO YOUR HEAD.

5 PLACE THE GUIDELINE FOR THE NOSE A *LITTLE CLOSER TO THE EYES THAN TO THE CHIN* (NOT HALFWAY).

THIS WORKS OUT TO BE A HAIR BELOW THE BOTTOM OF THE CIRCLE YOU STARTED WITH (IN CASE ANY IS STILL LEFT).

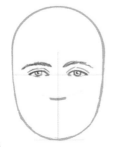

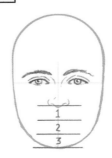

THE NOSE IS ROUGHLY THE WIDTH OF ONE EYE—USUALLY A LITTLE WIDER.

6 DIVIDE THE SPACE BETWEEN THE NOSE AND THE CHIN INTO EVEN THIRDS.

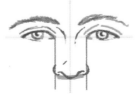

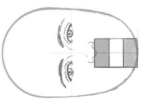

EVEN THIRDS ARE HARD! IT'S EASIER TO DO THIS IF YOU PICTURE IT AS A FLAG.

1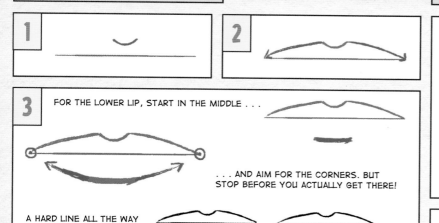

2

3 FOR THE LOWER LIP, START IN THE MIDDLE . . .

. . . AND AIM FOR THE CORNERS. BUT STOP BEFORE YOU ACTUALLY GET THERE!

A HARD LINE ALL THE WAY TO THE CORNERS CAN LOOK UNNATURAL.

NO

YES

4 REPLACE THE MIDDLE LINE WITH A FLATTENED VERSION OF THE TOP LINE.

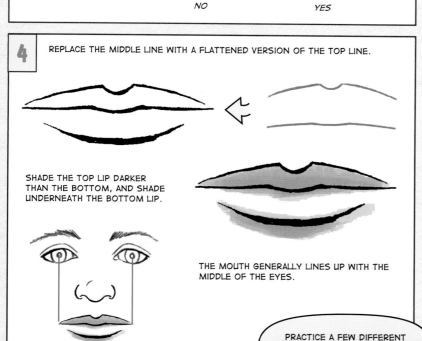

SHADE THE TOP LIP DARKER THAN THE BOTTOM, AND SHADE UNDERNEATH THE BOTTOM LIP.

THE MOUTH GENERALLY LINES UP WITH THE MIDDLE OF THE EYES.

AN ACTUAL EAR IS A COMPLEX SET OF CURVES, NONE OF WHICH SHOULD BE DRAWN WITH A HARD LINE.

TO REALLY DRAW AN EAR WELL, YOU'LL NEED TO DRAW FROM OBSERVATION.

BUT IN A PINCH, USE THIS SHORTCUT: START WITH HALF OF A SKINNY APPLE, THEN ADD A *C AND TWO CANDY CANES*.

HALF OF AN APPLE

C

CANDY CANE 1

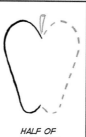
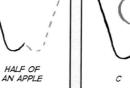

EARS EXTEND FROM THE TOP OF THE EYES TO THE BOTTOM OF THE NOSE.

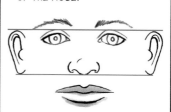

CANDY CANE 2

PRACTICE A FEW DIFFERENT ***MOUTHS AND EARS,*** THEN ADD THEM TO YOUR HEAD.

7 THE ***MIDDLE*** LINE OF THE LIPS (*NOT THE TOP*) IS ONE THIRD OF THE WAY DOWN FROM THE NOSE.

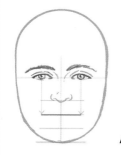
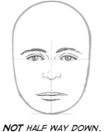
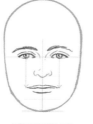

NOT *HALF WAY DOWN.* *THERE WE GO.*

8 ADD EARS.

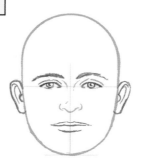
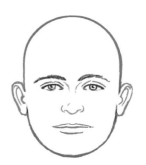

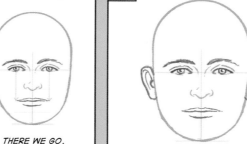

HAIR IS A PRETTY COMPLICATED SUBJECT, BUT IF YOU CAN DRAW A DECENT HAIRLINE, YOU'LL BE OFF TO A GREAT START.

IMAGINE THREE M BIRDS—A PARENT AND TWO BABIES.

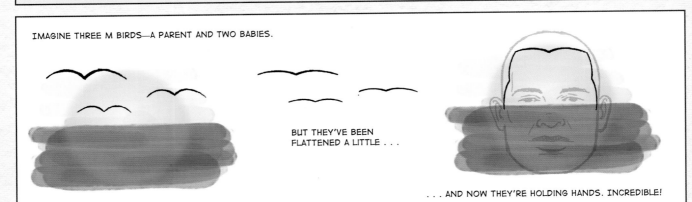

BUT THEY'VE BEEN FLATTENED A LITTLE . . .

. . . AND NOW THEY'RE HOLDING HANDS. INCREDIBLE!

1 THE TOP M-BIRD LINES UP A LITTLE OUTSIDE THE EYES.

THE SMALLER BIRDS CONNECT TO THE SIDE OF THE HEAD, JUST BELOW THE EARS.

A COMMON MISTAKE:

AVOID UPSIDE DOWN M-BIRDS!

2 LIGHTEN THOSE LINES SO YOU CAN BARELY SEE THEM . . .

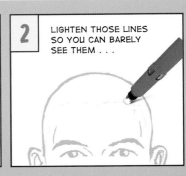

3 . . . AND REPLACE THEM WITH A SERIES OF DASHES. THE DASHES SHOULD LINE UP TO A VANISHING POINT AT THE TOP OF THE FOREHEAD.

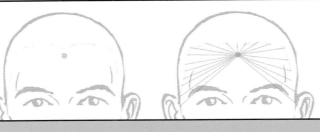

A LOT OF SHORT HAIRSTYLES CAN BE DRAWN BY ADDING (OR SUBTRACTING) A FEW SHAPES TO THE HAIRLINE.

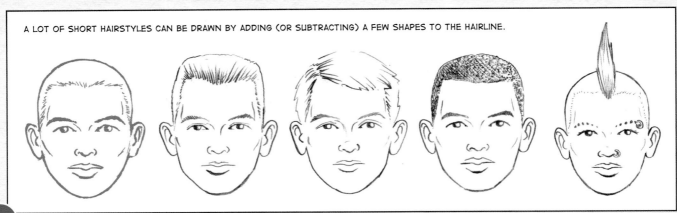

FOR HAIR THAT'S PULLED BACK, EXTEND THE HAIRLINE DASHES ALL THE WAY TO THE EDGE, SO THEY WRAP AROUND THE HEAD.

BUT YOU'LL NEED TO ADD A LITTLE SIZE TO THE BALD HEAD OR IT WILL LOOK LIKE THE HAIR IS PULLED BACK REALLY TIGHT (OR PAINTED ON).

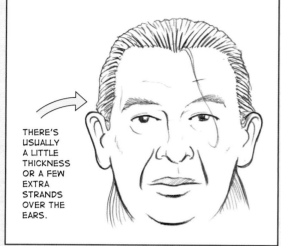

THERE'S USUALLY A LITTLE THICKNESS OR A FEW EXTRA STRANDS OVER THE EARS.

FOR OTHER MEDIUM OR LONG HAIRSTYLES, TRY NOT TO DRAW *EVERY SINGLE HAIR*. INSTEAD, DRAW THE OVERALL SHAPES FIRST, AND THEN USE A MODICUM OF WELL-PLACED LINES FOR THE TEXTURE.

1. 2.

3.

DON'T LET LINES CROSS. IF TWO LINES TOUCH, ONE SHOULD DISAPPEAR (GOING UNDER THE OTHER).

START YOUR LINES WHERE THE HAIR BEGINS OR ENDS, NOT IN THE MIDDLE.

END

START

WORK *OUTSIDE* TO *INSIDE*, LETTING YOUR PENCIL LINES TRAIL OFF.

FOR MORE COMPLEX HAIRSTYLES, START WITH A REFERENCE PHOTO. SKETCH THE HAIR ONE CHUNK AT A TIME.

USE FOUR OR FEWER STRAIGHT LINES TO GET THE SHAPES RIGHT (SEE CHAPTER 3).

ERASE THE HEAD SHAPE AND ADD A FEW TEXTURE LINES AS GUIDES.

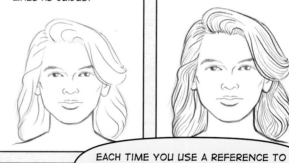

THEN ADD THE ADDITIONAL TEXTURE LINES.

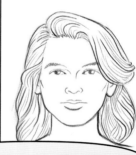

SHADE AND HIGHLIGHT IN THE SAME DIRECTION AS THE TEXTURE LINES.

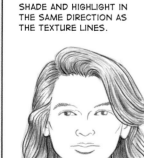

AN ERASER PENCIL WORKS GREAT HERE IF YOU HAVE ONE.

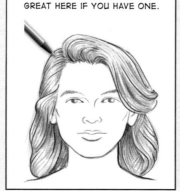

EACH TIME YOU USE A REFERENCE TO DRAW HAIR, YOU FILE AWAY A HAIRSTYLE TO DRAW LATER WHEN DRAWING FROM YOUR IMAGINATION.

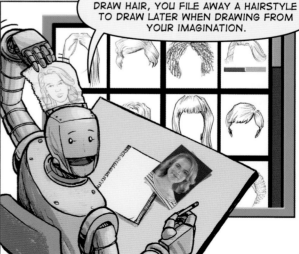

THOSE PROPORTIONS I SHOWED YOU ARE JUST STARTING POINTS. EVERY ONE OF THOSE RULES CAN (AND SHOULD) BE BROKEN.

TWEAK WHERE THE NOSE GOES. MAKE LIPS FULLER OR THINNER OR WIDER OR NARROWER! LENGTHEN OR SHORTEN THE WHOLE HEAD! *EVERYTHING IS ADJUSTABLE.*

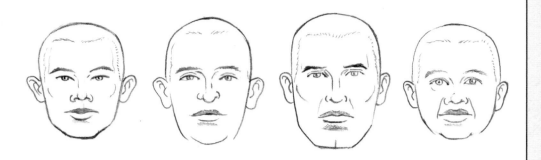

BUT DON'T OVERDO IT! IT ONLY TAKES SLIGHT ADJUSTMENTS TO MAKE A WIDER NOSE, THINNER LIPS, CLOSE-SET EYES, ETC.

FOR EXAMPLE, THESE TWO HEADS ARE VARIATIONS OF OUR STEP-BY-STEP FINAL.

THE HEAD SHAPE AND EARS WERE LEFT IDENTICAL, BUT I ADJUSTED THE SIZE AND POSITION OF THE EYES, NOSE AND LIPS. EVEN THOUGH THESE DIFFERENCES SEEM DRASTIC . . .

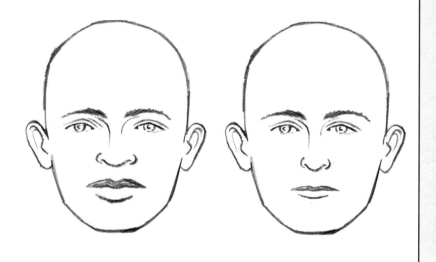

. . . THE *ACTUAL* AMOUNT OF CHANGE FROM THE ORIGINAL FEATURES IS PRETTY SMALL.

IN OTHER WORDS, IF YOU WANT A REALISTIC HEAD, BREAK THE RULES, BUT NOT *TOO* MUCH.

OF COURSE, WE CAN'T COVER ALL OF THE DETAILS IN A FEW PAGES. YOUR BEST BET IS TO DRAW AS MANY PEOPLE AS YOU CAN FROM OBSERVATION. BLACK-AND-WHITE SOURCES MAKE IT EASIER TO SEE THE VARIETY OF LINES AND FORMS THAT MAKE DRAWING HEADS SO INTERESTING.

KEEP AN EYE OUT FOR PLACES WHERE SKIN WRAPS AROUND THE SKULL. IF YOU WERE TO DRAW THEM WITH HARD LINES, THEY MIGHT LOOK SOMETHING LIKE THIS:

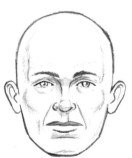

YIKES. LIKE THE SIDES OF THE NOSE, THESE LINES ARE BETTER SERVED WITH THIN, BROKEN LINES OR SHADING. BUT DON'T BE SCARED TO ADD THEM. JUST A FEW HINTS OF THE BONE STRUCTURE CAN ADD AN EXTRA LEVEL OF REALISM.

WHEN IT COMES TO SHOWING EMOTION, MOUTHS USUALLY GET ALL THE GLORY. BUT EYES CAN BE VERY EXPRESSIVE, TOO.

FOR EXPRESSIONS, YOUR BEST BET IS TO GRAB A MIRROR OR CAMERA, EMOTE AND PAY ATTENTION. DRAW WHAT YOU SEE, NOT WHAT YOU'RE USED TO SEEING FROM CARTOONS.

IN THE MEANTIME, THOUGH, HERE ARE SOME STEP-BY-STEPS TO GET YOU STARTED:

YEAH!

THE EYES CAN COMPLETELY CHANGE WHAT EMOTION IS CONVEYED BY A SMILE, A FROWN, ETC.

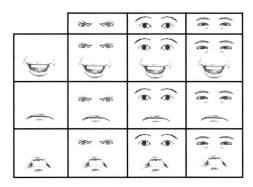

STEP-BY-STEP: A HAPPY FACE

1 A SMILE STARTS LIKE A NORMAL MOUTH, BUT IT'S A TINY BIT WIDER AND SLIGHTLY CURVED.

2 SMILES STRETCH THE LIPS, SO DRAW THEM THINNER.

AS ALWAYS, DON'T CONNECT TO THE CORNERS.

AWKWARD NATURAL

3 FLATTEN OR EVEN CURVE UP THE BOTTOM OF THE EYES.

4 USE LIGHT LINES TO SHOW HOW THE SKIN BELOW THE EYES GETS PUSHED UP AND WRINKLES A LITTLE.

STEP-BY-STEP: AN ANGRY FACE

1 THE TOP OF THE ANGRY-MOUTH TRAPEZOID IS RAISED UP A BIT.

2 THE TOP LIP IS *REALLY* STRETCHED, SO DRAW IT THIN! THE BOTTOM LIP, NOT SO MUCH.

THE TEETH DISAPPEAR AS THEY CURVE BACK INTO THE MOUTH.

3 THE NOSE PARENTHESES SHIFT UP, PULLING SOME SKIN WITH THEM AND CREATING INTERESTING WRINKLES.

FLIP AN ANGRY MOUTH UPSIDE DOWN AND WIDEN IT FOR A TOOTHY GRIN.

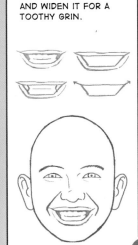

4 THE SKIN ABOVE THE EYES ACTUALLY COVERS THE TOP OF THE EYES AND GETS SMUSHED TOGETHER, MAKING A LITTLE BUTT.

5

HERE'S HOW TO GET REALLY GOOD AT DRAWING THE HUMAN BODY:

STEP 1: LEARN THE PROPORTIONS.

STEP 2: LEARN THE ANATOMY (MUSCLES, JOINTS, BONES).

STEP 3: LEARN THE BASICS OF PERSPECTIVE (ESPECIALLY FORESHORTENING CYLINDERS).

STEP 4: LEARN HOW TO DRAW FABRIC AND CLOTHES.

STEP 5: PRACTICE LIKE CRAZY! ALTERNATE BETWEEN DRAWING PEOPLE FROM YOUR IMAGINATION, THEN FROM OBSERVATION.

EACH ONE OF THESE STEPS DESERVES ITS OWN BOOK AND CAN TAKE YEARS OF PRACTICE TO MASTER. OUR GOAL FOR THE NEXT EIGHT PAGES IS TO CRAM IN JUST THE BASICS OF THIS COMPLEX TOPIC. BE GENTLE ON YOURSELF AND SET A REASONABLE GOAL. MAYBE SHOOT FOR SOMETHING A LITTLE MORE REALISTIC THAN KEITH HARING'S SYMBOL PEOPLE.

STEP-BY-STEP: NECK AND SHOULDERS

SOMETIMES, A HEAD AND SHOULDERS ARE ALL A DRAWING CALLS FOR, SO LET'S START THERE.

1 START WITH THE "TRAPS" (TRAPEZIUS MUSCLES).

THE SLOPE CAN VARY A LOT WITH THIS CURVE, BUT THE MAX SLOPE IS SOMEWHERE AROUND "CLOTHES HANGER."

2 THE NECK LINES UP ANYWHERE BETWEEN THE CORNER OF THE EYES AND THE EARS. BUT IT LOOKS WEIRD UNTIL YOU . . .

3 . . . REPLACE THE HARD CORNERS WITH NATURAL CURVES AND ERASE THE OVERLAP.

AS FOR THE DETAILS, YOU'LL PROBABLY BE DRAWING SOME KIND OF CLOTHING. OR NOT. EITHER WAY, PHOTO REFERENCES CAN HELP A LOT. IN THE MEANTIME, HERE ARE A FEW EXAMPLES OF COLLARS, REDUCED TO JUST A FEW LINES EACH.

THE TORSO	FOR THE REST OF THE UPPER BODY, IT'S USEFUL TO BREAK THE WHOLE THING INTO LENGTHS OF EITHER ONE OR TWO HEADS.

1 LIGHTLY SKETCH A HEAD-SHAPED BALLOON WITH A STRING THAT IS TWO HEADS LONG, HOLDING ALOFT ANOTHER HEAD.

1 HEAD 1 HEAD

2 GO A BIT MORE THAN HALF A HEAD DOWN AND ADD A LINE. THIS LINE ESTABLISHES THE WIDTH OF THE CHEST, AND WE'LL USE IT LATER TO ATTACH THE ARMS.

THE LENGTH OF THIS LINE VARIES, BUT A LITTLE LESS THAN A HEAD ON EITHER SIDE IS TYPICAL.

3 IMAGINE THE TOP OF A MARTINI GLASS OVER THE HIPS. THIS WILL HELP US ATTACH LEGS LATER, AND IT WILL ESTABLISH THE WIDTH AT THE HIPS.

4 EACH SECTION OF ARM IS ONE HEAD.

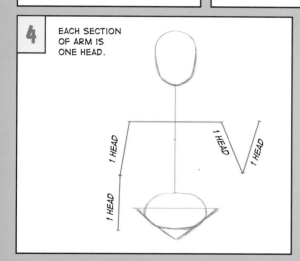

1 HEAD 1 HEAD 1 HEAD 1 HEAD

5 CONNECT THE DOTS!

THEN USE THE STEPS WE COVERED BEFORE FOR THE NECK AND TRAPS, AND ADD SHOULDERS THAT WRAP AROUND THE TOP OF THE ARM.

WE'LL COVER THE SHAPE OF THE ARMS NEXT.

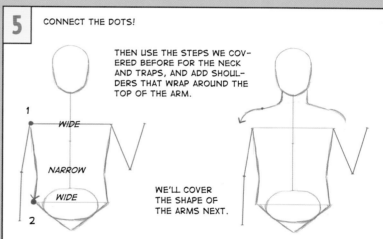

1
WIDE
NARROW
WIDE
2

BUT FIRST, HERE ARE A FEW TORSO TWEAKS TO BUILD CHARACTER . . .

FOR MORE *TRADITIONAL* MALE AND FEMALE FIGURES:

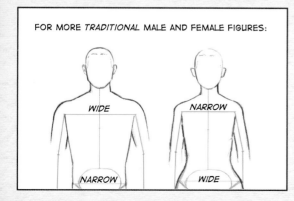

WIDE
NARROW

NARROW
WIDE

TO ADJUST THE BEEFINESS OF A TORSO:

NARROW/WIDEN NECK

LOWER/RAISE THE TRAPS

SCOOT THE SHOULDERS CLOSER IN/ FARTHER OUT.

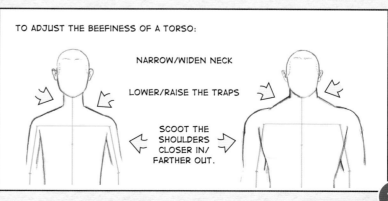

ARMS

ARMS GENERALLY GO FROM WIDE AT THE SHOULDER TO NARROW AT THE WRIST.

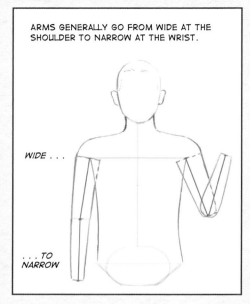

WIDE . . .

. . . TO NARROW

FOR BENT ARMS: DRAW EACH ARM SECTION SEPARATELY. WHICH OVERLAPPING LINES YOU ERASE AND WHICH YOU KEEP WILL DETERMINE IF THE ARM IS. . . .

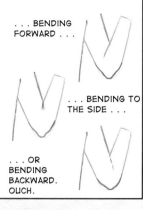

. . . BENDING FORWARD . . .

. . . BENDING TO THE SIDE . . .

. . . OR BENDING BACKWARD. OUCH.

FOR THE NEXT STEP IN REALISM, CHANGE THE SHAPE OF THE ARM BASED ON HOW THE HAND IS ROTATED.

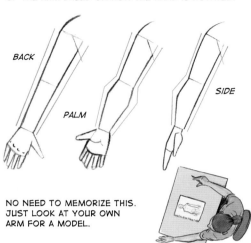

BACK

PALM

SIDE

NO NEED TO MEMORIZE THIS. JUST LOOK AT YOUR OWN ARM FOR A MODEL.

HANDS

START YOUR HANDS WITH SIMPLE SHAPES FIRST.

FINGERS GROW FROM ONE SIDE . . .

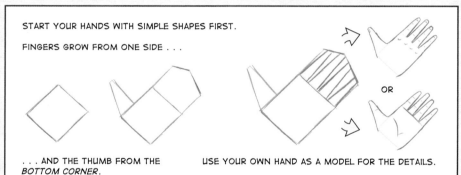

. . . AND THE THUMB FROM THE *BOTTOM CORNER.*

OR

USE YOUR OWN HAND AS A MODEL FOR THE DETAILS.

HANDS FROM THE SIDES FOLLOW THE SAME BASIC STEPS.

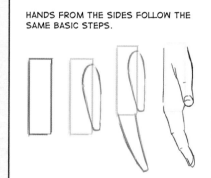

ONCE YOU GET THE BASICS . . .

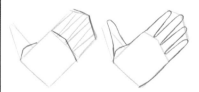

. . . THE FINGERS ARE ACTUALLY PRETTY CLOSE TO EACH OTHER IN LENGTH. THEY SEEM SO DIFFERENT BECAUSE THE TOP OF THE PALM IS UNEVEN.

IF YOUR THUMB LOOKS OFF, NOTE THAT IT ACTUALLY GROWS AND PIVOTS FROM A SMALL PROTRUSION.

WHEN DRAWING A CLOSED HAND, NOTE THAT THE FINGERS ACTUALLY BEND AT THE *KNUCKLES* NOT THE BASE OF THE FINGERS.

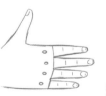

BEND AT THE BASE OF THE FINGERS (INCORRECT AND PAINFUL)

BEND AT THE KNUCKLES (CORRECT)

THERE'S NO REAL SHORTCUT FOR FORESHORTENED HANDS. YOU'LL NEED TO FIND A REAL HAND AND DRAW IT FROM OBSERVATION (REMEMBER CHAPTER 3).

THE SHAPES YOU DRAW PROBABLY WON'T LOOK QUITE RIGHT WHEN YOU START.

THESE ARE FINGERS?

+

A PALM?

=

INDEED.

LEGS

EACH SECTION OF LEG IS ABOUT *ONE AND THREE-QUARTERS HEADS*, NOT INCLUDING THE FEET.

GENERALLY, YOU CAN DRAW THEM FROM WIDE TO NARROW (LIKE THE ARMS).

ALSO LIKE THE ARMS, YOU CAN MAKE THE LEGS MORE REALISTIC BY CHANGING THE CURVES BASED ON THE ROTATION OF THE FOOT.

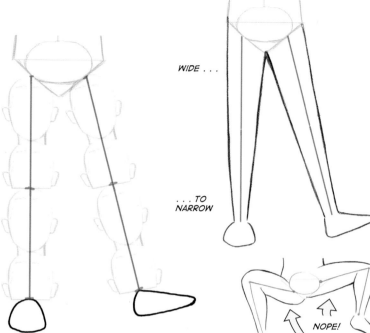

WIDE . . .

. . . TO NARROW

FACING FORWARD

CURVED

STRAIGHT

TURNED TO SIDE

STRAIGHT

CURVED

NOPE!

CORRECT

THOUGH THE LEG CAN ROTATE FROM THE HIPS, ITS ACTUAL *CONNECTION POINT* DOESN'T CHANGE. KEEP IT ANCHORED BELOW THE HIPS.

AVOID BALLOON LEGS! THIGHS GENERALLY JUST GO THICK TO THIN.

FEET

FEET (USUALLY IN THE FORM OF SHOES) CAN BE TRICKY BECAUSE THEY'RE ALMOST ALWAYS FORESHORTENED, AND THEY OFTEN DON'T LOOK LIKE WHAT YOU'D EXPECT. HERE'S A QUICK SHORTCUT APPROACH:

START BY DRAWING A HILL. THE TOP OF THE HILL IS CLOSER TO THE LEG. THE BOTTOM OF THE HILL IS V-SHAPED, WITH THE LOWEST POINT FARTHER FROM THE LEG.

THE ACTUAL SHOE (OR FOOT) WILL HAVE A LOT OF DETAILS BEST DRAWN FROM OBSERVATION.

TWO MORE THINGS:

1. WHEN DRAWING SMALLER FIGURES, ALL YOU REALLY NEED TO DRAW ARE THE "HILLS" AND MAYBE A FEW EMBELLISHMENT LINES.

2. THE FARTHER BELOW THE VIEWER'S EYES, THE STEEPER THE ANGLES OF THE BOTTOM OF THE FEET. SAME WITH THE ANGLE *BETWEEN* THE FEET.

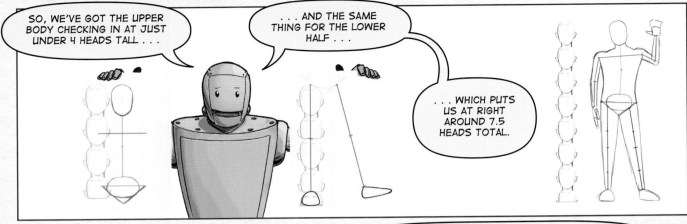

SO, WE'VE GOT THE UPPER BODY CHECKING IN AT JUST UNDER 4 HEADS TALL . . .

. . . AND THE SAME THING FOR THE LOWER HALF . . .

. . . WHICH PUTS US AT RIGHT AROUND 7.5 HEADS TOTAL.

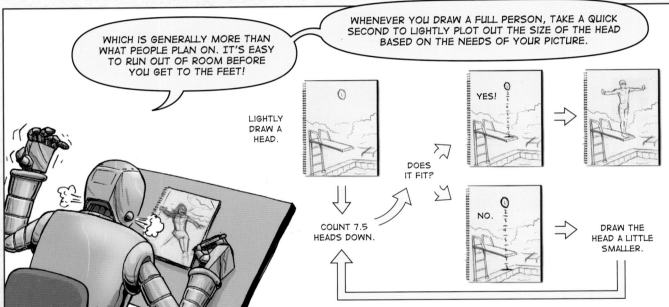

WHICH IS GENERALLY MORE THAN WHAT PEOPLE PLAN ON. IT'S EASY TO RUN OUT OF ROOM BEFORE YOU GET TO THE FEET!

WHENEVER YOU DRAW A FULL PERSON, TAKE A QUICK SECOND TO LIGHTLY PLOT OUT THE SIZE OF THE HEAD BASED ON THE NEEDS OF YOUR PICTURE.

LIGHTLY DRAW A HEAD.

COUNT 7.5 HEADS DOWN.

DOES IT FIT?

YES!

NO.

DRAW THE HEAD A LITTLE SMALLER.

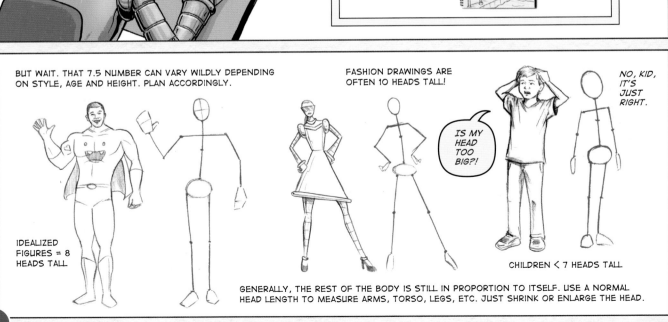

BUT WAIT. THAT 7.5 NUMBER CAN VARY WILDLY DEPENDING ON STYLE, AGE AND HEIGHT. PLAN ACCORDINGLY.

FASHION DRAWINGS ARE OFTEN 10 HEADS TALL!

NO, KID, IT'S JUST RIGHT.

IS MY HEAD TOO BIG?!

IDEALIZED FIGURES = 8 HEADS TALL

CHILDREN < 7 HEADS TALL

GENERALLY, THE REST OF THE BODY IS STILL IN PROPORTION TO ITSELF. USE A NORMAL HEAD LENGTH TO MEASURE ARMS, TORSO, LEGS, ETC. JUST SHRINK OR ENLARGE THE HEAD.

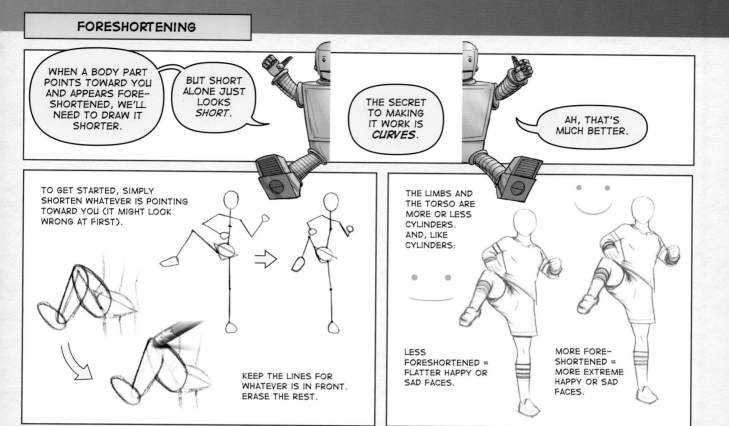

WHEN A BODY PART POINTS TOWARD YOU AND APPEARS FORE-SHORTENED, WE'LL NEED TO DRAW IT SHORTER.

BUT SHORT ALONE JUST LOOKS *SHORT*.

THE SECRET TO MAKING IT WORK IS *CURVES*.

AH, THAT'S MUCH BETTER.

TO GET STARTED, SIMPLY SHORTEN WHATEVER IS POINTING TOWARD YOU (IT MIGHT LOOK WRONG AT FIRST).

KEEP THE LINES FOR WHATEVER IS IN FRONT. ERASE THE REST.

THE LIMBS AND THE TORSO ARE MORE OR LESS CYLINDERS. AND, LIKE CYLINDERS:

LESS FORESHORTENED = FLATTER HAPPY OR SAD FACES.

MORE FORE-SHORTENED = MORE EXTREME HAPPY OR SAD FACES.

STEP-BY-STEP: FORESHORTENING

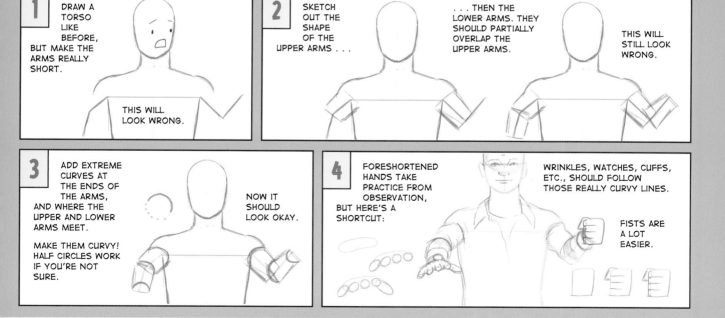

1 DRAW A TORSO LIKE BEFORE, BUT MAKE THE ARMS REALLY SHORT.

THIS WILL LOOK WRONG.

2 SKETCH OUT THE SHAPE OF THE UPPER ARMS . . .

. . . THEN THE LOWER ARMS. THEY SHOULD PARTIALLY OVERLAP THE UPPER ARMS.

THIS WILL STILL LOOK WRONG.

3 ADD EXTREME CURVES AT THE ENDS OF THE ARMS, AND WHERE THE UPPER AND LOWER ARMS MEET.

MAKE THEM CURVY! HALF CIRCLES WORK IF YOU'RE NOT SURE.

NOW IT SHOULD LOOK OKAY.

4 FORESHORTENED HANDS TAKE PRACTICE FROM OBSERVATION, BUT HERE'S A SHORTCUT:

WRINKLES, WATCHES, CUFFS, ETC., SHOULD FOLLOW THOSE REALLY CURVY LINES.

FISTS ARE A LOT EASIER.

FORESHORTENING IS STILL PRETTY TRICKY TO MASTER. FOLLOWING THESE BASIC PRINCIPLES WILL HELP YOU, BUT YOU'LL STILL NEED TO DRAW A TON OF PEOPLE FROM OBSERVATION TO GET THE HANG OF IT.

STEP-BY-STEP: BODY PROPORTIONS

OKAY, GOT ALL THAT? IF NOT, GO BACK AND REFER TO EACH SECTION AS YOU WORK THROUGH THIS STEP-BY-STEP. BE SURE TO LEAVE ROOM FOR THE WHOLE BODY (7.5 HEADS TALL).

1 DRAW A HEAD AND MARK DOWN THE LENGTH OF THE HEAD ON SCRAP PAPER.

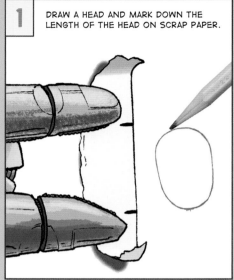

2 USE THE SCRAP TO MEASURE TWO HEADS DOWN, THEN ADD A SIDEWAYS HEAD.

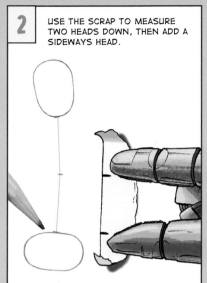

3 NOTICE THE SLIGHT CURVE TO THE BODY. THIS MAKES IT LOOK MORE NATURAL.

THIS PERSON HAS SHOULDERS A LITTLE LESS THAN 1 HEAD'S LENGTH ON EITHER SIDE.

HIPS ARE SLIGHTLY TILTED AND A LITTLE WIDER THAN 1 HEAD.

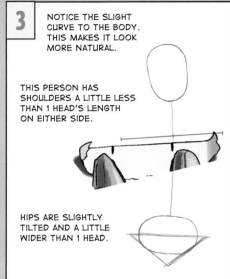

4 THE UPPER AND LOWER LEGS ARE EACH ABOUT 1 AND 3/4 HEADS.

THE SLIGHT ANGLE OF THE HIP ALLOWS THIS LEG TO START HIGHER AND GO STRAIGHT DOWN . . .

. . . AND THIS LEG TO START LOWER AND ANGLE OUT A BIT.

BUT THEY STILL END UP EVEN.

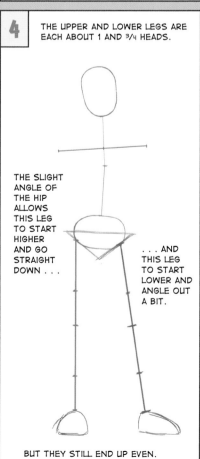

5 AS ALWAYS, EACH ARM IS ONE HEAD. BUT THIS UPPER ARM IS POINTING TOWARD YOU A LITTLE, SO IT'S DRAWN A BIT SHORTER.

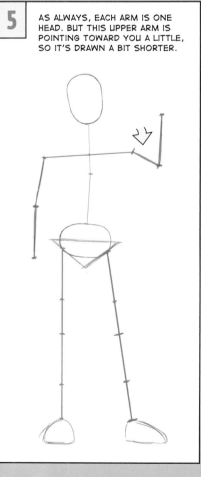

6 DRAW THE NECK, TRAPS AND SHOULDERS LIKE BEFORE, BUT KEEP THE SHOULDERS LOOSE. YOU MIGHT NEED TO TWEAK THEM BASED ON WHAT THE ARM IS DOING.

WIDE

NARROW

WIDE

CONNECT THE DOTS!

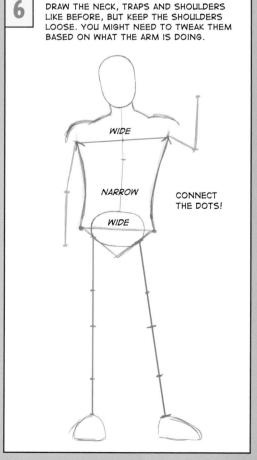

7 START OUT WITH SIMPLE SHAPES FOR THE LIMBS. FOCUS ON GOING FROM WIDE TO NARROW.

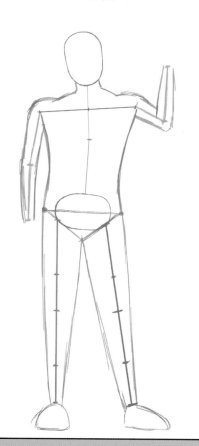

8 DRAW OVERALL SHAPES FOR HANDS, KEEPING THE FINGERS A LITTLE SHORTER THAN THE PALM.

IN THIS CASE, THE LOWER ARM OVERLAPS THE UPPER ARM.

OTHERWISE, THE ARM WOULD BE POINTING AWAY.

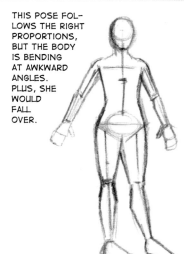

9 ADD THE FACE, TWEAK THE CURVES AND FIND A REFERENCE PHOTO TO PUT ON SOME CLOTHES.

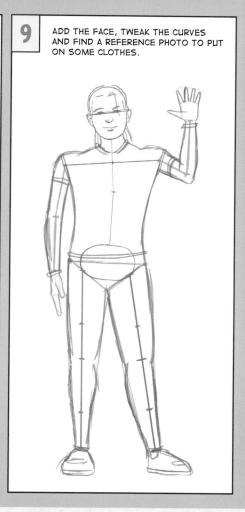

HAVE A PURPOSE AND A POSE

IT'S IMPERATIVE WHEN YOU START DRAWING THE FULL BODY TO FIRST RE-CREATE THE POSE YOU'RE TRYING TO DRAW. SERIOUSLY! THIS ISN'T A BONUS TIP OR ANYTHING. YOU'VE GOT TO PUT DOWN THE PENCIL, STAND UP AND PAY ATTENTION TO HOW YOUR WEIGHT IS DISTRIBUTED, THE ANGLES OF YOUR LIMBS, THE TILT OF YOUR HIPS AND SPINE, THE DIRECTION OF YOUR FEET, ETC. EVEN IF IT'S A SIMPLE POSE, THERE'S USUALLY SOME SHIFT OF THE WEIGHT, ONE FOOT IS FARTHER OUT, ETC., BUT YOU NEED TO IDENTIFY IT BEFORE YOU START!

THIS POSE FOLLOWS THE RIGHT PROPORTIONS, BUT THE BODY IS BENDING AT AWKWARD ANGLES. PLUS, SHE WOULD FALL OVER.

THIS LOOKS MORE SOLID. HER FEET ARE UNDER HER BODY, HER ARMS HANG NATURALLY, HER FEET ARE POINTED COMFORTABLY AND SO ON.

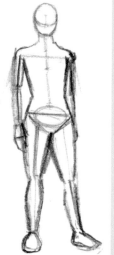

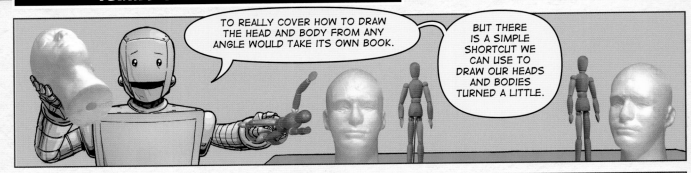

TO REALLY COVER HOW TO DRAW THE HEAD AND BODY FROM ANY ANGLE WOULD TAKE ITS OWN BOOK.

BUT THERE IS A SIMPLE SHORTCUT WE CAN USE TO DRAW OUR HEADS AND BODIES TURNED A LITTLE.

HERE'S HOW IT WORKS:

IF YOU DRAW A FACE IN THE MIDDLE OF A HEAD, THE PERSON SEEMS TO BE FACING FORWARD.

SCOOT IT TO THE SIDE A LITTLE, AND THE PERSON APPEARS TO BE TURNING THEIR HEAD.

IT WORKS FOR ANYTHING THAT'S NORMALLY IN THE MIDDLE OF AN OBJECT, LIKE A COLLAR OR BELT BUCKLE. JUST SCOOT IT OVER A LITTLE, AND THE OBJECT WILL APPEAR TO BE TURNED.

WITH A FEW ADJUSTMENTS, THIS CONCEPT IS A GOOD SHORTCUT SUBSTITUTE FOR DRAWING REALISTIC PEOPLE TURNED TO THE SIDE A LITTLE.

NORMALLY, THE CHIN GOES IN THE MIDDLE, BUT FOR A TURNED HEAD, SCOOT IT OVER SLIGHTLY.

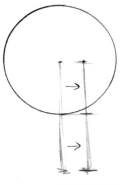

THEN, CONNECT THE SIDES OF THE CIRCLE TO THE CHIN, AND ADD A LITTLE TO THE BACK OF THE HEAD.

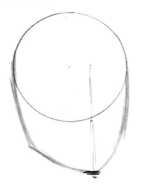

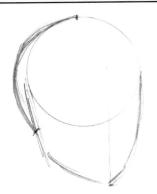

EYES ARE IN THE SAME PLACE AS BEFORE, BUT SHIFT THEM OVER A LITTLE AND SQUISH THEM IN A TINY BIT.

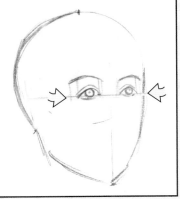

THE NOSE PARENTHESES LINE UP WITH THE CORNERS OF THE EYES AND LIE AT THE BOTTOM OF THE CIRCLE, JUST LIKE BEFORE. THE ONLY DIFFERENCE IS THAT THE *NOSEBALL* SHIFTS A LITTLE WITHIN THE PARENTHESES.

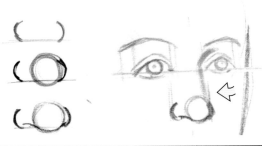

YOU CAN USE A HARD LINE TO DRAW THE SIDE OF THE NOSE WHEN THE HEAD IS TURNED.

THE MOUTH LINES UP THE SAME AS BEFORE, BUT THE LI LINES ABOVE AND BELOW SHIFT OVER A LITTLE WITHIN THE MOUTH SHAPE.

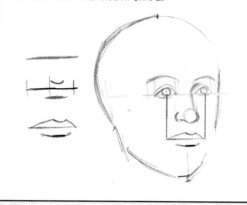

THE HAIRLINE STAYS LINED UP WITH THE CORNERS OF THE EYES, JUST LIKE BEFORE. THE EAR SCOOTS IN A LITTLE, AND THE FAR EAR DISAPPEARS.

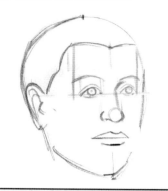

FLATTEN THE SIDE OF THE FOREHEAD AND USE A LIGHT LINE TO SHOW THE CHIN.

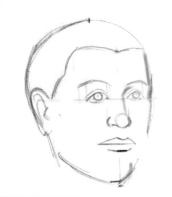

FOR TURNS TO THE BODY, IT'S THE SAME BASIC IDEA: SHIFT STUFF OVER.

START AS YOU NORMALLY DO . . .

. . . BUT MOVE THE BOTTOM OF THE HEAD AND THE BOTTOM OF THE HIPS OVER A LITTLE.

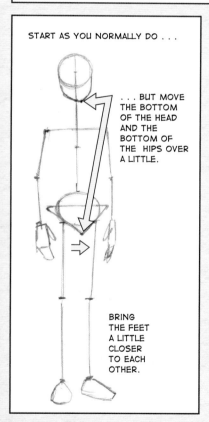

BRING THE FEET A LITTLE CLOSER TO EACH OTHER.

THE UPPER ARM SHIFTS IN FRONT OF THE CHEST ON THE NEAR SIDE . . .

. . . AND BEHIND THE CHEST ON THE FAR SIDE.

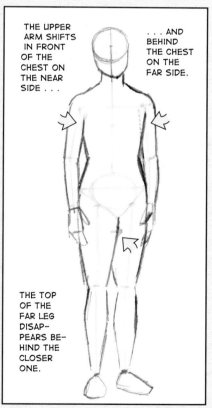

THE TOP OF THE FAR LEG DISAPPEARS BEHIND THE CLOSER ONE.

SCOOT DETAILS OVER IN THE SAME DIRECTION THE PERSON IS FACING.

EXAMPLES INCLUDE ZIPPERS, COLLARS, NECKLACES, HAT BRIMS, BELT BUCKLES, ETC.

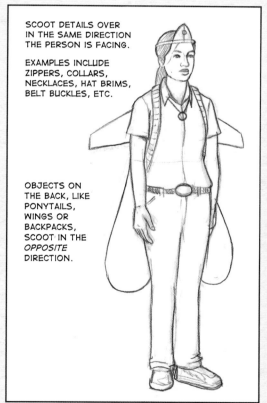

OBJECTS ON THE BACK, LIKE PONYTAILS, WINGS OR BACKPACKS, SCOOT IN THE *OPPOSITE* DIRECTION.

WE'VE JUST REDUCED WHAT COULD BE A VOLUME OF BOOKS INTO ONE CHAPTER, WHICH MEANS WE LEFT OUT A TON OF DETAILS AND NUANCES THAT YOU'LL NEED TO REALLY MAKE YOUR PEOPLE LOOK REALISTIC. BUT THESE TECHNIQUES WILL SERVE AS A USEFUL START ON YOUR LONG JOURNEY TO DRAWING REALISTIC PEOPLE.

BE PATIENT AS YOU LEARN TO DRAW PEOPLE. IT'S POSSIBLY THE MOST COMPLEX SUBJECT, AND EVERYONE CAN TELL IF YOU'RE OFF A LITTLE. EVEN IF YOU CONSIDER YOURSELF A TALENTED ARTIST, DON'T BE TOO HARD ON YOURSELF IF YOUR FIRST FEW YEARS OF EFFORTS LOOK KIND OF AWKWARD. GRADUALLY, PRACTICING BODY PROPORTIONS AND DRAWING FROM OBSERVATION WILL DO WONDERS.

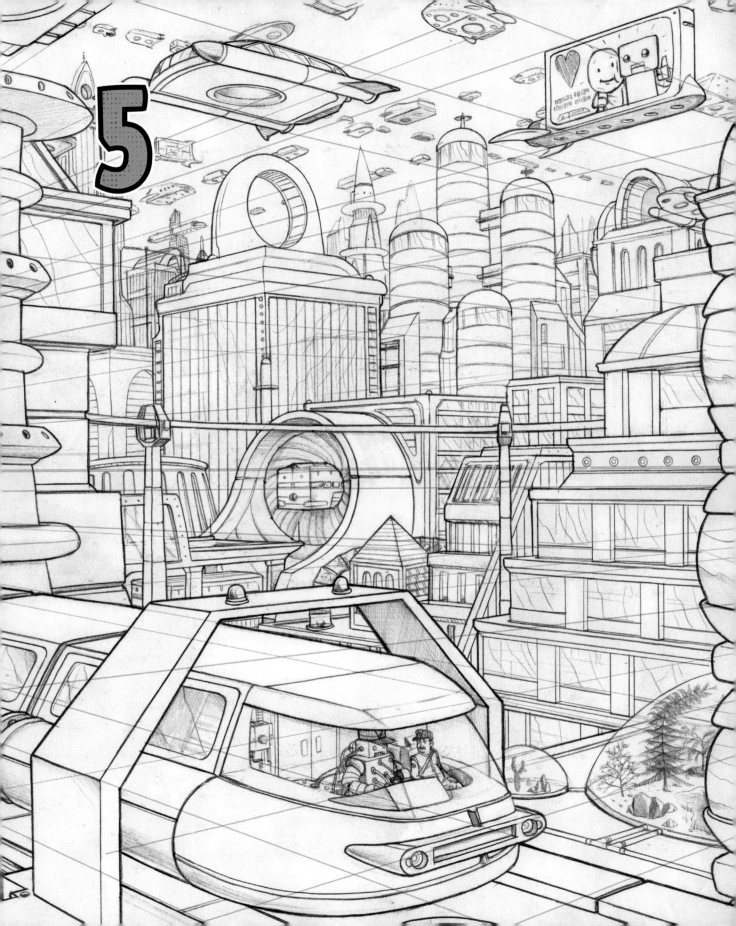

Perspective

HUMANS HAVE LARGELY SHAPED THE MODERN WORLD INTO BOXES, CYLINDERS AND SPHERES. LEARN TO DRAW THESE BASIC FORMS, AND YOU CAN DRAW THE UNDERLYING STRUCTURES OF ALL KINDS OF THINGS.

LOOKS OKAY . . . I GUESS.

SPHERES ARE EASY. THEY'RE JUST CIRCLES.

CYLINDERS CAN BE TRICKIER. LOTS OF PEOPLE DRAW THE TOP WITH AN OPENING AND LEAVE THE BOTTOM TOO FLAT.

FOR BOXES, THE MOST COMMON TECHNIQUE IS TO CONNECT TWO OVERLAPPING SQUARES.

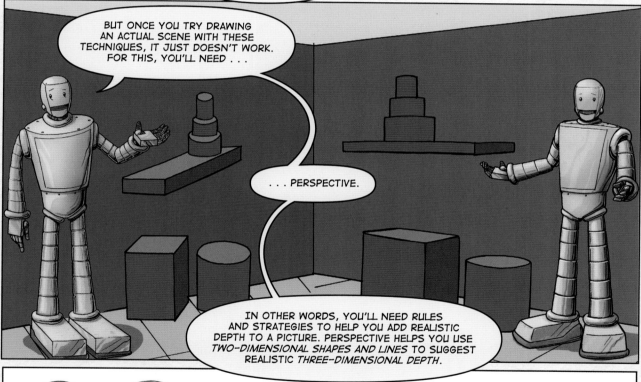

BUT ONCE YOU TRY DRAWING AN ACTUAL SCENE WITH THESE TECHNIQUES, IT JUST DOESN'T WORK. FOR THIS, YOU'LL NEED . . .

. . . PERSPECTIVE.

IN OTHER WORDS, YOU'LL NEED RULES AND STRATEGIES TO HELP YOU ADD REALISTIC DEPTH TO A PICTURE. PERSPECTIVE HELPS YOU USE TWO-DIMENSIONAL SHAPES AND LINES TO SUGGEST REALISTIC THREE-DIMENSIONAL DEPTH.

IN THIS CHAPTER, WE'LL LEARN THE RULES FOR DRAWING SPHERES, CYLINDERS AND BOXES IN CORRECT PERSPECTIVE AND USE THEM TO TURN THE SHAPES INTO A VARIETY OF SUBJECTS.

LET'S START WITH CYLINDERS, THOUGH WE COVERED THE BASICS PRETTY WELL BACK IN CHAPTERS 1 AND 2 WITH THAT STEP-BY-STEP OF THE ROCKET.

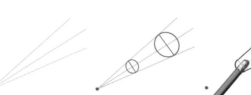

DRAW THREE EVENLY SPACED LINES CONVERGING ON A POINT.

DRAW ELLIPSES PERPENDICULAR TO THE MIDDLE LINE.

ERASE A BUNCH OF STUFF.

DRAW DETAILS LINED UP TO THE POINT OR PARALLEL TO THE ELLIPSES.

AVOID PENNE PASTA . . .

(ELLIPSES NOT PER-PENDICULAR TO THE MIDDLE LINE)

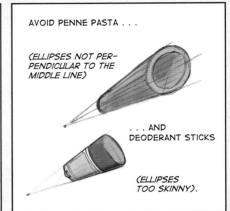

. . . AND DEODORANT STICKS

(ELLIPSES TOO SKINNY).

THE FARTHER AWAY THE POINT, THE *LESS* THE CYLINDER IS FORESHORTENED.

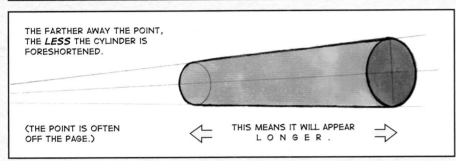

(THE POINT IS OFTEN OFF THE PAGE.)

← THIS MEANS IT WILL APPEAR L O N G E R. →

FOR CYLINDERS THAT ARE JUST BARELY ANGLING AWAY FROM YOU, THE POINTS ARE SO FAR AWAY THAT IT'S IMPRACTICAL TO DRAW THEM. SO DON'T. JUST CHEAT AND START WITH A RECTANGLE INSTEAD.

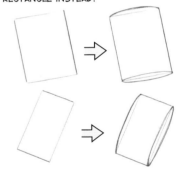

THE CLOSER THE POINT, THE *MORE* THE CYLINDER APPEARS FORESHORTENED.

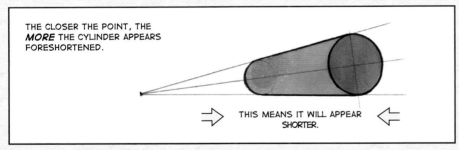

⇒ THIS MEANS IT WILL APPEAR SHORTER. ⇐

BE SURE TO USE REALLY THIN ELLIPSES, THOUGH, SINCE THE CYLINDER ISN'T POINTING TOWARD YOU MUCH.

NOTICE THAT THE ELLIPSES CHANGE, TOO. MORE FORESHORTENING MEANS FATTER ELLIPSES.

CLOSER VANISHING POINT = MORE FORESHORTENING = FATTER ELLIPSE

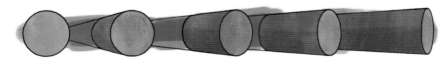

FARTHER VANISHING POINT = LESS FORESHORTENING = THINNER ELLIPSE

IN REALITY, THE MORE DISTANT CURVE WILL APPEAR A LITTLE FATTER THAN THE CLOSER ONE, BUT MOST OF THE TIME IT'S NOT NOTICEABLE.

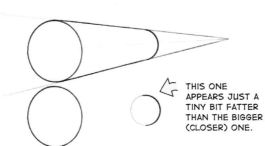

THIS ONE APPEARS JUST A TINY BIT FATTER THAN THE BIGGER (CLOSER) ONE.

PRACTICE BY DRAWING THE FOLLOWING CYLINDERS:

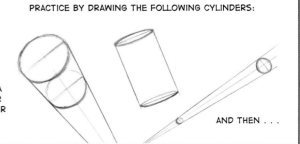

AND THEN . . .

. . . TRY TURNING THEM INTO THINGS. HERE ARE SOME POSSIBILITIES . . .

A LOT OF CYLINDERS ARE *HORIZONTAL*: EXHAUST PIPES, WHEELS, SPINNING COINS, ROLLING PINS, ETC. YOU CAN USE THE SAME STRATEGY FOR THESE AS YOU DID FOR TILTED ONES, JUST MAKE SURE THE POINT YOU USE IS ON THE *HORIZON LINE*. THAT'S AN IMAGINARY LINE THAT MARKS WHAT'S EYE LEVEL WITH YOU. GENERALLY, IT'S ALSO WHERE *THE SKY MEETS THE EARTH*.

TILTED CYLINDERS = POINTS *NOT* ON THE HORIZON LINE

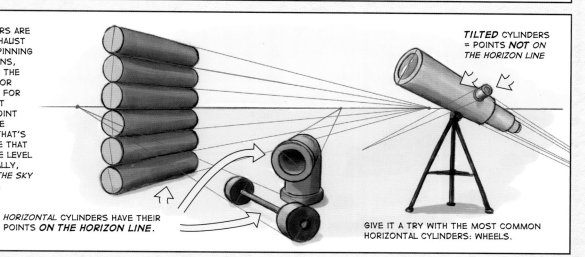

HORIZONTAL CYLINDERS HAVE THEIR POINTS *ON THE HORIZON LINE*.

GIVE IT A TRY WITH THE MOST COMMON HORIZONTAL CYLINDERS: WHEELS.

DRAW A HORIZON LINE AND A REALLY LIGHT BLOB.

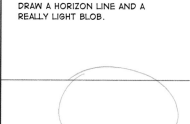

PICK A POINT ON THE HORIZON LINE AND DRAW THREE LINES FOR EACH SET OF WHEELS.

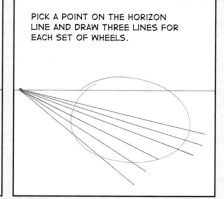

DRAW ELLIPSES PERPENDICULAR TO THE MIDDLE LINE FOR EACH CYLINDER.

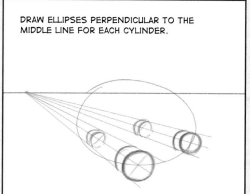

FINISH THE CYLINDERS AND ERASE THE UNNECESSARY LINES (EXCEPT FOR A TINY BIT TO GET THE TILT RIGHT FOR ANY DETAILS).

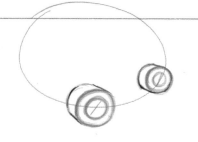

IT'S UP TO YOU TO TURN THE BLOB INTO SOMETHING . . .

PUMPKIN CARRIAGE?

WHATEVER THIS IS?

VERTICAL CYLINDERS

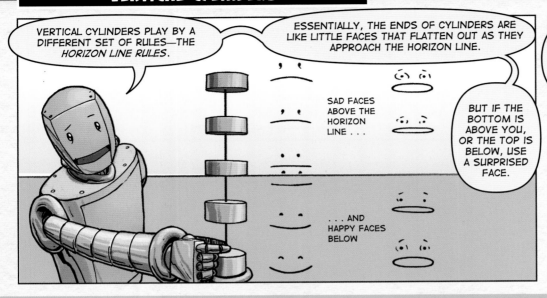

VERTICAL CYLINDERS PLAY BY A DIFFERENT SET OF RULES—THE *HORIZON LINE RULES.*

ESSENTIALLY, THE ENDS OF CYLINDERS ARE LIKE LITTLE FACES THAT FLATTEN OUT AS THEY APPROACH THE HORIZON LINE.

SAD FACES ABOVE THE HORIZON LINE . . .

BUT IF THE BOTTOM IS ABOVE YOU, OR THE TOP IS BELOW, USE A SURPRISED FACE.

. . . AND HAPPY FACES BELOW

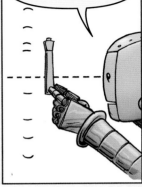

IF YOU FORGET WHICH IS WHICH, JUST HOLD A VERTICAL PEN OR CUP IN FRONT OF YOUR FACE AND SHIFT IT UP AND DOWN.

1 ESTABLISH THE HORIZON LINE IN THE MIDDLE OF THE PICTURE AND ADD A BUNCH OF VERTICAL RECTANGLES.

(KEEP YOUR SKETCHBOOK STRAIGHT!)

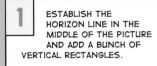

2 ERASE THE ENDS OF THE RECTANGLES. YOU SHOULD BE LEFT WITH PAIRS OF EVEN, VERTICAL LINES.

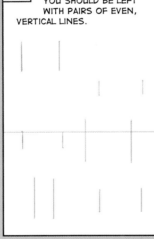

3 CAP OFF THE ENDS OF THE RECTANGLES WITH THE FOLLOWING COMBOS OF FACES.

FLATTEN THEM AS YOU APPROACH THE HORIZON!

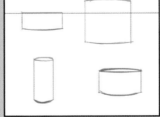

4 DETAILS FOLLOW THE SAME PATTERNS, FLATTENING AS THEY APPROACH THE HORIZON.

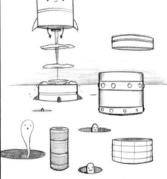

(HOLES DO, TOO!)

CAREFUL! IF YOU USE THE WRONG KIND OF CURVE, YOUR CYLINDER WILL LOOK EITHER

A LITTLE TILTED . . .

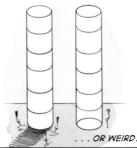

. . . OR WEIRD.

BUT THE MOST COMMON MISTAKE WITH VERTICAL CYLINDERS IS MAKING THE CURVES TOO CURVY.

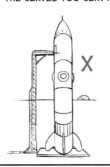

THE ENDS OF VERTICAL CYLINDERS ONLY CURVE *THAT MUCH* IF YOU'RE LOOKING *WAY UP OR DOWN.* MORE ON THAT LATER . . .

FOR NOW, KEEP THE CURVES MELLOW. IT MAY SEEM TOO SUBTLE, BUT IT ONLY TAKES A *SLIGHT* AMOUNT OF CURVE TO SHOW THE DIFFERENCE BETWEEN A RECTANGLE AND A CYLINDER.

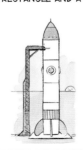
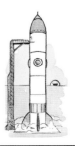

STEP-BY-STEP: CASTLE

LET'S PRACTICE BY DRAWING A CASTLE FULL OF VERTICAL CYLINDER TURRETS.

1 ESTABLISH YOUR HORIZON LINE AND DRAW THE FRONT WALL OF YOUR CASTLE.

2 TIME FOR THE CYLINDERS. START WITH RECTANGLES.

DRAW THE BOTTOMS OF THE RED ONES A *TINY* BIT LOWER THAN THE BIG RECTANGLE FROM STEP 1. THAT WAY THEY WILL APPEAR A TINY BIT CLOSER THAN THE REST OF THE CASTLE.

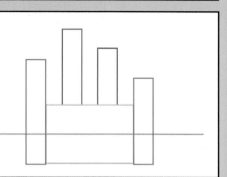

3 ERASE THE ENDS OF THE RECTANGLES, AND REDRAW THE TOPS AND BOTTOMS OF THE TOWERS WITH HAPPY AND SAD FACES.

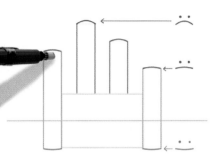

SAD FACES ABOVE THE HORIZON LINE.

HAPPY FACES BELOW THE HORIZON LINE.

KEEP THE FACES MELLOW! THE BOTTOM FACES ARE SO CLOSE TO THE HORIZON LINE THAT THEY APPEAR *ALMOST FLAT*.

4 INSTALL A CIRCULAR MOAT BY DRAWING SKINNY ELLIPSES AROUND THE CASTLE.

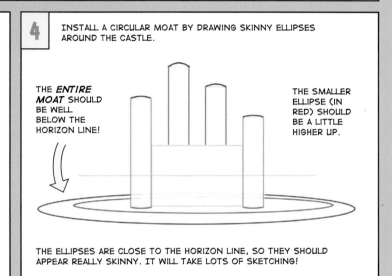

THE *ENTIRE MOAT* SHOULD BE WELL BELOW THE HORIZON LINE!

THE SMALLER ELLIPSE (IN RED) SHOULD BE A LITTLE HIGHER UP.

THE ELLIPSES ARE CLOSE TO THE HORIZON LINE, SO THEY SHOULD APPEAR REALLY SKINNY. IT WILL TAKE LOTS OF SKETCHING!

5 JUST LIKE OUR ROCKET EARLIER, ADD CONES BY PICKING A POINT IN LINE WITH THE CYLINDER AND CONNECTING THE DOTS.

6 TEXTURE LINES SHOULD APPEAR FLATTER AS YOU APPROACH THE HORIZON LINE. A BARELY CURVED LINE CAN BE TOUGH TO GET RIGHT. SKETCH LIGHTLY UNTIL YOU GET IT!

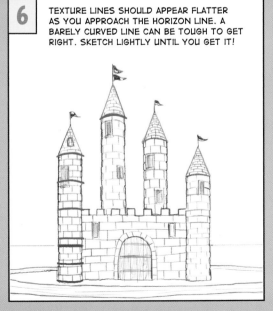

7 HOLD OFF ON THE FOREGROUND UNTIL WE LEARN ABOUT ONE-POINT PERSPECTIVE.

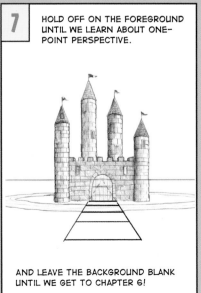

AND LEAVE THE BACKGROUND BLANK UNTIL WE GET TO CHAPTER 6!

FOR OUR CASTLE, WE PUT THE HORIZON LINE NEAR THE MIDDLE OF THE PICTURE AND USED VERTICAL LINES LIKE THESE.

BUT IF YOU LOOK UP OR DOWN, THE HORIZON LINE SHIFTS, AND VERTICAL LINES SEEM TO SLANT.

IN THESE SITUATIONS, DRAWING VERTICAL CYLINDERS BECOMES JUST LIKE DRAWING *TILTED* CYLINDERS, BUT WITH THE VANISHING POINT CENTERED ABOVE OR BELOW THE PICTURE. ALSO, THE HORIZON LINE SHIFTS IN THE *OPPOSITE* DIRECTION.

LOOKING UP A LITTLE . . .

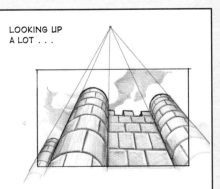

. . . THE VANISHING POINT IS WAY UP, BUT THE HORIZON LINE IS ONLY A LITTLE LOWER THAN NORMAL.

STEP-BY-STEP: SUSHI PLATE

IT'S THE SAME DEAL WHEN YOU'RE *LOOKING DOWN*, BUT IN REVERSE. LET'S PRACTICE WITH WHAT YOU SEE WHEN YOU LOOK DOWN AT A PLATE OF SUSHI.

1 BECAUSE THE VANISHING POINT AND HORIZON LINE SCOOT SO FAR AWAY, YOU SHOULD DRAW SMALL, LIKE THIS:

START WITH A VANISHING POINT AND HORIZON LINE, THEN DRAW THREE SETS OF LINES: ONE FOR THE CUP, TWO FOR THE SUSHI.

HORIZON LINE

(DRAW HERE)

VANISHING POINT

CUP SUSHI

2 JUST LIKE WITH TILTED CYLINDERS, DRAW ELLIPSES AND CURVES PERPENDICULAR TO THE MIDDLE LINE.

SKETCH LIGHTLY. AVOID PENNE AND DEODORANT STICKS.

LOOKING UP A LOT . . .

. . . THE VANISHING POINT IS BARELY ABOVE THE IMAGE, BUT THE HORIZON LINE SHIFTS *WAY* DOWN, FAR OFF THE BOTTOM OF THE PICTURE.

3 USE THE HORIZON LINE TO DRAW A HORIZONTAL SUSHI PIECE (LYING ON ITS SIDE).

MARK A POINT ANYWHERE ON THE HORIZON LINE

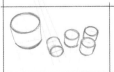

4 USE THE MIDLINES FROM STEP 2 FOR INTERIOR CIRCLES AND EDGES.

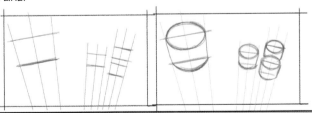

(IN A FEW PAGES, WE'LL COVER RECT-ANGLES WHEN LOOKING DOWN.)

TO REVIEW, WE'VE GOT TWO GENERAL APPROACHES TO CYLINDERS:

1. CYLINDERS THAT GO TO A VANISHING POINT AND USUALLY HAVE CURVIER "FACES" AND FATTER ELLIPSES.

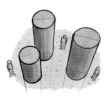

TILTED *HORIZONTAL* *VERTICAL WITH VIEWER LOOKING UP OR DOWN*

2. CYLINDERS THAT ARE DRAWN WITH VERTICAL LINES FOR WHEN THE VIEWER IS LOOKING STRAIGHT AHEAD. THESE HAVE FLATTER FACES AND SKINNY ELLIPSES.

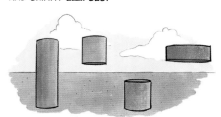

BUT **SHADING** THESE OBJECTS IS THE SAME NO MATTER WHICH WAY YOU DRAW THEM.

ANY POINTS ON THE SAME ROW FACE THE LIGHT AT THE SAME ANGLE AND WILL HAVE THE SAME VALUE.

WHICH MEANS SHADING ONLY HAPPENS FROM SIDE-TO-SIDE, NEVER END-TO-END*.

*UNLESS THE LIGHT SOURCE IS *REALLY* CLOSE.

THIS LEAVES THREE POSSIBILITIES FOR SHADING:

DARK TO LIGHT: WHEN THE LIGHT HITS MOSTLY THE SIDE

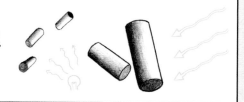

DARK/ LIGHT/ DARK: WHEN THE LIGHT HITS MOSTLY THE END

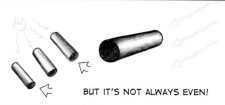

BUT IT'S NOT ALWAYS EVEN!

LIGHT/DARK/LIGHT: WHEN THE CYLINDER IS LIT FROM BEHIND

CHOOSE A LIGHT SOURCE FOR EACH OF THE PICTURES WE DREW IN THIS CHAPTER. (I IMAGINE LIGHT COMING FROM BEHIND THE VIEWER, A LITTLE ABOVE AND TO THE RIGHT). THEN, SHADE THE CYLINDERS ACCORDINGLY.

AFTER ALL THOSE RULES AND VANISHING POINTS, I'M HAPPY TO REPORT THAT SPHERES ARE ALMOST ALWAYS DRAWN AS CIRCLES.

BUT IN THAT CASE, HOW DO WE KNOW IF THIS OBJECT IS A FLAT CIRCLE OR A ROUND SPHERE?

YOU HAVE TWO WAYS TO SHOW THAT A CIRCLE IS A SPHERE:

SHADING

SURFACE LINES

(LET'S START WITH THIS ONE.)

OCCASIONALLY, SPHERES ARE DIVIDED UP WITH TWO SETS OF CONVERGING LINES.

MORE OFTEN, YOU HAVE ONE SET OF CONVERGING LINES, AND ONE SET OF PARALLEL LINES, LIKE A DISCO BALL.

STEP-BY-STEP: DISCO BALL

1 DRAW CIRCULAR CROSSHAIRS.

DECREASE THE SPACE BETWEEN TICK MARKS CLOSER TO THE EDGE.

2 CONNECT THE TOP TO THE BOTTOM WITH SMOOTH CURVES, LIKE LONGITUDE LINES. USE THE TICK MARKS FROM STEP 1 AS A GUIDE.

USE YOUR WRIST.

ROTATE YOUR PAPER SO YOU DON'T END UP PUSHING YOUR PENCIL.

3 THE LATITUDE LINES ARE MORE LIKE VERTICAL CYLINDER DETAILS, EXCEPT THEY GET CLOSER AS THEY APPROACH THE EDGES.

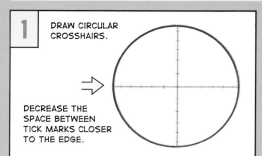

MELLOW CURVES

4 TRY TO KEEP ONE AREA GENERALLY LIGHT. SHADE THE REST RANDOMLY, ONE SQUARE AT A TIME.

UP FOR A CHALLENGE? TRY A TILTED SPHERE: DRAW A LINE RIGHT THROUGH THE MIDDLE OF A CIRCLE. ADD TWO ELLIPSES PERPENDICULAR TO THE LINE.

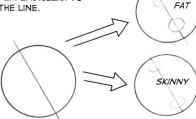

THE CLOSER IN THE ELLIPSES, THE FATTER THEY SHOULD BE.

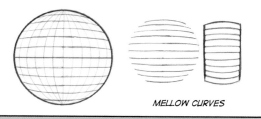

FAT

SKINNY

DIVIDE BOTH ELLIPSES INTO EQUAL SECTIONS.

LIGHTLY CONNECT CORRESPONDING LINES FROM ONE ELLIPSE TO THE OTHER.

ERASE THE INTERIOR LINES. REDRAW THE ELLIPSES, RADIATING OUT FROM THE FIRST ONE.

DRAW A FEW SPHERES AND LIGHTLY LAY IN THE LATITUDE AND LONGITUDE LINES. THEN, SEE WHAT YOU CAN TURN THEM INTO BY CARVING OUT DETAILS.

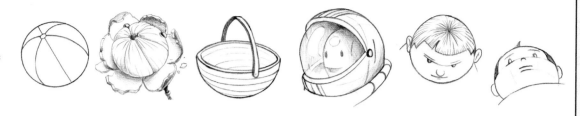

SHADING

THE PHASES OF THE MOON ARE EXCELLENT EXAMPLES OF HOW TO SHADE A SPHERE.

LET'S PRACTICE BY DRAWING A SCENARIO IN WHICH ONE SPHERE IS LIT FROM BEHIND A LITTLE, AND ONE IS LIT FROM THE FRONT.

1 DRAW A SINGLE LINE FROM THE LIGHT SOURCE THROUGH THE CENTER OF EACH CIRCLE.

2 DRAW A LINE PERPENDICULAR TO THE LIGHT SOURCE LINE.

3 SAME AS STEP 2 OVER HERE.

4 LIT FROM BEHIND? FILL IN A LOT OF SLIVERS.

LIT FROM THE FRONT? FILL IN A FEW OF THE SLIVERS.

5 USE THE SLIVERS TO CREATE A GRADUAL CHANGE IN VALUE.

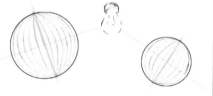

6 BLEND THE DIFFERENT VALUES FOR A SMOOTH GRADIENT.

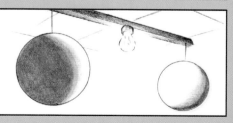

TO DRAW A CAST SHADOW, DRAW LINES FROM THE SOURCE TANGENT TO THE EDGE OF THE SPHERE. USE THOSE LINES AS A GUIDE TO DRAW A FORESHORT-ENED CIRCLE (AN ELLIPSE).

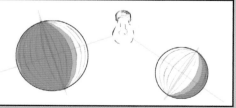

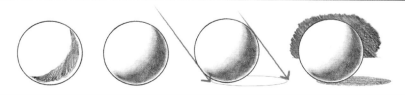

FOR MORE ON CAST SHADOWS, SEE CHAPTER 6.

LET'S MOVE ON TO BOXES, STARTING WITH *ONE-POINT PERSPECTIVE*. THAT'S WHEN YOU GENERALLY HAVE SOME LINES THAT ARE *NOT* POINTING AWAY FROM YOU . . .

. . . AND A BUNCH OF LINES THAT ARE POINTING *DIRECTLY* AWAY FROM YOU.

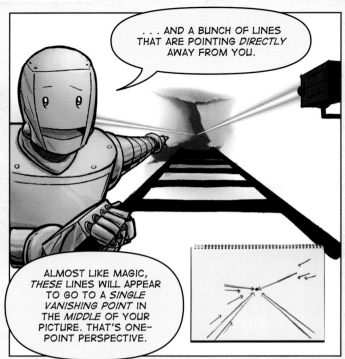

NO FORESHORTENING HERE! YOU CAN JUST DRAW THEM NORMALLY.

ALMOST LIKE MAGIC, *THESE* LINES WILL APPEAR TO GO TO A *SINGLE VANISHING POINT* IN THE *MIDDLE* OF YOUR PICTURE. THAT'S ONE-POINT PERSPECTIVE.

1 PUT A VANISHING POINT IN THE MIDDLE OF YOUR PICTURE, AND DRAW A BUNCH OF RECTANGLES.

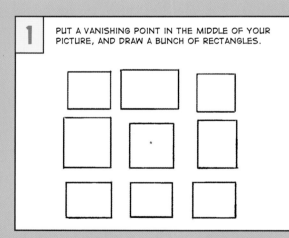

2 USE A STRAIGHTEDGE TO CONNECT THE **INSIDE CORNERS** TO THE VANISHING POINT.

TO CUT DOWN ON FUTURE ERASING, YOU CAN STOP DRAWING WHENEVER YOU HIT ANOTHER RECTANGLE.

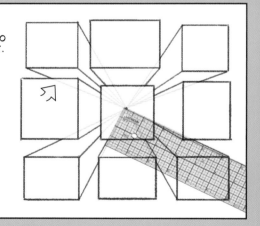

3 DRAW THE BACK EDGES OF EACH BOX.

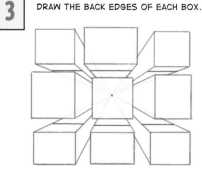

USE HORIZONTAL LINES FIRST . . .

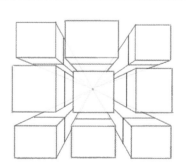

. . . AND THEN USE VERTICAL LINES TO FINISH.

4 ERASE THE EXTRA LINES.

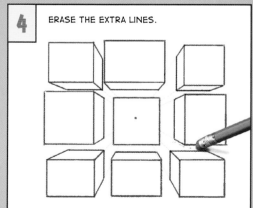

STEP 3 IS TOUGH TO GET RIGHT. YOUR ANALYTICAL LEFT BRAIN KNOWS THESE ARE RECTANGLES YOU'RE DRAWING, SO IT *REALLY* WANTS TO DRAW THOSE BACK ANGLES WITH PERPENDICULAR LINES.

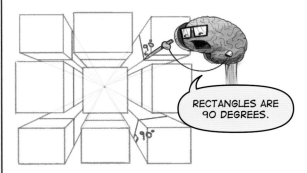

RECTANGLES ARE 90 DEGREES.

USE A STRAIGHTEDGE TO DOUBLE-CHECK YOUR BACK EDGES, COMPARING THEM TO THE EDGES OF THE PAPER.

IF YOU DO IT RIGHT, EVERY LINE IN THE PICTURE SHOULD BE VERTICAL, HORIZONTAL OR GOING TO THE VANISHING POINT.

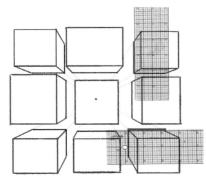

DETAILS FOLLOW THE SAME PATTERN:

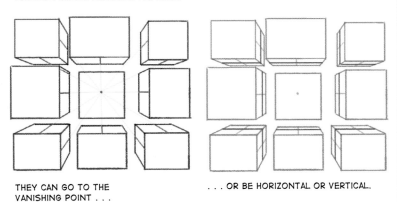

THEY CAN GO TO THE VANISHING POINT . . .

. . . OR BE HORIZONTAL OR VERTICAL.

THIS TECHNIQUE CAN BE USED ANY TIME SURFACES ARE LINED UP SQUARE TO YOUR SHOULDERS, WITH OTHER SURFACES RECEDING STRAIGHT BACK.

SO, HOW DO YOU KNOW HOW FAR BACK TO GO TO DRAW THE BACK EDGES, LIKE IN STEP 3? HERE'S THE GENERAL RULE: *SURFACES APPEAR MORE SQUISHED AS THEY GET CLOSER TO THE MIDDLE OF THE PICTURE.*

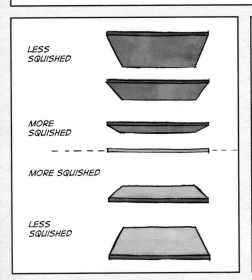

LESS SQUISHED

MORE SQUISHED

MORE SQUISHED

LESS SQUISHED

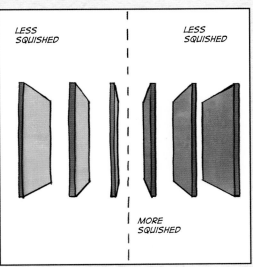

LESS SQUISHED

LESS SQUISHED

MORE SQUISHED

GIVE IT A TRY: PUT A VANISHING POINT ON THE HORIZON LINE IN YOUR CASTLE DRAWING AND GIVE THOSE RECTANGLES DEPTH.

STEP-BY-STEP: BOOKSHELF

1 ONE–POINT PERSPECTIVE CAN BE USED TO SHOW INTERIOR EDGES, LIKE THE KIND YOU'D SEE IN A BOOKSHELF.

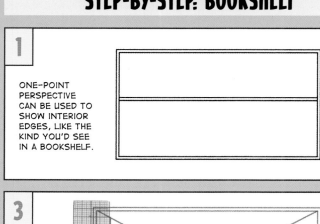

2 USE SHORT LINES THAT LEAD FROM THE CORNERS TO THE VANISHING POINT.

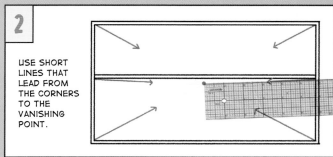

3 START DRAWING THE BACK EDGES.

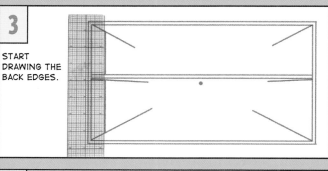

4 THIS SHELF IS SO CLOSE TO EYE LEVEL THAT IT SHOULD BARELY BE VISIBLE.

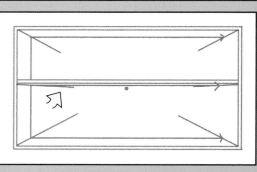

5 IT'S OKAY IF THESE LINES DON'T MATCH UP PERFECTLY. JUST FUDGE IT A LITTLE.

6 ERASE THE LEFTOVER LINES.

7 USE HARD CORNERS ON YOUR BOOKS. YOU CAN ROUND THE CORNERS LATER.

8 MORE SHORT LINES TO THE VANISHING POINT.

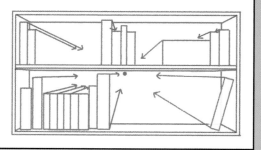

9 REMEMBER: SURFACES CLOSER TO THE MIDDLE APPEAR MORE SQUISHED!

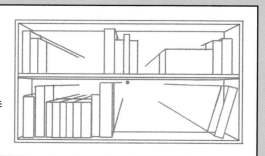

10 READ THE NEXT PAGE BEFORE ADDING DETAILS.

DETAILS ON A FORESHORTENED SURFACE MUST ALSO BE FORESHORTENED.

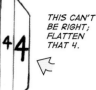 *THIS CAN'T BE RIGHT; FLATTEN THAT 4.*

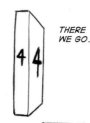 *THERE WE GO.*

FOR SURFACES LYING FLAT, FORESHORTEN FROM THE TOP.

AS SURFACES APPROACH THE MIDDLE, THE DETAILS USUALLY BECOME FORESHORTENED BEYOND RECOGNITION.

CIRCLES BECOME OVALS AND EVENTUALLY LINES. TEXT BECOMES ILLEGIBLE AND EVENTUALLY ENDS UP LOOKING LIKE A BARCODE.

(BUT YOU'LL STILL NEED TO KEEP VERTICAL LINES VERTICAL AND HORIZONTAL LINES GOING TO THE VANISHING POINT!)

AS FORESHORTENING SQUISHES A SURFACE, IT ALSO SHIFTS THE MIDDLE OF THE SURFACE FARTHER BACK. BUT THERE'S AN EASY WAY TO FIND EXACTLY HOW *FAR* THE MIDDLE SHIFTS BACK: JUST MAKE AN X.

CONNECT BOTH PAIRS OF OPPOSITE CORNERS. WHERE THEY MEET IS THE MIDDLE OF THE RECTANGLE.

YOU CAN THEN DIVIDE THE HALVES IN HALF, AND SO ON.

SAVE TIME AND PENCIL: ONCE YOU GET THE HANG OF USING AN X, YOU ONLY NEED TO DRAW THE SECTION OF THE DIAGONAL WHERE THE CENTER IS LIKELY TO BE.

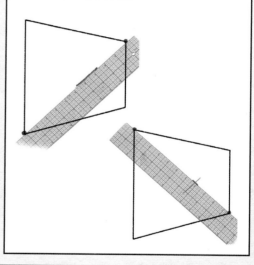

USE THE VANISHING POINT IN YOUR CASTLE PICTURE TO DRAW A PATH. DIVIDE THE PATH IN HALF, AND THEN THE HALVES IN HALF TO CREATE SECTIONS.

IT SHOULD MAKE THE DEPTH SEEM MORE BELIEVABLE.

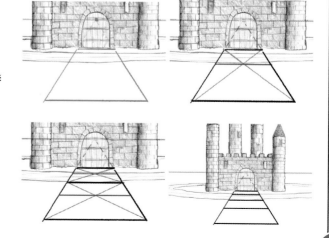

ONE-POINT PERSPECTIVE IS FOR LINES THAT GO THAT WAY.

AND SO, ONE POINT PERSPECTIVE . . .

BUT WHAT IF YOU TURN A LITTLE? SUDDENLY, "THAT WAY" HAS BECOME "*THAT* WAY," AND THE OTHER SET OF PARALLEL LINES APPEARS PINCHED IN, TOO.

. . . BECOMES TWO-POINT PERSPECTIVE.

LET'S TRY IT.

1 SET UP *TWO* VANISHING POINTS AT THE EDGE OF YOUR PAPER.

IMPORTANT: THESE TWO POINTS SHOULD BE DIRECTLY ACROSS FROM EACH OTHER.

2 DRAW A SMALL V BELOW THEM.

USING A STRAIGHTEDGE HERE IS A MUST!

3 KEEP THIS LINE (AND ALL GREEN LINES) AS VERTICAL AS POSSIBLE.

4 MORE LINES TO THE VANISHING POINTS.

5 MAKE SURE THESE LINES ARE VERTICAL. YOU'LL PROBABLY NEED TO ERASE LEFTOVER BITS FROM THE PREVIOUS STEPS.

6 MORE LINES TO THE VANISHING POINT AND ERASE THE LEFTOVERS.

NOW YOU'VE GOT A BOX IN TWO-POINT PERSPECTIVE!

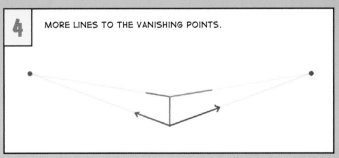

FROM THERE YOU CAN TURN THE BOX INTO ALL KINDS OF THINGS. LET'S MAKE OURS INTO A SOFA.

UP UNTIL STEP 6, *EVERY SINGLE LINE IS EITHER VERTICAL (GREEN), GOES TO THE LEFT VANISHING POINT (RED) OR RIGHT VANISHING POINT (BLUE).*

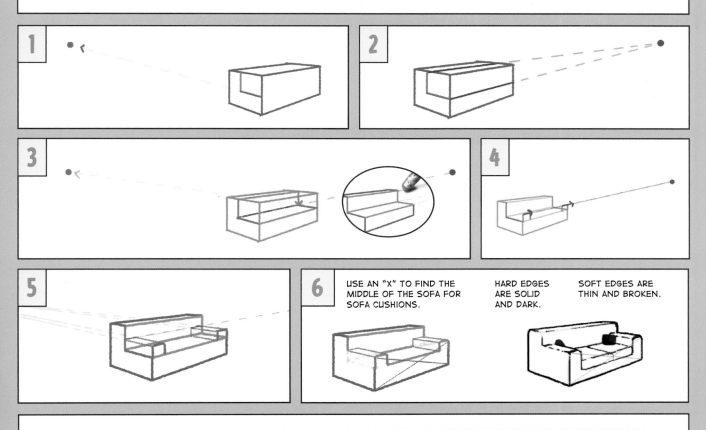

5

6 USE AN "X" TO FIND THE MIDDLE OF THE SOFA FOR SOFA CUSHIONS.

HARD EDGES ARE SOLID AND DARK.

SOFT EDGES ARE THIN AND BROKEN.

FOR INTERIOR WALLS, GO TO THE OPPOSITE VANISHING POINT: THE LEFT WALL GOES TO THE RIGHT VANISHING POINT, AND THE RIGHT WALL GOES TO THE LEFT VANISHING POINT. SAME GOES FOR THINGS ON THEM (WINDOWS, DOORS, ETC.).

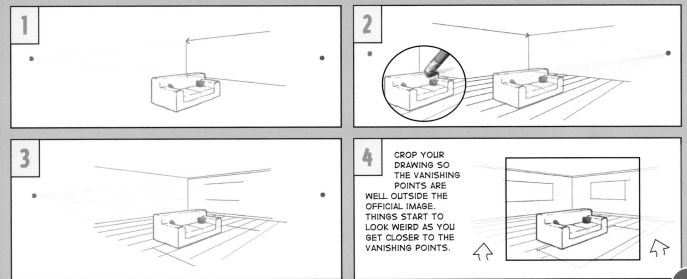

4 CROP YOUR DRAWING SO THE VANISHING POINTS ARE WELL OUTSIDE THE OFFICIAL IMAGE. THINGS START TO LOOK WEIRD AS YOU GET CLOSER TO THE VANISHING POINTS.

AS YOU MIGHT HAVE NOTICED, WE KEEP TALKING ABOUT THE *HORIZON LINE*. IT'S PRETTY IMPORTANT. NOT ONLY IS IT HOME TO VANISHING POINTS FOR HORIZONTAL STUFF LIKE WHEELS, BOOKCASES AND SOFAS . . .

. . . IT ALSO MARKS WHAT'S *EYE LEVEL WITH THE VIEWER.*

SO, LET'S SAY THE TOP OF OUR SOFA GREW UP TO THIS LINE. THAT MEANS IT WOULD NOW BE EYE LEVEL WITH US. AT THIS LEVEL, THE LINES APPEAR *FLAT.*

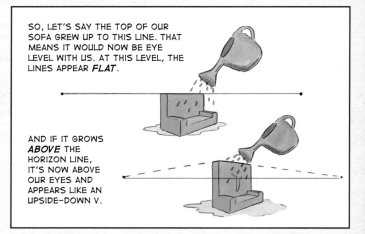

AND IF IT GROWS *ABOVE* THE HORIZON LINE, IT'S NOW ABOVE OUR EYES AND APPEARS LIKE AN UPSIDE-DOWN V.

POINT IS, YOU CAN USE THE *HORIZON LINE* TO FIGURE OUT WHETHER OR NOT YOU CAN SEE THE TOPS OF OBJECTS. TRY THIS CONCEPT OUT WITH A CITY. *EVERY SINGLE LINE IN THESE STEPS EITHER GOES TO THE LEFT VANISHING POINT (RED), THE RIGHT VANISHING POINT (BLUE), OR STRAIGHT UP AND DOWN (GREEN).*

1

TAPE YOUR PAPER DOWN AND DRAW YOUR VANISHING POINTS *FAR* OFF THE PAGE.

2

3

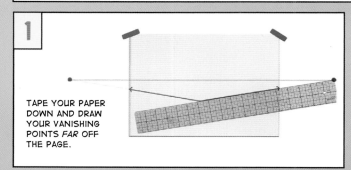

4 THE TOP OF THIS BUILDING IS BELOW THE HORIZON LINE . . .

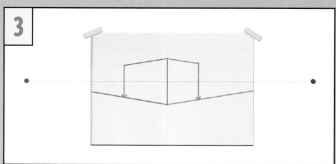

5

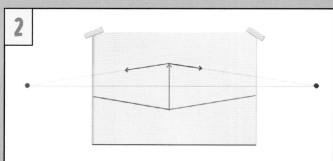

. . . WHICH MEANS WE CAN SEE THE ROOF. USE THE LEFT VANISHING POINT TO DRAW IT.

6

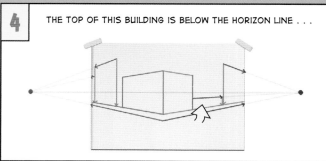

RECTANGLES ON THE GROUND ARE DRAWN THE SAME WAY: TO THE VANISHING POINTS.

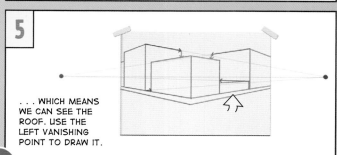

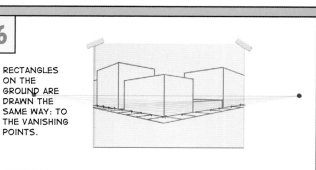

7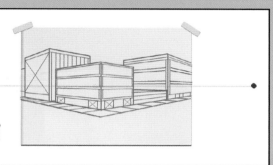

BASED ON THIS FIRST SET OF DETAILS, THE HORIZON LINE PASSES THROUGH THIS BUILDING NEAR THE TOP OF THE SECOND FLOOR. THAT MEANS YOU'RE *EYE LEVEL* WITH THE TOP OF THE SECOND FLOOR. TRY TO MATCH UP THE SECOND FLOOR OF OTHER BUILDINGS TO THE HORIZON LINE, TOO.

8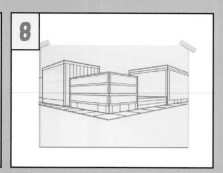

9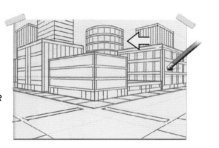

USE AN X TO DIVIDE DOORS AND FACADES IN HALF.

10

11

ADD A VERTICAL CYLIN- DER FOR VARIETY. REMEMBER TO USE BARELY SAD SAD FACES.

12

DON'T GO ANY FURTHER YET. WAIT UNTIL THE NEXT PAGE. THAT'S WHEN WE'LL COVER HOW TO DRAW STUFF LIKE AWNINGS AND ARROWS.

SO, THAT GIVES US TWO APPROACHES TO TWO-POINT PERSPECTIVE:

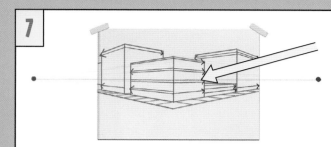

FOR BOXES THAT STRADDLE THE HORIZON LINE, LIKE OUR BUILDINGS, WE CAN DRAW A *FLEXIBLE YO-YO PRO* WHOSE ARMS AND LEGS POINT TO THE VANISHING POINTS.

FOR BOXES BELOW EYE LEVEL, LIKE OUR SOFA, WE DRAW THE SAME GUY, BUT WITH HIS WHOLE TORSO BELOW EYE LEVEL.

AND SINCE THE TOP OF THE BOX IS BELOW EYE LEVEL, WE DRAW IT, TOO (TO THE VANISHING POINTS).

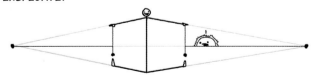 . . . BOXES BELOW AND COMBOS.

BOXES THAT STRADDLE . . .

AN X IS GREAT FOR DIVIDING RECTANGLES IN HALF, BUT YOU CAN ALSO USE AN X TO DRAW SYMMETRICAL ARCHES AND TRIANGLES IN PERSPECTIVE.

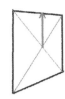
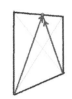
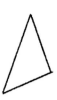

FOR OTHER KINDS OF ANGLES, CONNECT THE CORNERS OF BOXES DRAWN IN CORRECT PERSPECTIVE, AND YOU'LL HAVE SLANTED LINES DRAWN IN CORRECT PERSPECTIVE.

SOMETIMES YOU'LL NEED TO DRAW THE BACK EDGES FIRST TO CONNECT TO HIDDEN CORNERS:

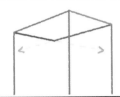

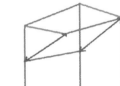

ADVANCED ALTERNATIVE TO THE X

DIVIDE UP YOUR BOX WITH VANISHING POINT LINES, THEN DRAW A DIAGONAL. USE THE INTERSECTION OF THE DIAGONAL AND THE VANISHING POINT LINES TO SEE WHERE THE VERTICAL LINES GO.

THIS STUFF WORKS ON THE GROUND AND UNDERGROUND!

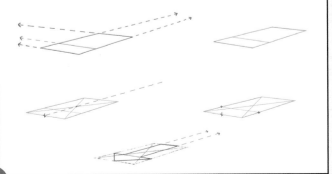

TRY ADDING SOME AWNINGS, ARROWS AND ANGLED ROOFTOPS, BUT HOLD OFF ON PEOPLE, TREES, CLOUDS AND BACKGROUND UNTIL WE FINISH THE NEXT CHAPTER.

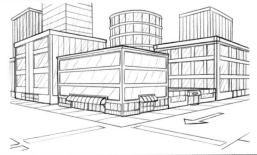

Q: HOW FAR APART ARE THE VANISHING POINTS SUPPOSED TO BE EXACTLY?

A: THE SHORT ANSWER IS VERY FAR APART. BUT THERE IS NO WRONG ANSWER.

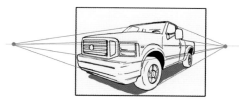

IT'S EASIEST TO UNDERSTAND
IN CAMERA TERMS:

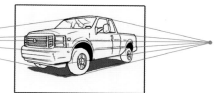

CLOSER VANISHING POINTS MAKE IT FEEL LIKE YOU'RE
CLOSE TO THE SUBJECT BUT ZOOMED WAY OUT.

MOVE THE POINTS FARTHER APART, AND IT'S LIKE YOU'RE
STANDING FARTHER AWAY BUT ZOOMED IN.

THE TRUCKS ARE DRAWN ABOUT THE SAME SIZE IN EACH PICTURE, BUT CLOSER VANISHING POINTS MAKE IT FEEL LIKE YOU ARE CLOSER TO THE SUBJECT AND CRAMMING MORE OF YOUR FIELD OF VISION INTO YOUR DRAWING.

Q: SO I ALWAYS HAVE TO DRAW VANISHING POINTS OFF THE PAGE?

A: OFF THE PICTURE, YES. OFF THE PAGE, NO. YOU CAN
*PUT YOUR POINTS AT THE EDGE OF THE PAGE AND DRAW
SMALL. IF IT'S A KEEPER, YOU CAN CROP THE EDGES
WHEN YOU'RE DONE.*

BUT IF YOU *DO* DRAW THEM OFF
THE PAGE, USE TAPE SO THE
POINTS DON'T MOVE.

OR, AFTER YOU GET
THE HANG OF THINGS,
YOU CAN EVEN JUST
IMAGINE THEM.

Q: CAN I SCOOT THE VANISHING POINTS AROUND?

A: YES, BUT NOT THE SAME AMOUNT. THE CLOSER ONE OF THE POINTS MOVES TO THE MIDDLE,
THE FARTHER THE OTHER POINT MOVES OUT.

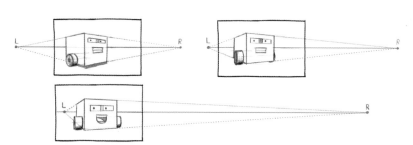

THE RESULT WILL BE SEEING THE OBJECT AT DIFFERENT ANGLES. (NOTICE
THAT YOU CAN USE THE CAR'S VANISHING POINTS FOR THE WHEELS, TOO,
TO KEEP THEM LINED UP WITH THE VEHICLE.)

IF YOU SCOOT ONE OF THE POINTS ALL
THE WAY TO THE MIDDLE, THE OTHER ONE
WOULD SCOOT INFINITELY FAR OUT. AT
THAT POINT, YOU'D BE RIGHT BACK TO
ONE-POINT PERSPECTIVE!

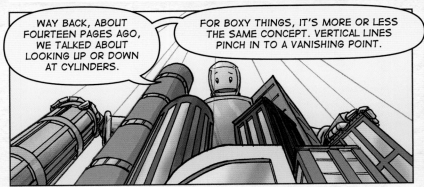

WAY BACK, ABOUT FOURTEEN PAGES AGO, WE TALKED ABOUT LOOKING UP OR DOWN AT CYLINDERS.

FOR BOXY THINGS, IT'S MORE OR LESS THE SAME CONCEPT. VERTICAL LINES PINCH IN TO A VANISHING POINT.

BUT FINDING THAT POINT IS A LOT TOUGHER, SO PUT ON YOUR THINKING CAP.

FOR EXAMPLE, LET'S SAY YOU WANT THE VIEWER TO BE LOOKING UP. YOU'LL FIRST NEED TO SET YOUR PICTURE UP NORMALLY FOR ONE-POINT OR TWO-POINT PERSPECTIVE . . .

 ONE-POINT PERSPECTIVE *TWO-POINT PERSPECTIVE*

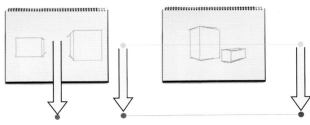

. . . BUT THEN *SLIDE THE VANISHING POINTS AND THE HORIZON LINE STRAIGHT DOWN.* THE FARTHER DOWN YOU GO, THE MORE THE VIEWER WILL FEEL LIKE THEY'RE LOOKING UP.

NEXT, PLACE A NEW VANISHING POINT DIRECTLY ABOVE THE PICTURE.

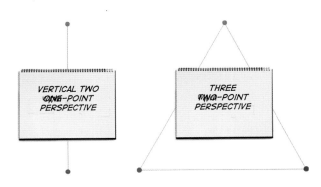

ONE-POINT PERSPECTIVE BECOMES VERTICAL TWO-POINT PERSPECTIVE.

AND TWO-POINT PERSPECTIVE BECOMES THREE-POINT PERSPECTIVE.

USE THE TOP VANISHING POINT AS A GUIDE FOR PINCHING IN THE VERTICAL LINES . . .

. . . AND THE BOTTOM VANISHING POINTS TO DRAW THE DEPTH LINES.

IF YOU WANT THE VIEWER TO FEEL LIKE THEY'RE LOOKING DOWN, FLIP THE ENTIRE PROCESS (OR JUST ROTATE YOUR SKETCHBOOK).

WITH THREE-POINT, THE *TRIANGLE'S* DIRECTION IS THE DIRECTION *YOU'RE* LOOKING.

 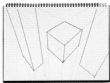

GETTING THE POSITIONS RIGHT FOR VERTICAL TWO-POINT PERSPECTIVE IS JUST LIKE BEFORE: IF ONE SLIDES IN, THE OTHER SLIDES WAY OUT.

FOR THREE-POINT, IT GETS REALLY COMPLEX! BUT JUST MAKING THE TRIANGLE LARGE AND PUTTING YOUR SKETCHBOOK IN THE MIDDLE WORKS WELL ENOUGH.

LOOKING DOWN WITH VERTICAL TWO-POINT PERSPECTIVE

1 DRAW THE HORIZONTAL (RED) LINE FIRST.

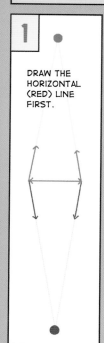

2

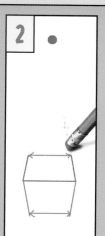

3

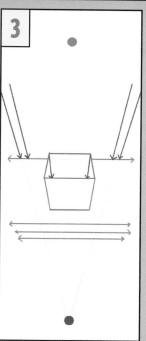

4

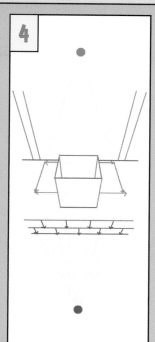

DON'T DRAW TOO CLOSE TO THE VANISHING POINTS; CROP YOUR PICTURE LIKE THIS.

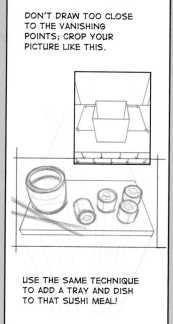

USE THE SAME TECHNIQUE TO ADD A TRAY AND DISH TO THAT SUSHI MEAL!

LOOKING UP WITH THREE-POINT PERSPECTIVE

1 DRAW THREE POINTS THAT WILL FORM A *HUGE EQUILATERAL TRIANGLE.* FOR LOOKING UP, POINT THE TRIANGLE UP.

KEEP YOUR PAPER IN THE MIDDLE OF THE TRIANGLE.

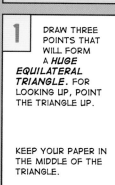

2

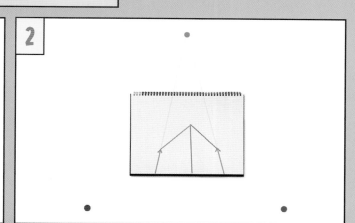

3 REPEAT STEPS 1 AND 2 FOR OTHER BUILDINGS.

4 YOU CAN SOMETIMES SEE ONLY ONE SIDE OF BUILDINGS NEAR THE EDGES.

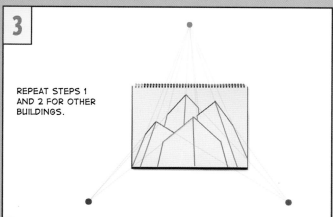

USE THE SAME THREE POINTS FOR WINDOWS, TRIM, ETC.

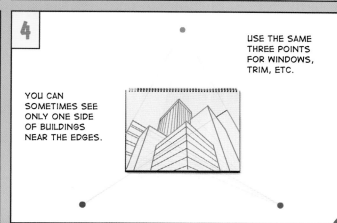

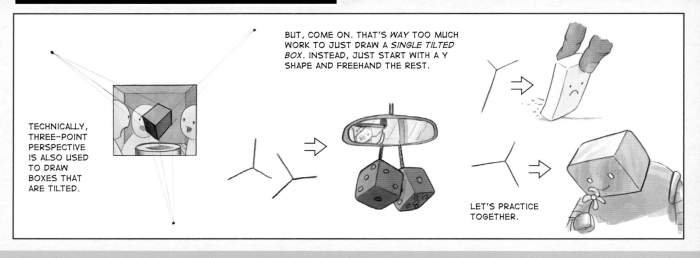

TECHNICALLY, THREE-POINT PERSPECTIVE IS ALSO USED TO DRAW BOXES THAT ARE TILTED.

BUT, COME ON. THAT'S *WAY* TOO MUCH WORK TO JUST DRAW A *SINGLE TILTED BOX.* INSTEAD, JUST START WITH A Y SHAPE AND FREEHAND THE REST.

LET'S PRACTICE TOGETHER.

1 SKETCH A FLATTENED Y.

FLATTEN THE Y A LOT, AND YOUR BOX WILL TILT A LITTLE.

FLATTEN IT LESS AND YOUR BOX WILL TILT MORE.

BUT KEEP IT FLATTER THAN 90 DEGREES OR IT WILL LOOK WEIRD.

TOO ANGLED!

2 DRAW THE BACK EDGES *ALMOST* PARALLEL TO YOUR Y, BUT A TINY BIT *FLATTER* (LESS STEEP).

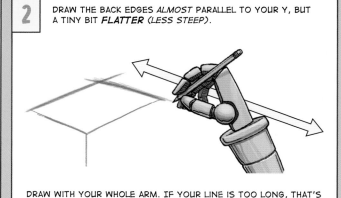

DRAW WITH YOUR WHOLE ARM. IF YOUR LINE IS TOO LONG, THAT'S GOOD. IT'S EASIER TO COMPARE ANGLES WITH LONGER LINES.

YOUR ANALYTIC LEFT BRAIN IS REALLY PUSHING YOU TO DRAW A 90 DEGREE ANGLE HERE.

THIS CAN MAKE IT TOUGH TO DRAW THE BACK EDGES FLATTER THAN THE LINES IN YOUR Y SHAPE.

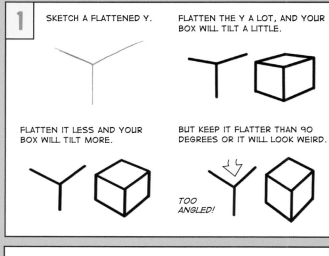

BUT PLACING PENCILS ON YOUR LINES CAN HELP YOU MAKE SURE YOU DREW THE BACK EDGES A LITTLE FLATTER THAN THE FRONT.

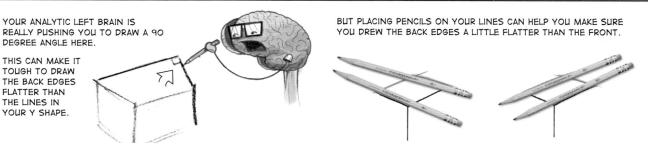

3 DRAW THE BOTTOM EDGES ALMOST PARALLEL TO THE Y BUT SLIGHTLY *STEEPER* (LESS FLAT).

LIKE THIS:

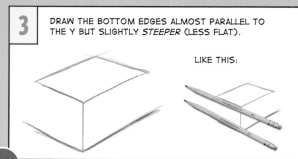

4 DROP DOWN LINES PARALLEL TO THE MIDDLE OF THE Y FOR THE SIDES.

KEEP THE SIDES PARALLEL TO THE MIDDLE OF YOUR Y.

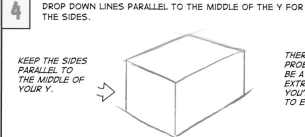

THERE WILL PROBABLY BE A LITTLE EXTRA THAT YOU'LL NEED TO ERASE.

IF YOUR BOX LOOKS WEIRD, IT'S LIKELY THAT ONE OF YOUR ANGLES WAS 90 DEGREES OR LESS.

IF SO, SKETCH LIGHTLY AND ADJUST YOUR LINES.

WITH SMALL ADJUSTMENTS TO YOUR INITIAL Y SHAPE, YOU CAN DRAW A BOX FROM ALMOST ANY ANGLE.

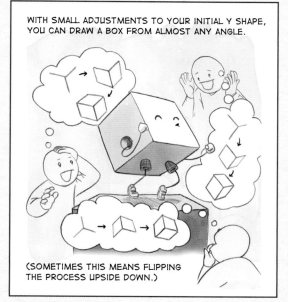

(SOMETIMES THIS MEANS FLIPPING THE PROCESS UPSIDE DOWN.)

IN ADDITION TO DRAWING TILTED BOXES, THE SHORTCUT METHOD ALSO WORKS GREAT IF YOU'RE JUST DRAWING A VERTICAL BOX THAT'S NOT PART OF A SCENE.

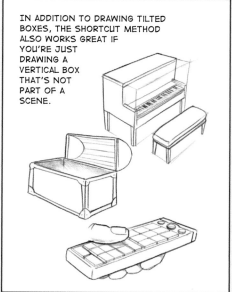

TO REVIEW, HERE ARE ALL THE WAYS WE LEARNED HOW TO DRAW BOXES AND RECTANGLES:

ONE-POINT

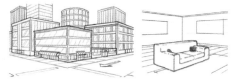

TWO-POINT

VERTICAL TWO-POINT

THREE-POINT

SHORTCUT

YOU CAN ALSO THROW IN CYLINDERS, AND EVEN COMBINE DIFFERENT PERSPECTIVE SYSTEMS WITHIN THE SAME PICTURE.

JUST MAKE SURE YOU USE THE SAME HORIZON LINE FOR YOUR ONE-POINT, TWO-POINT AND CYLINDER SYSTEMS, AND YOU SHOULD BE FINE.

FOR TILTED BOXES, THERE'S A LITTLE MORE FLEXIBILITY.

AND HERE'S THE REAL PAYOFF WITH ONE- AND TWO-POINT PERSPECTIVE: JUST LIKE WAX-ON/WAX-OFF, AFTER ENOUGH PRACTICE, YOU BEGIN TO INTERNALIZE HOW PERSPECTIVE WORKS AND HOW LINES FLATTEN OUT IN THE MIDDLE OF THE PICTURE. THEN YOU'LL FIND YOURSELF APPLYING ITS GENERAL PRINCIPLES IN STUFF LIKE ANIMALS, PEOPLE, CARS AND MORE.

ONE-POINT

TWO-POINT

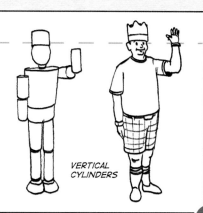

VERTICAL CYLINDERS

Drawing Scenes

THE LAST TWO CHAPTERS COVERED HOW TO DRAW HUMANS AND OBJECTS.

NOW IT'S TIME TO LEARN HOW TO PUT THEM TOGETHER.

WE'LL START WITH HOW TO MAKE A PICTURE BETTER . . .

. . . SIMPLY BY REARRANGING THINGS WITH A SENSE OF *COMPOSITION.*

THEN WE'LL COVER HOW BIG AND WHERE TO DRAW OBJECTS THAT ARE FARTHER OR CLOSER.

WONKY SCALE AND DEPTH MAKE THE SCENE UNBELIEVABLE . . .

. . . BUT REALISTIC SCALE AND CLEAR DEPTH MAKE YOU FEEL LIKE YOU'RE PART OF THE SCENE.

ALONG THE WAY, WE'LL COVER HOW TO DRAW COMMON BACKGROUND ELEMENTS LIKE TREES, MOUNTAINS, RIVERS AND CLOUDS, INCLUDING HOW TO INCORPORATE THEM INTO A SCENE WITH CORRECT SCALE AND PERSPECTIVE.

WE'LL ALSO COVER HOW TO GROUND ELEMENTS IN A PICTURE BY ADDING SHADOWS.

YOU'LL HAVE THE OPPORTUNITY TO START ALL NEW DRAWINGS WITH REALISTIC DEPTH AND COMPELLING ARRANGEMENTS . . .

. . . AND TO GO BACK AND FINISH ALL THOSE OTHER DRAWINGS WE'VE BEEN WORKING ON.

COMPOSITION REFERS TO THE ARRANGEMENT OF THE THINGS IN YOUR PICTURE. DEPENDING ON WHOM YOU TALK TO, YOU MIGHT GET DIFFERENT ANSWERS ABOUT WHAT IS GOOD OR BAD COMPOSITION.

REGARDLESS, ALMOST EVERYONE AGREES THAT COMPOSITION *MATTERS*, WHICH MEANS YOUR FIRST MOVE FOR ANYTHING BEYOND A SKETCH OR DOODLE IS TO SKETCH THE COMPOSITION.

EACH OF THESE DRAWINGS HAS THE SAME ELEMENTS; THEY'RE JUST ARRANGED DIFFERENTLY. WHICH DRAWING DO YOU LIKE BEST?

MOST PEOPLE WOULD SAY B. BUT SOME SAY A. HARDLY ANYONE SAYS C OR D, BUT THAT'S OKAY IF YOU DID! THE IMPORTANT THING IS THAT YOU HAD A PREFERENCE. IN OTHER WORDS, *COMPOSITION MATTERS*.

BUT WHY? WHAT MAKES SOME ARRANGEMENTS MORE APPEALING THAN OTHERS? ARE THERE RULES? SORT OF. IT CAN GET PRETTY COMPLICATED, AND IT'S VERY SUBJECTIVE. BUT HERE ARE SOME BASIC GUIDELINES:

KEEP YOUR IMAGE BALANCED

KEEP YOUR VISUAL WEIGHT EVEN. DON'T OVERLOAD ANY SIDE, INCLUDING TOP OR BOTTOM.

VISUAL WEIGHT WORKS JUST LIKE REAL WEIGHT: LARGE OBJECTS TIP THE BALANCE MORE THAN LITTLE OBJECTS.

UNBALANCED :(

BALANCED :)

ASYMMETRICAL BALANCE: INTERESTING

SYMMETRICAL BALANCE: CALM

EMPHASIZE YOUR MAIN SUBJECT WITH SIZE

JUST LIKE WITH **SYLLABLES** AND **WORDS**, THE SIZE OF THE ELEMENTS USUALLY DETERMINES HOW MUCH EMPHASIS THEY HAVE. GENERALLY YOU WANT EMPHASIS ON ONE OR TWO ELEMENTS IN THE PICTURE UNLESS YOU WANT THE PICTURE TO BE ABOUT THE SCENE ITSELF.

EMPHASIS ON THE SCENE

EMPHASIS ON THE BATTLE

EMPHASIS ON THE EMOTIONS

MOVE THE VIEWER THROUGH THE PICTURE	MOVEMENT REFERS TO THE PATH THE EYE TAKES THROUGH THE PICTURE. PEOPLE GENERALLY LIKE IT WHEN YOU GUIDE THEM TO THE MAIN SUBJECT.

WE TEND TO FOLLOW LINES OR EDGES IN A PICTURE.

WHEN POSSIBLE, CREATE PATHS TO LEAD THE EYE WHERE YOU WANT IT TO GO.

IS YOUR EYE DRAWN TO THE CHAMELEON IN THE CORNER?

THESE LINES GUIDE OUR EYES . . . WELL, ALL OVER THE PLACE.

THESE LINES GUIDE US TO THE HAPPY CAMPER.

WHICH ONE IS CORRECT? IT DEPENDS ON WHETHER YOU WANT THE VIEWER'S ATTENTION ON THE *SCENE* OR THE *CAMPER*.

INTENTIONAL OR NOT, YOU ALSO CREATE MOVEMENT ANY TIME YOUR SUBJECT HAS EYES. THE VIEWER WILL LOOK WHERE YOUR SUBJECT IS LOOKING.

WE LOOK WHERE THE CHARACTER LOOKS, SO WE FEEL FORCED INTO THE CORNER. FEELS CRAMPED.

AH—THIS FEELS FREER.

WHEN "BAD" COMPOSITION IS GOOD

CREATING A SENSE OF BALANCE AND DRAWING YOUR MAIN SUBJECT BIG USUALLY MEAN GOOD COMPOSITION, ESPECIALLY IF THERE'S PURPOSEFUL MOVEMENT. BUT . . .

THE IDEA ISN'T SO MUCH TO ACHIEVE "GOOD" COMPOSITION AS MUCH AS IT IS TO BE *PURPOSEFUL* ABOUT YOUR COMPOSITION.

THIS IMAGE FEELS MORE ISOLATING BECAUSE THE MAIN SUBJECT IS TINY, PUTTING THE EMPHASIS ON THE DARK SKY.

THE MOVEMENT AND LACK OF BALANCE DRAW THE VIEWER'S EYES TO THE RIGHT SIDE, WHICH HEIGHTENS THE SUSPENSE.

FOR DOODLES OR STUDIES OR SKETCHES, NONE OF THIS STUFF *REALLY* MATTERS. BUT IF YOU'RE DRAWING A FINISHED PIECE OF ART, TAKE A MINUTE OR TWO TO MAKE A FEW THUMBNAIL SKETCHES, EXPERIMENTING WITH DIFFERENT COMPOSITIONS.

THEN, TRANSFER YOUR FAVORITE COMPOSITION TO YOUR ACTUAL PAPER WITH A FEW REALLY LIGHT BLOBS TO REMIND YOU OF WHERE EVERYTHING GOES.

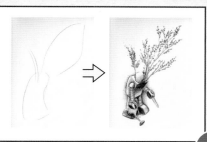

WHO APPEARS FARTHER AWAY, *BLUE* OR *RED*?

UNIVERSALLY, WE INTERPRET *BLUE* BEING FARTHER AWAY. MOST PEOPLE WOULD SAY IT'S BECAUSE BLUE IS *HIGHER UP*.

BUT THAT'S ONLY *HALF* CORRECT.

AFTER ALL, MOVING *RED'S* HEAD UP OR MOVING *BLUE'S* HEAD DOWN WOULDN'T CHANGE ANYTHING.

INDEED, IT'S THE *BOTTOM* OF THE OBJECT YOU NEED TO CONSIDER. THE HIGHER UP THE BOTTOM IS, THE FURTHER AWAY THE OBJECT IS.

OR, IF IT'S IN THE AIR, ITS SHADOW.

IF SOMETHING SEEMS OFF ABOUT YOUR PICTURE'S DEPTH, START BY LOOKING AT THE BOTTOM OF THE OBJECTS. DO THINGS LINE UP THE WAY THEY SHOULD?

BUT WE HAVE A PROBLEM: *EXACTLY HOW HIGH UP SHOULD THE BOTTOM GO IF SOMETHING IS FARTHER AWAY?* AND THEN, HOW HIGH UP DO YOU GO FOR THE TOP? IN OTHER WORDS, WHEN YOU'RE DRAWING DISTANCE, HOW HIGH UP AND HOW BIG?

THE ANSWER IS SIMPLE, THOUGH IT USUALLY TAKES A LITTLE PRACTICE TO FULLY GET IT.

WHATEVER IS EYE LEVEL WITH YOU GOES IN THE MIDDLE OF THE PICTURE.

A.K.A. THE HORIZON LINE

SO IF YOU'RE EYE LEVEL WITH A BUNCH OF PEOPLE, PUT THEIR EYES IN THE MIDDLE OF THE PICTURE. YOU CAN'T *HELP* BUT DRAW PEOPLE THE CORRECT SIZE AS THEY GET FARTHER AWAY.

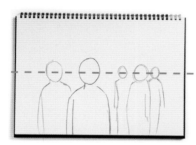

AND IF YOU SIT DOWN AND ARE EYE LEVEL WITH PEOPLE'S TUMMIES, DRAW THEIR *TUMMIES* IN THE MIDDLE OF THE PICTURE.

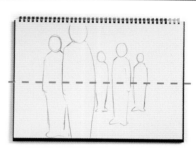

IT WORKS WITH JUST ABOUT ANYTHING. JUST ASK "WHAT PART OF THE _____ IS EYE LEVEL WITH ME?" AND THEN MAKE SURE *THAT PART* GOES IN THE MIDDLE.

FOR EXAMPLE, BEING EYE LEVEL WITH *EYES* MEANS YOU'RE ALSO EYE LEVEL WITH THE *PEEPHOLES OF DOORS* AND *MIDDLES OF WINDOWS.*

SO NOW YOU KNOW WHERE TO PUT THAT STUFF, TOO.

AND DON'T FORGET: THE VANISHING POINTS GO IN THE MIDDLE OF THE PAGE, TOO (ON THE HORIZON LINE). SO NOW YOU CAN FINISH A PICTURE WITH CORRECT SCALE, DEPTH AND PERSPECTIVE.

SIMILARLY, BEING EYE LEVEL WITH TUMMIES MEANS YOU'RE ALSO EYE LEVEL WITH THE *BOTTOMS* OF WINDOWS AND THE *MIDDLE* OF DOORS.

STEP-BY-STEP: MOUNTAIN RANGE

LET'S USE THE HORIZON LINE TO DRAW SOME MOUNTAINS. TO BEGIN, DRAW A HORIZON LINE AND ASK YOURSELF, "WHICH PART OF THE MOUNTAINS IS EYE LEVEL WITH ME?"

1 LET'S SAY YOU'RE EYE LEVEL NEAR THE BOTTOM OF THE MOUNTAIN. DRAW A TRIANGLE THAT OVERLAPS THE HORIZON LINE NEAR ITS BOTTOM.

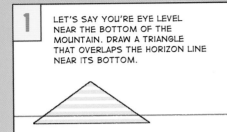

2 OVERLAP MORE TRIANGLES THE SAME WAY. FOR EXAMPLE, ALL OF MINE OVERLAP TWO TENTHS OF THE WAY FROM THE BOTTOM.

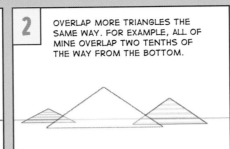

3 KEEP IT UP AND YOU'LL SEE A PATTERN. DISTANT MOUNTAINS WILL APPEAR SHORTER.

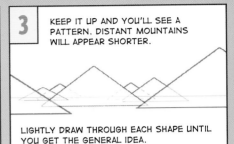

LIGHTLY DRAW THROUGH EACH SHAPE UNTIL YOU GET THE GENERAL IDEA.

4 BUT IF YOU WERE AT A HIGHER ELEVATION, YOU WOULD PLACE EACH MOUNTAIN LIKE THIS, ABOUT TWO TENTHS FROM THE TOP:

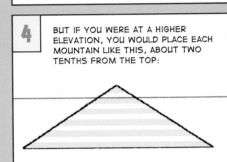

5 ADD A COUPLE MORE . . .

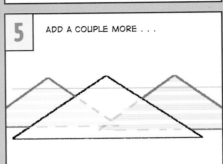

6 . . . AND REPEAT UNTIL YOU GET THE GIST OF IT. THEN FREEHAND THE REST.

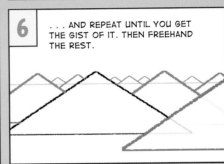

REFINE THE SHAPES:

1
2
3

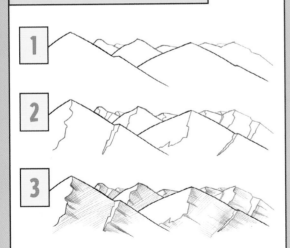

1. ERASE THE BOTTOM OF EACH TRIANGLE; REPLACE THE TOP SIDES WITH IRREGULAR, JAGGED LINES. DRAW MORE DISTANT MOUNTAINS WITH THINNER, LIGHTER LINES.

2. DROP JAGGED LINES DOWN FROM *PEAKS*, AND ALSO FROM THE *BOTTOMS OF ANY V SHAPES* YOU MADE ALONG THE TOP EDGE.

3. PICK A LIGHT SOURCE AND SHADE ANY SURFACES FACING THE OPPOSITE DIRECTION.

OF COURSE, REAL MOUNTAINS ARE A LOT MORE NUANCED, ESPECIALLY AT THE BOTTOM, WHERE THERE'S NO CLEAR DEFINITION.

LOOK AT PHOTOS FOR DETAILS, INCLUDING HOW TO SUGGEST THE BOTTOMS OF MOUNTAINS OR OVERLAP THEM WITH TREES OR SMALLER HILLS (WE'LL LEARN HOW TO DRAW TREES IN A FEW PAGES).

GO BACK AND ADD MOUNTAINS TO YOUR CASTLE. USE THE SAME HORIZON LINE AS YOU DID FOR GETTING THE HAPPY AND SAD FACES RIGHT. DON'T DRAW TOO DARK; WE'LL BE ADDING TREES IN A FEW PAGES.

HORIZON LINE EXCEPTIONS

IT GETS A LITTLE MORE COMPLICATED IF AN OBJECT ISN'T TALL ENOUGH TO REACH EYE LEVEL, LIKE A BICYCLE OR A TABLE. IN THESE CASES, YOU'LL HAVE TO TEMPORARILY *STACK* THE OBJECT UNTIL IT *DOES* REACH EYE LEVEL.

LET'S SAY YOU WANT TO ADD CATS TO A PICTURE OF A PERSON.

FIRST, IDENTIFY WHAT IS *ALREADY* ON THE HORIZON LINE. IN THIS CASE, IT'S THIS PERSON'S CHEST.

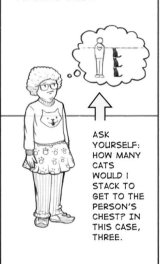

ASK YOURSELF: HOW MANY CATS WOULD I STACK TO GET TO THE PERSON'S CHEST? IN THIS CASE, THREE.

THOUGH IT MIGHT BE A FUN CHALLENGE TO DRAW ENTIRE STACKS OF CATS, YOU WOULD JUST END UP ERASING THE TOP TWO. SO JUST DRAW REALLY LIGHT BLOBS INSTEAD.

REMEMBER: THE TOP OF EACH STACK SHOULD BE *EYE LEVEL*.

REPLACE EACH BOTTOM BLOB WITH A CAT.

ONCE YOU GET THE IDEA, YOU CAN EYEBALL THE REST WITHOUT NEEDING TO DRAW STACKS FIRST.

THIS CONCEPT STILL WORKS WHEN YOU LOOK UP OR DOWN. YOU JUST NEED TO SHIFT YOUR EYE LEVEL LINE (A.K.A. THE HORIZON LINE) UP OR DOWN. BUT ANYTHING THAT'S THE SAME ALTITUDE AS YOU (EYE-LEVEL WITH YOU) GOES WITH IT.

AS WE LOOK DOWN AND UP, EYE LEVEL STUFF STAYS ON THE HORIZON LINE.

IF YOU'RE LOOKING UP OR DOWN A LITTLE, LIKE THE PREVIOUS EXAMPLES, YOU CAN ESSENTIALLY JUST SCOOT EVERYTHING UP OR DOWN.

BUT ONCE YOU LOOK *SO FAR UP OR DOWN THAT THE HORIZON LINE MOVES OFF THE PAGE*, DRAWING THINGS NORMALLY SEEMS A LITTLE OFF.

THAT'S WHEN YOU'LL NEED TO REMEMBER ALL THAT PERSPECTIVE BUSINESS FROM THE LAST CHAPTER. PINCH IN THE VERTICAL LINES, MAKE ANGLES STEEPER, AND DRAW HAPPY FACES AND ELLIPSES CURVIER.

SHADOWS

DRAWING AN OBJECT'S SHADOW GENERALLY MEANS CONNECTING THE TOP AND BOTTOM OF THE OBJECT TO THE TOP AND BOTTOM OF THE LIGHT.

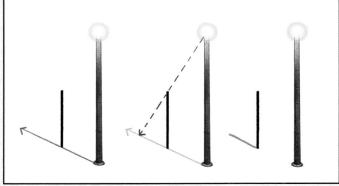

THAT'S THE BASIC IDEA, ANYWAY. BUT AS YOU'RE ABOUT TO SEE, DIFFERENT SITUATIONS CALL FOR DIFFERENT STRATEGIES.

YOU'LL PROBABLY NEED TO REVISIT THESE PAGES LATER. I KNOW I HAD TO GO BACK AND RE-LEARN THIS STUFF A FEW TIMES.

LET'S PRACTICE A FEW DIFFERENT SITUATIONS.

FOR PLANES

1. MARK THE SPOT ON THE GROUND DIRECTLY BELOW THE TORCH.

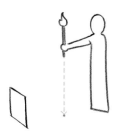

2. CONNECT THE SPOT TO THE *BOTTOM CORNERS OF THE OBJECTS*. THEN EXTEND THE LINES OUT A LITTLE.

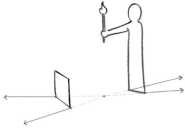

3. CONNECT THE LIGHT SOURCE TO THE *TOP CORNERS* OF THE OBJECTS, THEN KEEP GOING UNTIL YOU HIT THE LINES FROM STEP 2.

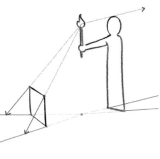

4. CONNECT THE DOTS TO MAKE THE SHADOW AND THEN FILL IT IN.

OBJECTS TALLER THAN THE LIGHT SOURCE NEVER CONNECT; THEREFORE, THEY HAVE NO END TO THEIR SHADOW.*

*UNLESS THERE'S A WALL OR SOMETHING BEHIND THEM:

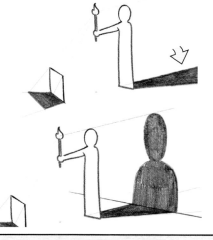

FOR 3-D FORMS

1. IDENTIFY THE SPOT ON THE GROUND DIRECTLY BELOW THE LIGHT. THEN, CONNECT IT TO THE BOTTOM CORNERS, DRAWING THROUGH THE BOX.

IGNORE THE CORNER CLOSEST TO THE LIGHT SOURCE.

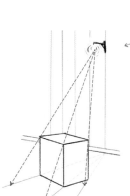

2. CONNECT THE LIGHT SOURCE TO THE TOP CORNERS OF THE OBJECT (EXCEPT THE CLOSEST CORNER), AND EXTEND IT LIKE BEFORE.

3. CONNECT THE DOTS AND FILL IN THE SHAPE.

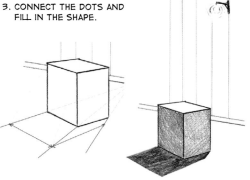

IF THE SUN IS IN THE PICTURE . . .

IT'S BASICALLY THE SAME AS BEFORE, BUT TO FIND THE SPOT BELOW THE LIGHT SOURCE, DROP STRAIGHT DOWN FROM THE SUN TO THE HORIZON LINE.

IF SOMETHING DOESN'T ACTUALLY TOUCH THE GROUND, LIKE THE CACTUS ARM, DROP A LINE STRAIGHT DOWN TO THE POINT WHERE IT *WOULD* TOUCH THE GROUND IF IT WERE TALLER.

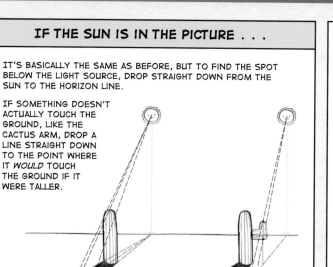

IT'S A PRETTY DIFFERENT PROCESS *IF THE SUN IS BEHIND THE VIEWER*. THE SHADOW WILL CONVERGE AT A POINT ON THE *HORIZON LINE*:

1. CONNECT THE BOTTOM CORNERS OF THE OBJECT TO A POINT ON THE HORIZON LINE.

2. DROP A POINT STRAIGHT DOWN AND CONNECT IT TO THE TOP CORNERS OF THE OBJECT.

3. CONNECT THE DOTS AND SHADE.

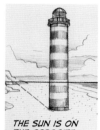

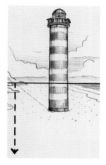

THE SUN IS ON THE OPPOSITE SIDE.

THE CLOSER THIS POINT IS TO THE HORIZON LINE, THE LOWER IN THE SKY THE SUN WILL BE (BUT ON THE OPPOSITE SIDE).

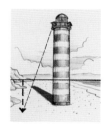

MORE EXAMPLES ⇒

AGAIN, IGNORE THE CORNER CLOSEST TO THE LIGHT SOURCE.

THAT STUFF CAN GET COMPLICATED, AND UNLESS YOU HAVE DRAMATIC LIGHTING, IT'S OFTEN UNNECESSARY. SO HERE'S A SHORTCUT FOR EVERYDAY SITUATIONS WHEN THE LIGHT IS DIRECTLY OVERHEAD AND FAR AWAY.

VISUALIZE WHAT THE OBJECT LOOKS LIKE FROM DIRECTLY ABOVE.

FORESHORTEN IT BY SQUISHING IT DOWN AND ADD IT UNDER THE OBJECT.

MOST OF THE TIME, THE RESULT WILL LOOK A LOT LIKE A SKINNY ELLIPSE.

F
O
R
E
S
H
O
R
T
E
N
I
N
G

IF YOU'RE NOT SURE WHAT YOUR OBJECT MIGHT LOOK LIKE FROM OVERHEAD, JUST GO WITH A SKINNY ELLIPSE. THAT'S WHAT I USUALLY DO.

DRAWING TREES

TREES ARE KIND OF LIKE FIRE OR CLOUDS. THEY VARY WILDLY IN SIZE AND SHAPE, AND THEY CAN BE DRAWN IN A VARIETY OF STYLES.

BUT WHEN DRAWING TREES REALISTICALLY, IT'S USEFUL TO MIRROR THE HIERARCHY OF THE TREE ITSELF:

TRUNK ⇨ LIMBS ⇨ BRANCHES ⇨ LEAVES

1 TAPER THE TRUNK FROM THICK TO THIN. BE SUBTLE— IT'S NOT A CONE.

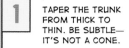

2 ADD LIMBS. DRAW THEM A LITTLE THINNER THAN THE TRUNK.

LIMBS POINTING TOWARD AND AWAY FROM YOU ARE FORESHORTENED. THEY SHOULD BE DRAWN *SHORTER* AND WITH *STEEPER ANGLES*.

BRANCHES GET SHORTER AND MORE ANGLED NEAR THE TOP.

THESE LIMBS POINT THIS WAY . . .

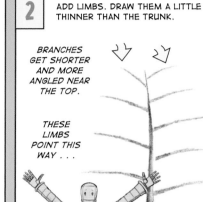

DOUBLE THIS NUMBER OF LIMBS . . .

. . . TO DRAW THIS NUMBER OF LIMBS.

. . . BUT THESE POINT THIS WAY AND THIS WAY.

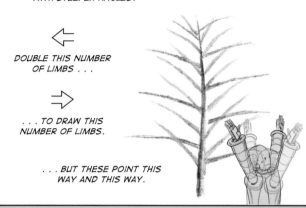

3 ADD BRANCHES THAT ARE A LITTLE THINNER THAN THE LIMBS.

KEEP THE BRANCHES LONG AND ANGLED CLOSE TO THE LIMBS . . .

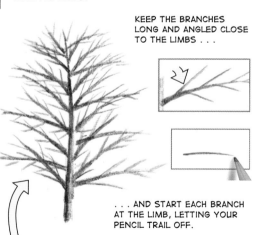

. . . AND START EACH BRANCH AT THE LIMB, LETTING YOUR PENCIL TRAIL OFF.

4 FOR A LEAFY TREE, COVER EACH BRANCH AND LIMB WITH BUNCHES OF SCRIBBLED OVALS.

START WITH A LOOSE, SLOPPY OVAL. WITHOUT PICKING UP YOUR PENCIL, SCRIBBLE ADDITIONAL OVALS UNTIL YOU HAVE A CLUSTER OF THEM.

ADD SOME IN THE MIDDLE, TOO, WHERE BRANCHES WOULD BE POINTING TOWARD YOU.

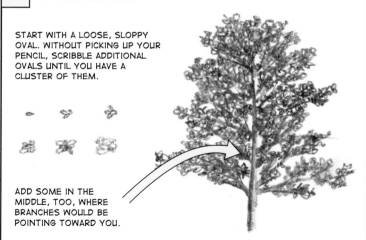

FOR A BARREN TREE, YOU CAN STOP THERE, OR YOU CAN GET OUT A SHARPENED PENCIL AND ADD SMALLER BRANCHES TO YOUR BRANCHES.

AND, IF YOU HAVE THE PATIENCE, EVEN SMALLER ONES, AD INFINITUM.

FOR PINE TREES, IT'S A DIFFERENT PROCESS, THOUGH YOU STILL FOLLOW THE HIERARCHY OF THE TREE:

1 TAPER THE TRUNK AND LIGHTLY SKETCH THE GESTALT OF THE LIMBS.

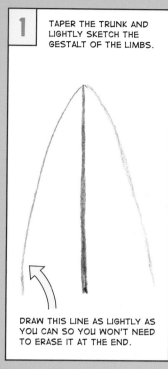

DRAW THIS LINE AS LIGHTLY AS YOU CAN SO YOU WON'T NEED TO ERASE IT AT THE END.

2 DRAW THE MAJOR LIMBS SLIGHTLY THINNER THAN THE TRUNK.

ANGLED LIMBS NEAR THE TOP . . .

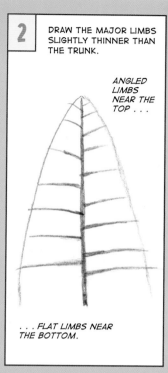

. . . FLAT LIMBS NEAR THE BOTTOM.

3 USE A LIGHT GUIDELINE TO ADD BRANCHES THAT ARE POINTING TOWARD AND AWAY FROM YOU.

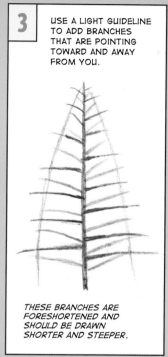

THESE BRANCHES ARE FORESHORTENED AND SHOULD BE DRAWN SHORTER AND STEEPER.

4 REPEAT STEP 3, BUT MAKE THE BRANCHES EVEN SKINNIER AND WITH LINES ANGLING EVEN HIGHER.

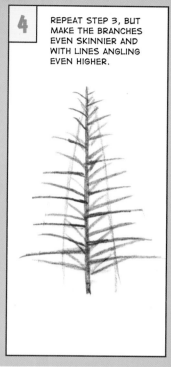

5 THOUGH THE ANGLES VARY WILDLY FOR DIFFERENT SPECIES OF PINE TREES, YOU CAN DRAW A GENERIC PINE TREE NEEDLE TEXTURE LIKE THIS:

DO IT LOOSELY, RANDOMLY VARYING THE ANGLES AND LENGTHS AS YOU WORK.

NOT LIKE THIS:

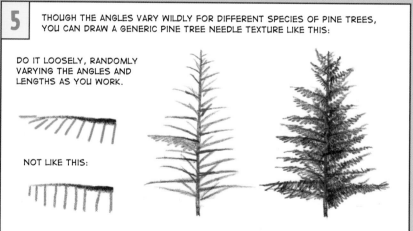

I USED SCRIBBLED OVALS AND SCRIBBLED LINES FOR THE FOLIAGE ON THESE TWO TREES, BUT THERE ARE LOTS OF POSSIBILITIES, ESPECIALLY IF YOU PLAN ON FINISHING YOUR DRAWING WITH ANOTHER MEDIUM.

YOU CAN APPLY THIS GENERAL TECHNIQUE OF STARTING WITH THE TRUNK, THEN DRAWING THE LIMBS AND BRANCHES, ETC., TO DRAW OTHER KINDS OF TREES, TOO.

HERE'S AN ALTERNATIVE APPROACH TO DRAWING TREES IF YOU'RE IN A BIT OF A HURRY:

DRAW ONE SIDE OF THE TREE SO IT FLARES OUT AT THE TOP . . .

. . . THEN DRAW THE NEGA-TIVE SPACE BETWEEN THE BRANCHES . . .

. . . AND THE OTHER SIDE.

DON'T DRAW THE BOTTOM; JUST IMPLY IT WITH A HAPPY FACE OF GRASS.

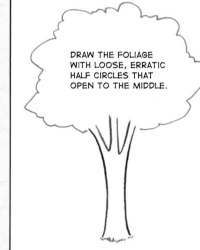

DRAW THE FOLIAGE WITH LOOSE, ERRATIC HALF CIRCLES THAT OPEN TO THE MIDDLE.

DRAW INTERIOR TEXTURE THE SAME WAY, SUGGESTING A CLUSTER OF SPHERES.

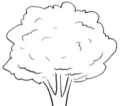

FOR SHADING, IMAGINE THE CLUS-TER OF SPHERES, BUT SHADE LOOSELY AND ERRATICALLY.

FOR TEXTURE, USE LONG, BROKEN VERTICAL LINES AND SHORT, CHOPPY HORIZONTAL ONES.

FOR CLOSE-UPS OF INDIVIDUAL LIMBS, COMBINE THE TECHNIQUE FOR A SHORTCUT TRUNK WITH THE TECHNIQUE WE USED FOR THAT FIRST TREE WE COVERED.

SHADE THE BRANCH LIKE A CYLINDER.

SHADE THE SIDE OF THE LEAF FACING AWAY FROM THE LIGHT.

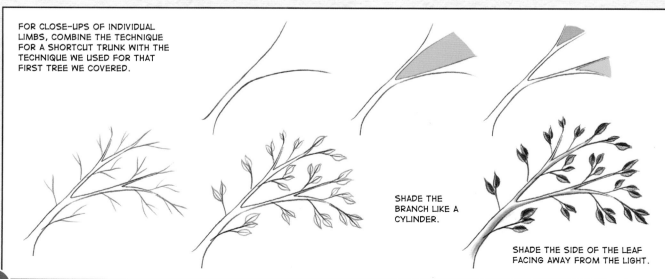

ADD TREES TO A SCENE

WHEN ADDING TREES TO A SCENE, THINK ABOUT WHICH PART OF THE TREE WOULD BE EYE LEVEL, AND PUT THAT PART IN THE MIDDLE.

SO, IF ONE TREE IS EYE LEVEL MIDWAY UP THE TRUNK . . .

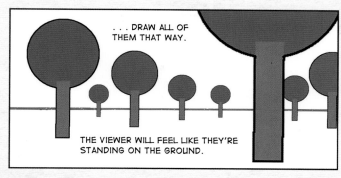

. . . DRAW ALL OF THEM THAT WAY.

THE VIEWER WILL FEEL LIKE THEY'RE STANDING ON THE GROUND.

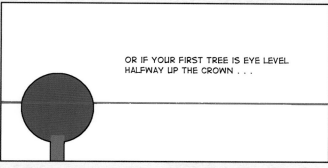

OR IF YOUR FIRST TREE IS EYE LEVEL HALFWAY UP THE CROWN . . .

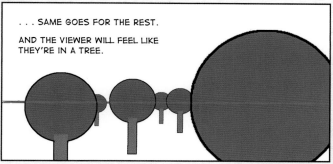

. . . SAME GOES FOR THE REST.

AND THE VIEWER WILL FEEL LIKE THEY'RE IN A TREE.

IF THE WORLD WERE FLAT AND EVERY TREE THE SAME SIZE, WE COULD STOP THERE. BUT YOU'LL LIKELY WANT TO INCLUDE SOME SLOPES IN THE LANDSCAPE AND A VARIETY OF TREE SIZES.

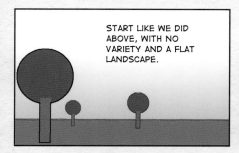

START LIKE WE DID ABOVE, WITH NO VARIETY AND A FLAT LANDSCAPE.

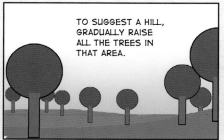

TO SUGGEST A HILL, GRADUALLY RAISE ALL THE TREES IN THAT AREA.

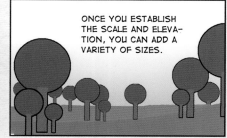

ONCE YOU ESTABLISH THE SCALE AND ELEVATION, YOU CAN ADD A VARIETY OF SIZES.

TREE TRUNKS ARE VERTICAL CYLINDERS, SO THEIR BOTTOMS WILL BE MELLOW HAPPY FACES AND CURVE MORE AND MORE THE FARTHER BELOW EYE LEVEL THEY GO.

THE HAPPY FACE WILL BE HARDER TO SEE, HOWEVER, BECAUSE OF ALL THE LUMPS AND GRASS AND STUFF.

AND SURE, THOSE ARE SOME PRETTY CARTOONY TREES UP THERE, BUT THAT'S USUALLY HOW YOU WANT TO START. DRAW A FEW SIMPLE, LIGHT TREE SHAPES TO GET THE SIZE AND POSITION RIGHT, AND THEN GO BACK AND ADD REAL TREES ON TOP.

IN THE PERSPECTIVE CHAPTER AND ELSEWHERE, WE'VE SEEN A PATTERN OF STUFF ON THE GROUND GETTING FLATTER AND FLATTER AS IT APPROACHES THE HORIZON LINE. IT APPLIES TO THE NATURAL WORLD, TOO.

AS YOU CAN SEE, THE CIRCLES, HORSES, SIDEWALK PANELS AND RIVER BENDS ARE THE SAME SIZE AND EVENLY SPACED . . .

. . . BUT THE DISTANCE BETWEEN THE OBJECTS WOULD NOT BE DRAWN EVENLY WHEN SEEN FROM THE GROUND.

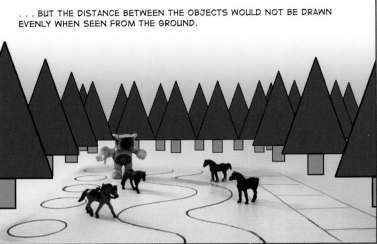

NOTICE HOW THE SPACING BETWEEN CIRCLES AND SIDEWALK CRACKS CHANGES DRAMATICALLY AS YOU GET FARTHER BACK. SAME GOES FOR THEIR SHAPE. REMEMBER THIS WHEN DRAWING PRETTY MUCH ANYTHING THAT'S *FLAT* AND *ON THE GROUND*—THINGS LIKE LAKES, FOOTPRINTS, PUDDLES, PARKING SPACES, FLOOR TILES AND RIVERS.

WHEN DRAWING PEOPLE, ANIMALS, TABLES AND CHAIRS (THINGS WITH LEGS), THE SPACING FROM THE BACK LEGS TO THE FRONT ONES SHOULD DECREASE AS THEY APPROACH EYE LEVEL (THE HORIZON LINE).

IF YOU'RE JUST DRAWING A SOLITARY HORSE, MAKE SURE THE ANGLE AND THE SPACING OF THE FEET MATCH.

SEEN FROM ABOVE, SPACE THE LEGS OUT MORE.

SEEN FROM A TYPICAL ANGLE, SPACE THE LEGS OUT JUST A LITTLE.

SO PAY ATTENTION. INCORRECTLY SPACED LEGS CAN LOOK REALLY WEIRD.

DRAWING RIVERS AND THEIR FRIENDS

HERE'S AN ILLUMINATING EXAMPLE OF THE EXPONENTIAL RATE AT WHICH FORESHORTENED THINGS GET FLATTENED AS THEY APPROACH EYE LEVEL. YOU CAN USE THIS JAGGED CHASM AS THE FRAMEWORK FOR ALL KINDS OF THINGS, AS WE'LL SEE BELOW.

DRAW A HORIZON LINE.

PUT A POINT OFF TO THE RIGHT SIDE AND DRAW A COUPLE OF LINES GOING TOWARD THAT POINT.

ADD A LIGHT HORIZONTAL LINE.

HORIZONTAL

PUT ANOTHER POINT OFF TO THE LEFT AND DRAW ANOTHER PAIR OF LINES GOING TO THAT POINT.

ERASE ALL THIS STUFF, LEAVING A COUPLE OF BACKWARD L'S.

ADD ANOTHER LIGHT HORIZONTAL LINE.

THEN GO BACK TO THE RIGHT POINT.

ERASE THAT HORIZONTAL LINE.

ADD ANOTHER HORIZONTAL LINE, JUST ABOVE THE ONE YOU ERASED.

BACK TO THE LEFT POINT . . .

AT THIS POINT, YOU CONTINUE THE PATTERN, BUT IT'S IMPRACTICAL TO DO SO BECAUSE THE LINES ARE ALMOST ON TOP OF ONE ANOTHER. TRY ANYWAY AS A ONE-TIME EXERCISE TO HELP YOU UNDERSTAND THE RATE AT WHICH THINGS FLATTEN AND COMPRESS AS THEY APPROACH THE HORIZON LINE.

FROM THERE YOU CAN DROP LINES DOWN FROM EACH CORNER TO CREATE A CHASM . . .

. . . OR ROUND OUT THE CORNERS FOR RIVERS, SHORE-LINES, WINDING ROADS, ETC.

GETTING THESE CURVES RIGHT CAN TAKE A LOT OF SKETCHING!

THIS WHOLE BOOK WE'VE SEEN NOTHING BUT CLEAR SKIES. LET'S WRAP THINGS UP BY LEARNING HOW TO FILL THE SKY WITH CLOUDS.

CLOUDS COME IN A WIDE VARIETY OF FORMS, BUT GENERALLY, THEY APPEAR TO FLATTEN OUT AT THE BOTTOM AS THEY APPROACH THE HORIZON. THIS WORKS IN ALMOST ANY STYLE.

WAY ABOVE THE HORIZON, CLOUDS CAN TAKE ALMOST ANY SHAPE . . .

. . . BUT NEAR THE HORIZON, THE BOTTOMS ARE FLAT.

CLOUDS ARE DISTANT OBJECTS THAT HAVE SOFT EDGES, SO USE LIGHT OR EVEN BROKEN LINES TO DRAW THEM.

ALSO, TRY TO OVERLAP THE CLOUDS WITH THE EDGES OF THE PICTURE AND OBJECTS IN THE FOREGROUND.

NO OVERLAP + HEAVY LINES + ROUNDED BOTTOMS NEAR THE HORIZON = COLLECTIONS OF STEAM AROUND THE ROBOT

OVERLAP + LIGHT LINES + FLAT BOTTOMS NEAR THE HORIZON = CLOUDS IN THE SKY

CLOUDS HAVE VOLUME AND CAN BE SHADED AND TEXTURED LIKE A COLLECTION OF SPHERICAL FORMS.

CLOUDS NEAR THE HORIZON ARE SEEN MORE FROM THE SIDE AND SHADED LIKE THIS.

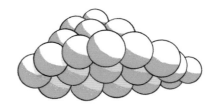

BUT CLOUDS HIGHER UP MIGHT BE SHADED LIKE THIS (DEPENDING ON WHERE THE SUN IS).

BUT THAT'S JUST THE GENERAL IDEA, OF COURSE. THE ACTUAL SIZE AND SHAPE OF THE LUMPS VARIES WILDLY.

1 DRAW THE SHAPES WITH THE LIGHTEST LINES YOU CAN.

DRAW CLOUDS CLOSE TO THE HORIZON WITH FLAT BOTTOMS.

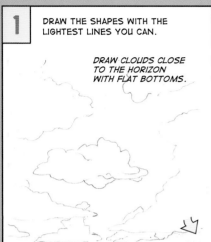

2 SHADE THE SKY WITH A GRADIENT, LEAVING THE CLOUDS WHITE. IT'S OKAY IF YOU GO INTO THE CLOUDS A LITTLE AS YOU SHADE. YOU'LL NEED TO CLEAN UP THE EDGES LATER ANYWAY.

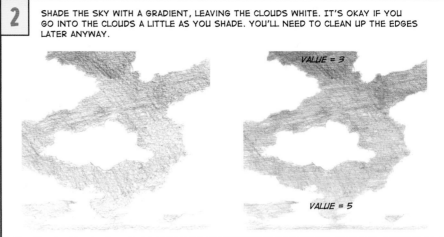

VALUE = 3

VALUE = 5

3 USING JUST THE BLENDING STUMP, STRING TOGETHER A BUNCH OF LOOSE CRESCENT SHAPES TO SHADE THE BOTTOMS.

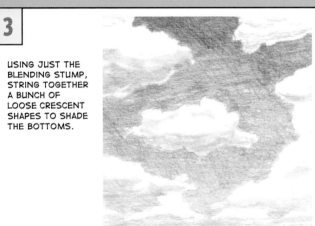

4 USE ERASERS TO BRING THE TOPS OF THE CLOUDS UP TO 8 (WHITE).

USE A COMBINATION OF SHADING AND HIGHLIGHTING TO CREATE CONTRAST.

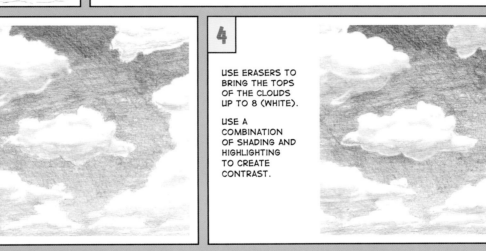

OF COURSE, THAT'S JUST HOW TO DRAW ALL-PURPOSE NIMBUS AND CUMULONIMBUS CLOUDS. IT WOULD TAKE A WHOLE CHAPTER TO COVER ALL THE DIFFERENT CLOUD TYPES. IN THE MEANTIME, TAKE YOUR SKETCHBOOK OUTSIDE AND EXPERIMENT WITH DIFFERENT TECHNIQUES TO DRAW DIFFERENT KINDS OF CLOUDS AND ADD VARIETY TO YOUR SKY.

NOW WE CAN FINALLY FINISH THE SKY IN OUR OTHER DRAWINGS!

HERE WE ARE AT THE END OF THE BOOK. I HOPE THAT IT'S HELPED YOU DRAW BETTER THAN BEFORE YOU STARTED.

BUT, SO WHAT? LET'S SAY THAT YOU CAN DRAW BETTER, YOU STILL NEED TO FIGURE OUT **WHAT YOU WANT TO DRAW**. TO THAT END, I'D LIKE TO SHARE SOME THOUGHTS ABOUT AUDIENCE. IT'S A LINE OF THINKING THAT HELPS ME WHEN I ITCH TO MAKE ART, BUT I DON'T KNOW EXACTLY *WHAT* TO MAKE.

FIRST, YOU SOMETIMES MAKE ART FOR OTHER PEOPLE, LIKE A CLIENT OR A FRIEND OR FAMILY MEMBER.

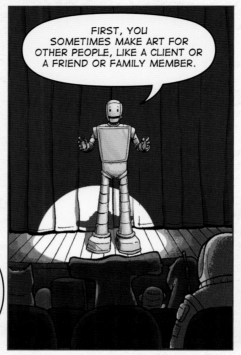

THIS APPROACH MAY SEEM LESS SINCERE, BUT I'VE ACTUALLY MADE SOME OF MY BEST PIECES WITH THIS PROCESS. PLUS I MADE PEOPLE HAPPY. AND SOME MONEY.

I WOULD NEVER WEAR THIS T-SHIRT DESIGN I MADE. BUT IT SOLD FIVE THOUSAND COPIES AND IS MY FRIEND'S SON'S FAVORITE T-SHIRT. COOL!

OTHER TIMES, YOU MAKE ART AS IF *YOU* WERE THE AUDIENCE.

I'VE ALWAYS LIKED ART WITH AND ABOUT ROBOTS, EVEN WHEN I WAS GROWING UP. THAT'S PARTIALLY WHY I USED A ROBOT AS MY AVATAR FOR THIS BOOK AND WHY I OFTEN DRAW THEM IN MY ART.

MY "ROBOT VS. GOLEM" DESIGN SOLD JUST A FEW COPIES. BUT I BOUGHT ONE.

AND SOMETIMES, YOU JUST CREATE. THERE'S NO REGARD FOR AUDIENCE AT ALL, EVEN YOURSELF.

SOMETIMES I STRUGGLE WITH THIS KIND OF ART, BUT SOME OF MY ABSOLUTE FAVORITE PIECES (AND SOME OF MY LEAST FAVORITE) HAVE COME FROM THIS PROCESS.

IF I STRUGGLE WITH ARTISTS' BLOCK . . .

. . . I CAN THINK ABOUT THIS STUFF AND GET INSPIRED. SHOULD I MAKE A PIECE OF ART FOR A FRIEND OR FAMILY MEMBER? MAYBE ENTER AN ART CONTEST OR POKE A FORMER CLIENT? PAINT A ROBOT PICTURE TO HANG IN MY HOUSE? OR SHOULD I JUST SIT DOWN, START DRAWING AND SEE WHAT HAPPENS? THINKING ABOUT THE AUDIENCE (OR LACK OF) CAN OFTEN REDIRECT ME AND GET ME DRAWING AGAIN. AND THAT MAKES ME HAPPY.

BEST OF LUCK WITH YOUR DRAWINGS. KEEP LEARNING, KEEP DRAWING, AND HAVE FUN.

a content + ecommerce company

Other fine IMPACT books are available from your favorite bookstore, art supply store or online supplier. Visit our website at fwmedia.com.

22 21 20 19 18 5 4 3 2 1

DISTRIBUTED IN THE U.K. AND EUROPE
BY F&W MEDIA INTERNATIONAL LTD
Brunel House, Pynes Hill Court, Pynes Hill, Rydon Lane,
Exeter, EX2 5AZ, United Kingdom
Tel: (+44) 1392 79680
Email: enquiries@fwmedia.com

ISBN 13: 978-1-4403-5290-4

Edited by Noel Rivera
Production edited by Jennifer Zellner
Designed by Jamie DeAnne
Production coordinated by Debbie Thomas

ABOUT THE AUTHOR

ROBBIE LEE'S FIFTEEN YEARS OF TEACHING INCLUDES VISUAL ART FOR MIDDLE SCHOOL KIDS, AS WELL AS WORKSHOPS ON PERSPECTIVE DRAWING FOR ADULTS. ROBBIE'S PROFESSIONAL ILLUSTRATION WORK RANGES FROM ADVERTISEMENTS AND VIDEO GAMES TO BACKPACKS AND SKATEBOARDS. THE BULK OF HIS WORK LIES IN T-SHIRT DESIGN, WHERE HE'S CONCOCTED HUNDREDS OF DESIGNS THAT HAVE SOLD HUNDREDS OF THOUSANDS OF TEES. ROBBIE LIVES WITH HIS WIFE AND TWO CHILDREN IN ORLANDO, FLORIDA. THIS IS HIS SECOND BOOK ON DRAWING INSTRUCTION.

ACKNOWLEDGMENTS

THANK YOU TO MY FAMILY FOR ONCE AGAIN PUTTING UP WITH MY EFFORTS TO TAKE ON SUCH A TIME-CONSUMING PROJECT. I APPRECIATE YOUR PATIENCE AND FLEXIBILITY, AND I'M EXCITED TO FINALLY PLAY THE NEW ZELDA GAME WITH YOU. THANK YOU TO MELISSA, ERIC AND DANNY FOR LOOKING OVER THE LESSONS AND STEP-BY-STEPS AND OFFERING ADVICE. THANK YOU TO THE FOLKS AT IMPACT FOR THE OPPORTUNITY TO PUT THIS ALL TOGETHER.

METRIC CONVERSION CHART

TO CONVERT	TO	MULTIPLY BY
INCHES	CENTIMETERS	2.54
CENTIMETERS	INCHES	0.4
FEET	CENTIMETERS	30.5
CENTIMETERS	FEET	0.03
YARDS	METERS	0.9
METERS	YARDS	1.1

DEDICATION

TO THE FOLKS WHO HELPED ME BECOME AN ARTIST:
JOEL LEWIS, BOB RANKIN AND RAFI GOLDBERG. AND TO
THE ARTISTS WHO INSPIRE ME: DAVID BYRNE, EDGAR
MCHERLY, KEITA TAKAHASHI AND PENDLETON WARD. AND
TO ALL OF MY STUDENTS OVER THE YEARS: I WISH I
COULD TEACH YOU ALL OVER AGAIN, ESPECIALLY NOW
THAT I'VE GOT A BOOK WE CAN USE.

Ideas. Instruction. Inspiration.

Check out these IMPACT titles at IMPACTUniverse.com!

These and other fine **IMPACT** products are available at your local art & craft retailer, bookstore or online supplier. Visit our website at IMPACTUniverse.com.

Follow **IMPACT** for the latest news, free wallpapers, free demos and chances to win FREE BOOKS!

Follow us!

IMPACTUniverse.com

· Connect with your favorite artists
· Get the latest in comic, fantasy and sci-fi art instruction, tips and techniques
· Be the first to get special deals on the products you need to improve your art